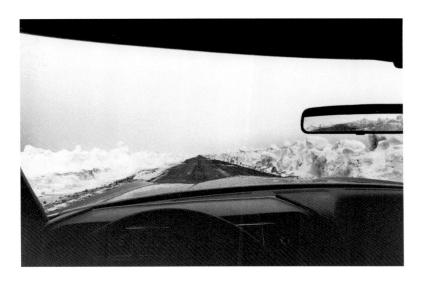

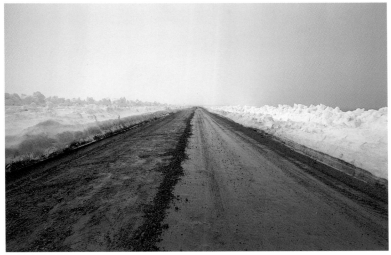

NEWFOUNDLAND, 1971

EN ROUTE BETWEEN CAPE ST. MARY'S AND PATRICK'S COVE, NEWFOUNDLAND, WITH WRITER ROB PARKER

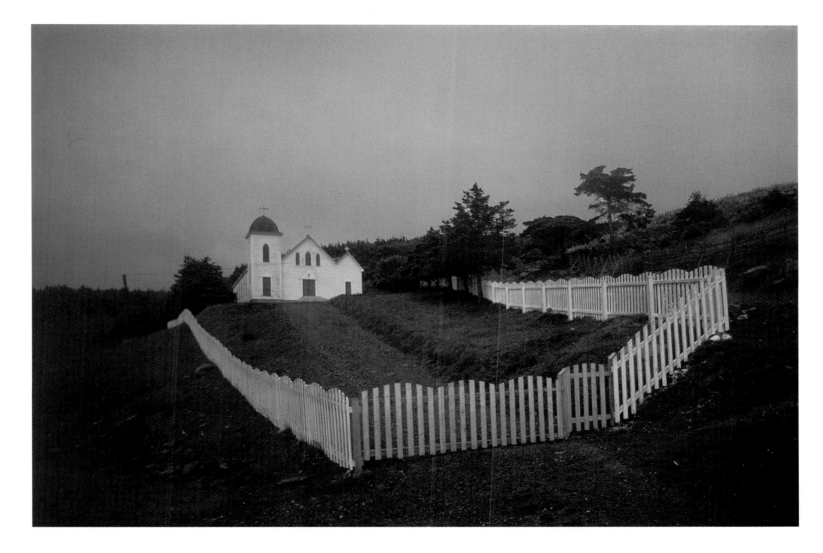

PATRICK'S COVE, NEWFOUNDLAND, 1970

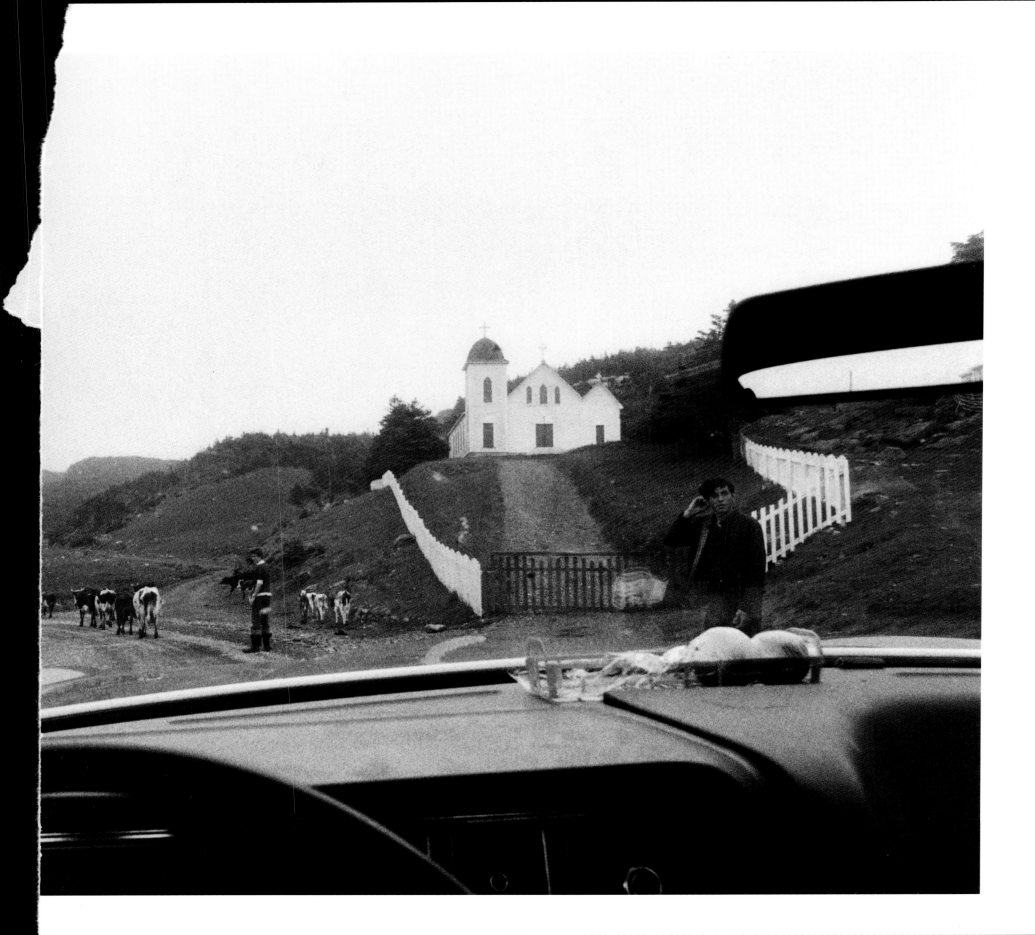

June 24, 1972. Patrick's Cove, Newfoundland.

When I made these photographs I was 27—on the road living the photographic life.

It was a life that excluded nothing and required little: a camera for color and another for
a black and white photographic diary.

And though I'd been taking pictures since before I was ten, it felt like life—the photographic life—
was just beginning.

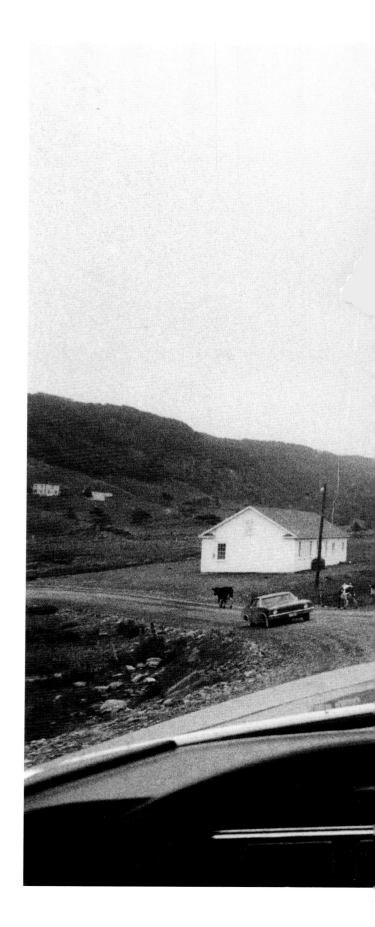

DEDICATION

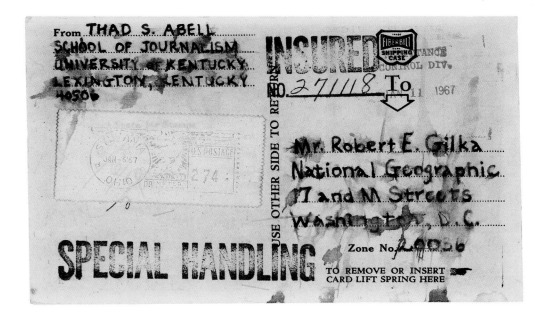

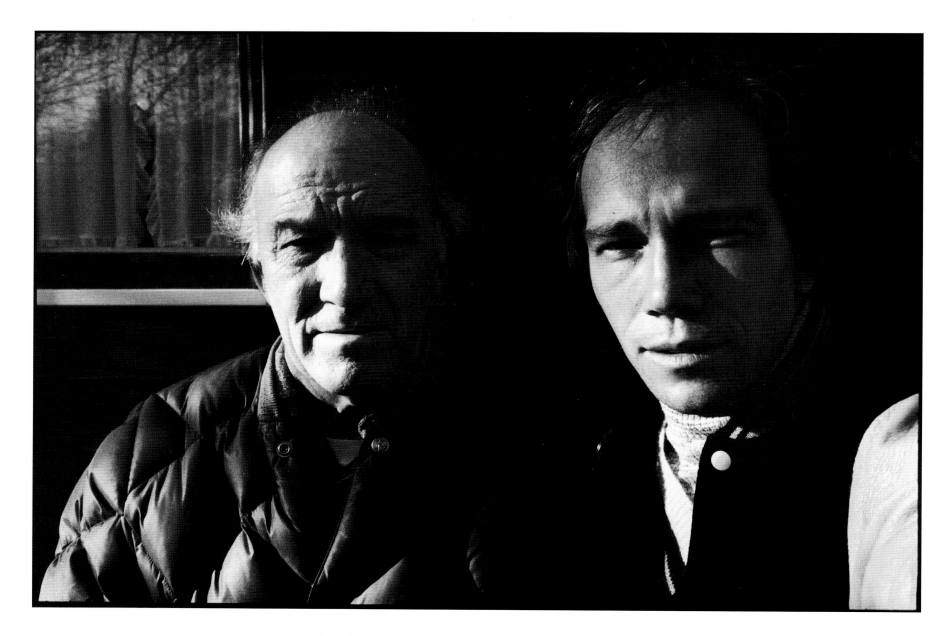

SELF PORTRAIT WITH MY FATHER, SYLVANIA, OHIO, 1977

SAM ABELL

THE PHOTOGRAPHIC LIFE

LEAH BENDAVID-VAL

RIZZOLI, NEW YORK, 2002

SAM ABELL: THE PHOTOGRAPHIC LIFE

Supported by and published in collaboration with
THE OAKWOOD ARTS AND SCIENCES CHARITABLE TRUST

In conjunction with a traveling exhibition organized by
THE UNIVERSITY OF VIRGINIA ART MUSEUM
Charlottesville, Virginia, July 2002

With sustained support from
SANTA FE CENTER FOR THE VISUAL ARTS

Principal sponsors of the exhibition
NATIONAL GEOGRAPHIC SOCIETY
VIRGINIA NATIONAL BANK

CONTENTS

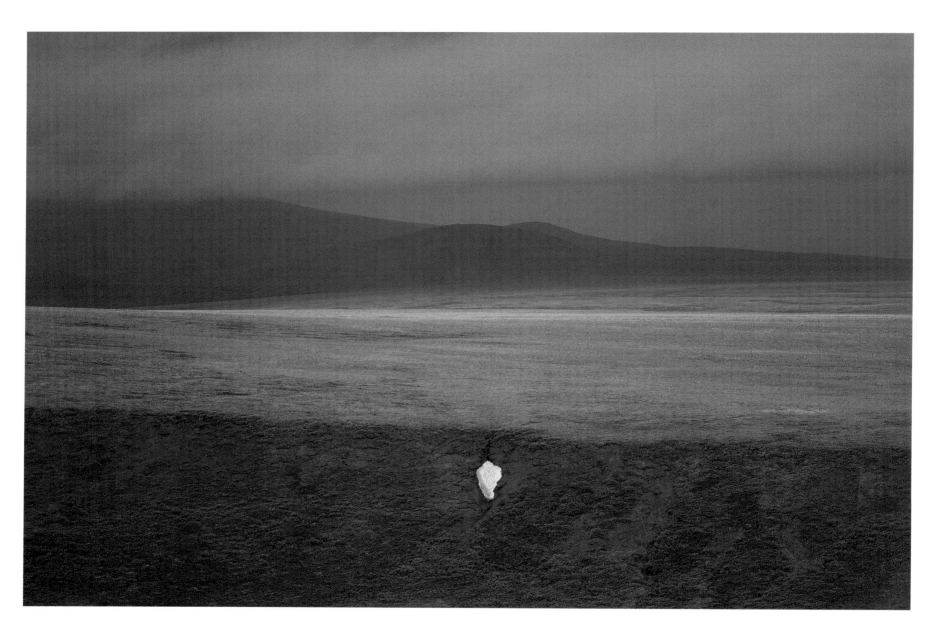

FIRTH RIVER VALLEY, YUKON TERRITORY, 1981

SAM ABELL

Something about the photograph on the facing page made me hang it on my office wall nine years ago, and through the years, when I stop and pay attention to it, I'm filled with pleasure. The inexplicable, strong calmness of the picture has lasted for me all this time. The photograph's power seems held in the irregular patch of snow lying wedged in a crevice at the center of the scene. At first sight the small white shape looks hard—solid like a bleached rock or skull Georgia O'Keefe might have painted. It seems alive, almost near enough to touch, but a shallow valley keeps it just out of reach, and the green-inflected ground extending back toward a range of vague hills gives no clue to the identity of the unfamiliar object. The elements of the composition—its subdued color and spatial volumes—are layered in such a way that the photograph is simultaneously deep and flat. Light from an impending storm gives the raw landscape a brooding tone with just a bare suggestion of disquiet. The total effect is strangely exhilarating—restrained and unembellished, yet unknowable.

Sam Abell grew up in northwest Ohio, one of the flattest places in North America. That landscape of uninterrupted horizons influenced his way of seeing by heightening his awareness of slight departures from level. The grain elevators just north of his house and the town water tower at the end of the street stood out. He carried his notion of midwestern flatness out into the world, and created photographs with details and relationships we normally fail to notice—how the shape of a fallen tree trunk mimics a far-off hill, to take just one example, or how a road or canoe prow or simply a pedestrian on a plaza may draw us forward to an ever-present horizon line and its vanishing point of possibility.

But more than attention to detail and dead-on composition make a Sam Abell picture. Often there is something else: In a photograph from Tierra del Fuego monochromatic shapes on a beach hover ambiguously between being weathered rocks or the stranded whales that they are(page 257); seal pelts in the hold of a ship are transformed into an intricate tapestry (page 249); a tile face on a cemetery stone seems lit from within and alive (page 172); and tree branches seen against a tiled roof flatten, shimmer and merge until distance itself disappears (page 233).

These are faithful documentary photographs yet they are ambiguous. Abell records everyday physical existence but simultaneously suggests other possibilities. It is this steady looking for another life behind things that characterizes his work.

Abell started taking pictures when he was nine. "The first photographs I took got me in trouble," he says. "I got the bright idea of following my fourth grade teacher, Miss Fitkin, from school to her hairdresser and photographing her there. My friend Marshall Adams and I stealthily followed her and waited until she was settled and had her hair in curlers. Then we sprang into view and I photographed her through the big picture window. It was a riot. Everyone thought it was funny except Miss Fitkin. That night my mother found out about the episode. She didn't think it was funny either and apologized to Miss Fitkin. She made me hand over my Brownie Hawkeye camera, and later the film and prints."

More than forty years later Marge Fitkin told me with amusement that she remembered the event vividly, and Abell recalls feeling that the camera gave the enterprise legitimacy. "The camera was a great companion," he says, "and I've done things all my life with it that by myself I would have had second thoughts about."

Eventually Abell got his camera back and kept taking pictures, especially on family trips and at summer camp. He learned printing from his father, Thad Abell, who in 1956 started a camera club at the high school where he was a geography teacher. At home his father outfitted a tiny basement darkroom and encouraged his eleven-year-old son to share it. For several years Abell was his father's willing assistant and photo-expedition companion.

Before his career as a color photographer at *National Geographic* began in 1970 Abell, like most of his contemporaries, took black-and-white pictures almost exclusively. In college he started a black-and-white photography diary, a running picture story of his life. He kept it up after he went to work for the *Geographic* and carried a camera for the purpose. In addition to the diary's role as a repository for memories it was a release that allowed him to look at a more chaotic, less resolved truth than the isolated climactic moments called for by *National Geographic* magazine, where light, timing,

subject matter, and composition all had to be theatrically perfected.

For years the diary photographs existed as boxes of unpublished contact sheets. Now edited they show the two sides of his life—the closely seen world of family and friends and the contrasting, colder life of a solitary photographer on the road. On one roll of film are the domestic details of home—the backyard parties, living rooms and eventually the hospitals his parents inhabited. On other rolls are the cinderblock motels, the anonymous mens rooms, the official meetings, the airplane wings and automobiles of his new, itinerant existence. The diary is the story behind a photographer's life. But it is also about trying to find worth: As a totality it expresses the belief that worth lies in life's daily details, not only its theatrical highs.

I met Abell in 1990 and for more than a decade assumed that the refined, controlled, color compositions that had gained the upper hand in his photography—the snow patch and so many other pictures—had little in common with his helter-skelter, black-and-white diary pictures. The two groups of photographs portray vividly contrasting moods. But I've recently grown to think that though their purposes are often quite different the color photographs arise from the same spirit and desire as the black and whites—to document and appreciate the nuances of everyday experience.

To that desire he added the belief that he could suggest an unseen life behind the subjects in his pictures without manipulating his prints—to find in straight documentary settings the power sometimes conveyed through controlled darkroom work or digital manipulation of images.

In college he especially admired Paul Caponigro's straight force of seeing. "One of Caponigro's great achievements," Abell says, "is a black-and-white photograph of an ordinary apple. Except it doesn't seem at first to be an apple. It seems to be a photograph of the cosmos—an image of stars and swirling galaxies in a dark universe. Caponigro's photograph was proof that

through straight seeing you could picture the immediate and the infinite at the same time, and hold both of them in your hand."

Inspired by that, Abell understood he had to find a clear, personal viewpoint that would make his pictures fresh and unsentimental.

During the early 1970s Abell was alone on the road for long assignments. He photographed the experience—the pain, the occasional pleasures, the universal human fact of aloneness. Solitude, and its puzzling link to spirituality, gradually became one of his main subjects.

I find it interesting that Abell did not photographically distinguish solitariness from loneliness—the calm of the former, the desolation of the latter. In fact he slowly grew to blend the two.

In his images of solitude, a bedrock emptiness is seen from—and indeed heightened by—an intimate vantage point: An invitation is extended into the experience of being alone. Abell chooses lenses and a direct stance to give the feeling of being there. Beneath the surface of the straightforwardly photographed scene, a power resides in what is suggested—aspirations or yearnings, loss or possibility.

Both the diary and color pictures display this theme of aloneness. In the winter of 1971 Abell photographed a snow-lined muddy road in Newfoundland (page 3). He recorded it two ways—in color as a bleak yet beautiful landscape that compels a traveler forward while suggesting pointlessness, and in black and white, a diary picture from the driver's seat of his car. The color version wasn't quite enough, he felt, to express the fact of being there and the feeling of loneliness. By photographing the scene in black and white and including the interior of the car he places himself in the scene physically and emotionally.

Four years later Abell takes the same position, emotionally and physically, in a color photograph of a canoe (page 211). From the secure cradle of the canoe the view is across smooth water to a dark and remote landscape. A storm is approaching but the water is calm. The photograph is a distilled example of Abell's photographic style and a statement of his version of solitude. It poises the viewer between contrasting forces: intimacy and infinity, warmth and cold, dark and light. It is a symbolic picture, dark but not without optimism.

The Newfoundland road pictures and the color photograph featuring a canoe prow in a stormy scene are easily seen as coming from a single imagination. The color is just one step away from black and white. The muddy road, the snow patch, and the canoe prow all point toward the horizon— always the familiar, centered one of northern Ohio.

But the differences between Abell's diary and his color work are significant. The diary pictures, often filled with friends and family, are consistently looser, denser and more intimate. They are anchored to the time they were taken so with passing years they acquire a nostalgic quality.

The color photographs show reality reduced to its essence, often without a single element that doesn't contribute directly to the central subject, a reduction of elements nearly unattainable in photojournalism. They seem to delete time, contradicting the very nature of documentary.

When Abell was fifteen he went on a trip with his father to a photography seminar at Kent State University. While there he saw a staple-bound yearbook that emulated Life magazine, put together by student photographer Laird Brown. "When Brown created *The Student* I'm sure he had an audience in mind, but it couldn't have included me," Abell says. "Nevertheless, was there a person who studied his work more than me? I doubt it. I still look at it. *The Student* taught me about creative bookmaking, and also was a lesson in the unintended influence a book can have."

In high school Abell discovered journalism and met his first mentor, teacher Frederick Marlo. "Marlo made me coeditor of the newspaper and the yearbook and photographer for both," Abell remembers. "He encouraged me to do everything—photography, design, and writing. "We sat side by side at the typewriter crafting individual words and sentences that would be just right. Working with him gave me a love of publishing and belief in collaboration that's lasted and given meaning to my life. He taught me that discipline and imagination could be combined. Up until meeting him I was all imagination and no discipline. He enlarged the world and my place in it more than anyone else."

Abell followed Marlo's suggestion to attend the University of Kentucky and there he met a second mentor, Dick Ware, a hardworking, generous university staffer who produced yearbook and newspaper photographs in his darkroom. Ware's readiness to be a guide and Abell's willingness to be guided benefited his photography through college. At that time the university had no photography program. Dick Ware and Abell did all the work required by the student publications, despite not agreeing on what great photography was exactly.

Abell majored in English but centered his life in the school of journalism, working first on the newspaper, then on a two-volume yearbook, and always on photography. He took steps toward a photographic style with a few pictures that displayed the graphics he would employ in the future and he started his photo diary.

Abell spent six years in college instead of four because of time devoted to his yearbook, and because he took extracurricular newspaper and magazine jobs. In the summer of 1966 he worked at the *Lexington Herald Leader* writing nightly police reports, obituaries, and weather. He spent hours alone in the newsroom and had time on his hands to read picture magazines.

One night in the newsroom, sifting through a pile of old *National Geographics,* he was captivated by a story titled "Across the Alps in a Wicker Basket" by writer Paul Walker, who had documented his subject suspended from a hydrogen balloon. In the empty newsroom the story and photographs had a particularly vivid appeal.

On another night, in a *Popular Photography* magazine story, he read a profile of *National Geographic* Director of Photography Robert E. Gilka. Gilka, the story said, had launched a summer internship program for college students between their junior and senior years.

Abell recalls that the idea of working at *National Geographic* had not seriously occurred to him until he read the article about Gilka. In those days *Life* and *Look* were the magazines that published great photography. *National Geographic* meant adventure travel. This had appeal in its own right for a restless student with wanderlust but the internship program suddenly suggested that *National Geographic* also took photography seriously. Abell applied and got accepted to the program for the summer of 1967. The internship was the key to everything that followed but it almost didn't happen. One of the two portfolios he sent—the one with color originals—disappeared in the mail when rain blurred the address. Only the black-and-white photographs reached Gilka and the mailing label on the package that contained them was barely legible (page 9).

Before moving to Washington to start the internship Abell made a trip to Manhattan to photograph. While there he stopped by the Museum of Modern Art to peruse its photography collection. He was immersed in looking at photographs when the museum's assistant photography curator Peter Bunnell appeared and engaged him in a conversation about photography. "Bunnell invited me into his office and sat behind his desk," Abell recalls. "For twenty minutes he held forth on photography and photogra-

phers. 'Right now you should be composing my head against the background. That's what photographers do,' he said. I'd been doing that—there was a plain white wall, a framed photograph and a window behind him; it wasn't a complicated composition. He talked on about art. I was interested in that, but I was also looking for a path to it. So when he was finished I said, 'what about *Life*, *Look*, or *National Geographic?*' Bunnell's expression and tone of voice changed. 'So you want to go off in that direction,' he said, as though it were no direction at all." Bunnell gave Abell a copy of Walker Evans' *American Photographs* to make his point about the kinds of photographs that qualify as art and how those are made.

"I was surprised by Bunnell's statement about magazine photography but it wasn't to be the last time I heard that idea expressed," says Abell. "His words had an unintended effect on me. I admired the photographs I had seen in those magazines and redoubled my belief that limits should not be put on individuals taking that path in photography, namely me."

Competition for the *Geographic* internships was fierce every year and Abell, after getting to know Gilka a little, came to believe Gilka had given him the internship out of pity over the lost package of color originals. When I telephoned Bob Gilka to find out he said, "I didn't feel sorry for anybody we named as an intern. I couldn't, really, because we didn't bring these people in to sit around and shoot crashed automobiles for insurance companies. We sent them out in the field."

Gilka didn't advertise the program. "I was interested in attracting people who had the motivation to find out where these internships were," he says. "I didn't want to run a lot of ads in the paper as if we were crying for interns." Even so, Gilka received hundreds of portfolios a year.

He looked for technical skills but the right ones rarely appeared. College students in the 1960s typically shot Tri-X film with available light and developed it themselves. The *Geographic* used only color and in those days it was slow or grainy and likely to need supplementary lighting.

But Gilka also knew skill wasn't everything. "I would look at portfolios and get a pretty good feel for imagination, versatility, and drive," he says. "I could get an idea of whether this person was extending himself or herself, not just taking assignments."

Gilka's estimation of Abell's potential from his black-and-white college photography had gotten him the internship. And Abell thrived on the work and comradeship, imaginatively lying to turn the three-month internship into a seven-month one. He told Gilka's assistant his college was on an experimental trimester system and he didn't need to go home until January so he could accept an assignment to accompany two Coast Guard icebreakers on a round-the-world voyage (page 44-5).

From the start of the internship, Abell checked out cameras, lenses and hundreds of rolls of film through the *Geographic*'s Test Film program, a scheme that encouraged photographers to try out new equipment. It allowed him to experiment with color film which otherwise was too expensive. Until the internship he hadn't been sure color could work for him artistically or financially. The internship forced him to work exclusively in color for seven months and the Test Film program let him take chances.

Gradually Abell became comfortable with color and used it to serve his photographic themes. His color stops, at times, just short of being colorless. The stones under the fallen tree (page 108-9) in their browns, grays, blues, and purples, show a range of different colors yet, paradoxically, are all the same color. The effect is deeper stillness than possible in black and white. That quietude is the significant feature in many of Abell's canoeing and landscape pictures and even in populated photographs like one in which a pair of Japanese women bid farewell on a street corner (page 128-9).

Occasionally Abell uses vivid color. Sometimes just dashes of it

appear—on the lips of a Japanese youth; on the ice at a seal hunt, on a bucket at a branding, on the hat and stockings of a woman at a horse race. The small, intense red patches in these photographs hover above their settings and work on two levels. They are sensual elements in themselves but they also help drive the essential meaning of each photograph: ambiguity in the case of the Japanese youth, bloodiness on the ice and at the branding, and theatrical improbability at the horse race.

At times a color dominates a photograph so thoroughly it seems to be the subject itself, and yet it is suffused and integral to each element inside the picture—like the red in the photograph of a sleeping baby (page 116-17). This picture is opulent but restrained: The flamboyant red is held in check by the straightforward composition, modest domestic setting, and the enigmatic bow and posture of the sleeping child herself .

In January 1968 Abell's *National Geographic* internship was over and he went back to Kentucky. In the next two years he graduated from college, worked as an intern at the *Louisville Courier Journal* and taught high school English in Toledo, Ohio. All this time he kept photographing for his diary, shooting his daily life on grainy Tri-X film as if for *Life* magazine, printing the pictures in his father's darkroom.

In the summer of 1970 he wrote to Gilka and succeeded in getting a three-month contract to photograph for the *Geographic* in Newfoundland. In September he was back teaching in Toledo. He felt oppressed, he recalls now, by the feeling that life as a high school teacher stretched dully and repetitively ahead. "I was too young to be a teacher," he says now. "I was restlessly wanting to be out in the world doing work." At Christmas he wriggled out of his teaching contract and wrote Gilka to say he was available.

He picked up where he left off in Newfoundland. Winter in Newfoundland turned out to be the perfect assignment for him. It was a foreign-seeming, exotic but English-speaking place, austere and physically demanding. Abell responded to the raw landscape and its people. Hundreds of boxes of film show that he applied every photographic technique and lens he knew. Out of the diversity of mistakes and styles and the expenditure of energy he emerged with a core set of photographs that provided the aesthetic foundation for his future work.

On one pearly dawn he went out with a two-dory, father-son fishing team to document Newfoundland's maritime culture. His pictures show that he was attentive to the timelessness of their vocation and also to their individual gestures—how the fleeting turn of a shoulder, a distinctive posture or fold of fabric reveals something about the person. From a cramped position Abell photographed the choreography of men and boats, concentrating on the moment when every part of the scene came together yet also existed separately as its own small composition (page 106-7).

This duality of a moment and timelessness became one of Abell's most basic themes. Seeking to photograph a specific moment within a timeless setting tends to separate him from other documentary photographers who stress the moment above all. This aspiration to have both the fleeting moment and the deeply composed setting has occasionally cost him photographs. The moment evaporates before the setting can be resolved.

In Newfoundland's art museum in St. Johns Abell encountered the rigorous paintings of artist Christopher Pratt. Pratt paints scenes frontally, almost with a T-square. Among his strict, spare verticals and horizontals a puff of wind or a gesture or a shaft of light—the evidence of life or its residue—animate his pictures delicately.

Abell went to the artist's house, met him, and spent the afternoon looking at more work. The visit had an affirming effect. Abell left his house

ready to believe in life and light as he already tentatively saw it, which was similar to the way Pratt saw it. His photographs were subsequently more directly seen and formally composed, with a resonance of life—sometimes only an inflection—that he would wait for, invite, and allow to enter.

Another kind of recognition made possible Abell's picture of bloody seal pelts (page 249). Out on a sealing ship he was looking for editorial magazine pictures and thought the right one would be men unloading pelts from the ship's hold. He devoted seven rolls of film to the subject. In the midst of that effort he attached his camera to a tripod and pointed it directly into the hold where layers of pelts supported a wire basket full of seal flippers. He took only one picture of the abstract tapestry before folding his tripod and turning his attention again to the working men.

That one frame stayed in the slide box until three years later when, in one of Abell's regular examinations of past work, he drew out the seal pelt picture. He was strongly affected, troubled even, by the fact that he had reacted to such a striking scene with only one photograph and had not even thought the result worthy of removal from the box. He finally labeled the complex act of taking this photograph, which came not out of intellect but out of some other consciousness, "photographing out ahead of yourself."

When Abell first explained this to me I privately doubted it: Maybe the seal pelt picture was an accident (though he did go to the trouble to set up his tripod). Art critic Ben Madow also happens to have wondered about the phenomenon. In his book *Edward Weston: His Life* he wrote "…with Weston (and indeed with most artists, and certainly all great ones), the work came first, the aesthetic justification later, and often as a rationalization, though not necessarily untrue." But I knew Abell recognized something authentic in the seal pelt picture—it wasn't a rationalization in the negative sense. The question is why hadn't he seen it before.

When Abell photographed the seal pelts he likely wasn't thinking much about the art of still life, not consciously anyway; he was concentrating on his Newfoundland assignment. The mandate to get a story that would satisfy his editors occupied him almost fully. This fact brings to mind an idea that writer-actor Steve Martin once expressed in a *New Yorker* magazine story: that art is created on the way to doing something else. It makes art seem less self-absorbed, and certainly Abell's finest work frequently fits Martin's description: art made on the way to somewhere else.

In any case it is an intuitive, organic process. The crucial, completing component of the process is the editing: It delivers a second layer of seeing from the perspective of distance and increased maturity. Abell is a serious editor. With analytical scrutiny of his work he seems to have gained insights into his own nature and gradually created a photographic identity.

He started a self-editing process in high school and continued it in college. Contact sheets from that era bear his grease pencil marks and notations. In 1971, shortly after starting at *National Geographic*, he got a desk and light table in the Film Review department. He periodically selected his best pictures and had them made into 4" by 5" duplicates, lined them up on his light table, and considered them carefully. Away from the office, he listed his best pictures in a notebook, carried the lists in his pocket, and revised them frequently. He included personal, black-and-white diary pictures in his selections (page 72-3).

Abell knew his photographic life would be a series of episodes, but he wanted his images to have cumulative power. And even in his twenties he believed that some editors at the Geographic were overlooking the intentions and heart of his photography. It seemed to him that any professional photographer had to closely examine his own work in order to progress.

Abell's self editing complements the loose, improvisational way he approaches assignments. He doesn't do much advance reading or research; he wants to avoid draining the surprise from a place. A map hung on the

refrigerator or displayed on the dashboard of his car suggestively conveys just the right cryptic information, introduces a place, inspires his imagination. I (and probably no viewer) would ever guess from the controlled, precise results that the process is so uncalculated.

"I know what my fellow travelers think of me," says Abell. "Loose shoes. I'm tyrannized by my own cargo and schedules bore me. I'm a question mark for paperwork. But in the flow of fieldwork I'm unwilling to be pinned down, even by my own plans. In Venice I photographed a blue racing gondola at low tide (page 174). But I wanted to photograph it at 'king tide'—the highest tide of the month. There was only one chance and I carefully planned to be there at dawn. But something intervened (page 88-9). It often does. It's the things you can't plan for that matter most in life."

Despite or perhaps because of his improvisational ways writers and editors seek Abell out. "Work with Sam," writer Cathy Newman told her colleague Harvey Arden. "Things happen when you're with him."

It wasn't always easy but *Geographic* photography director Bob Gilka did his best to match photographers with their interests. "If we had an outdoorsy type story, Abell was a natural," Gilka told me. "The guy was a mountain goat—all muscle. It would have been a grievous error to assign him to places like Vegas or Dallas." Between 1972 and 1976 Gilka sent Abell on a string of outdoor assignments: magazine stories on Yellowstone and Zion national parks; a chapter in a book called *Primitive Worlds* that took him to the former New Hebrides Islands, now called Vanuatu; entire books on the Pacific Crest Trail and canoeing. Except when he went to the New Hebrides, Abell worked in American wilderness areas, mostly in the west, during that entire period of time.

He did some of his truest photography for the canoeing book. But getting this assignment had been difficult. Gilka wanted him to do a magazine story in West Virginia. Gilka needed a highly flexible stable of photographers, not prima donnas, and Abell knew this. But he held out for the book because for him canoeing had mingled with photography since boyhood and he felt he had something to say about it.

The book, done together with his friend Ron Fisher, took fourteen months. The geometry of a canoe prow was already present as a central motif in his compositions. Now the actual prow was present in the foreground of the photographs. The canoe prow photographs are a sustained study of a shape. Each photograph has a distinct mood but all are variations on a single graphic theme. Still water, subtle color, and simple shapes come together in them; time is absent.

Only a couple of years before embarking on the canoeing assignment Abell had questioned everything he was doing, even the act of photography itself. Gilka, ever juggling the *Geographic*'s needs, had sent him to the New Hebrides Islands for several weeks to document the disappearing Namba culture. Abell returned to the United States from that assignment infected with malaria and completely taken with the simplicity of the Nambas' subsistence lifestyle. He considered giving up photography altogether. For the first and only time it seemed contrived and pointless to him. "The Nambas lived a life of direct physical and spiritual experience," says Abell "It gave them a dignity that I admired. For the first time I questioned photography. Why put a box between myself and life?"

Recovery coincided with a get-well gift book on Japanese gardens. Abell was struck by the way the gardens in the book were mingled with architecture and landscape—how windows, doorways, roofs and porch supports framed and linked the gardens to choice views beyond, allowing the eye and the imagination to move backward and forward through three spaces. Unexpectedly, it reminded him of camera framing and its possibilities.

Framing shapes viewers' thoughts, feelings and ways of seeing a subject, and is one of the only aspects of photography purely under the documentary photographer's control. Abell reconsidered its importance when he read the garden book. and saw fresh ways that elements in a composition could frame other elements.

His interest in photography was now rekindled, and henceforward the relationships between frame and subject in his pictures grow increasingly unexpected and refined: a closely seen fallen tree forms a frame with the distant horizon (page 109); a dog's face extends beyond the cab of a truck while its body is part of a composition framed in the window (page 139); cowboys are framed and reframed, forming three separate scenes, at a calf branding in Montana (page 113).

Abell uses traditional framing too. In Hagi, Japan, in 1980 he photographed a courtyard tree framed by an inn window (page 233). Using broken light—hard sun and hard shadow—to splinter and compress the tree and tiles behind, he made a still image vibrate. This photograph takes the three spaces of the Japanese garden—the frame, the tree, the view beyond—and distills them.

In Moscow three years later he photographed another window with the same three spaces, not quite as compressed: the intimate vantage point is established by the interior wall and lace curtain; the window frames a row of pears that resemble, in shape and color, the cupola of St. Basil's Cathedral in the distance (page 111).

After his bout with malaria Abell went back to work on an assignment to photograph the Pacific Crest Trail for a book. He spent the two summers of 1973 and 1974 photographing the trail which extends from Mexico to Canada through the mountains of California, Oregon and Washington.

During the course of the project he met his future wife, Denise Myers.

They were married two years after they met. They bought a house in rural Crozet, Virginia, a two-and-a-half-hour drive from *National Geographic* headquarters in Washington, and Denise has accompanied her husband on most of his Geographic assignments since then.

Before Abell got married he like other young photographers arriving at the *Geographic* at that time looked to the *Geographic* for a family life. Newly away from home, these photographers saw Gilka as boss, critic, and father figure. Gilka's expectations and integrity seemed to reach wherever in the world an assignment led. "Assignments were so long," says Abell, "that after awhile the *Geographic* seemed abstract and remote. Gilka never seemed that way. His strength of character gave him a presence. Often I felt I was only working for two people, myself and Bob Gilka."

But Gilka didn't concern himself with individual style. What the *Geographic* wanted was a specific kind of informative and upbeat content. Style, if it had any role at all, was for crafting that content. Gilka sometimes sent congratulatory notes to the photographers and once when asked by a photographer for approval said, "if you weren't doing alright you wouldn't be here." Gilka's vote of confidence was tinged with a democratization not entirely welcomed by young, competitive photographers. It seemed to drain meaning from their individual accomplishments; at the same time it drove them to work harder for his approval.

But photographers coming to the *Geographic* with personal viewpoints had another maybe even tougher problem: holding their own in a seductive *National Geographic* world where enormous resources made employees comfortable and where institutional viewpoints filled almost every space. For an employee it was easy and tempting to measure work solely in terms of the *Geographic*'s often thrilling realities. It takes a certain kind of strength for a member of the community to value his or her own path and resolve to stay on it.

Abell's path was particularly problematic: His photographs did not really

match the magazine's style. "One or two picture editors recognized pretty quickly that his style was a lot different from most of these kids," Gilka told me. "He was a very fine image maker, but his pictures were what they called 'quiet' and of course here that was kind of a fatal description. But he got by that."

Abell knew that the silence in his pictures, a key to their meaning, was unappreciated by the editors. When directly challenged by this he resolved not to change his photographic style but to find a way to make his quiet pictures more powerful and less of a liability. In 1977 on his next assignment, Ontario, he made a number of new photographs with this resolve in mind: The minimalist photographs of a woman on a plaza (page 215), the neon 'flowers' sign (page 82) and the arriving train (page 118-9) took his photography to a new level—quiet with an edge—and also reassured his editors.

Abell's disappointments at the Geographic never led to thoughts of leaving. Eventually his work was embraced, but even during hard times he preferred the benefits of an institution over the hustling required by a freelancer's life. Instead of quitting, his disappointments propelled him to push harder to create an independent identity while staying at the Geographic.

After completing the Ontario assignment he booked an exhibition at a small Toronto gallery and produced a poster of the woman on the plaza. People at the *Geographic* put the poster on their walls. It contributed to creating the unique identity Abell was after and that identity led to new expectations for his photography. Henceforth he was given assignments—Hagi, Japan; Life of Tolstoy; British hedgerows; Japanese Imperial Palace—where his photographic style was seen as a strength.

He also began a teaching career outside the Geographic. The same year the Ontario exhibition opened he taught a photography workshop in Maine. Abell came from a family of teachers, already had some teaching experience himself, and was a gifted workshop teacher from the start. The word got out.

A young photographer named Pam Spaulding signed up for one of the first workshops Abell taught. The pictures she brought to class were of first-time parents—a year's worth of daily moments in a middle-class, material-rich family's life. Abell saw something in her work right away and urged her to keep the project going. She did so, through two more children, following the oldest all the way through college. The result is a two-decade long document that shows an American family with realism and intimacy.

"He took everybody in that class, at whatever level they were, to the next level," Spaulding told me. Not surprisingly, students are grateful; they stay in touch and return for more of Abell's workshops, year after year.

A committed photographer rarely spends time teaching and most don't do it well. Painter-photographer Ben Shahn (quoted by Howard Greenfeld in his book, *Ben Shahn: An Artist's Life*) once gave his view on why this is so: "I think that the artist as teacher pours so much of his thinking and so much of his energy into other people that he saps his own creative springs at the source." But Abell manages to keep the two enterprises in workable balance; In fact his photography and his teaching stimulate each other.

"I wonder how I could have grown as a photographer without teaching," he says. "I never would have looked within my work to understand it so I could explain it to others. In workshops I do this and I ask the participants to do the same." Abell creates an atmosphere of trust in which students talk about their work publicly and hear reactions from everyone present.

I watched Abell teach for the first time in 1995. During the course of that week, he devoted an hour-long, concentrated one-on-one session to each of a dozen students. "The purpose is to put their careers and their photography into perspective," he says. "We discuss their place in photography—where they have been, where they are, and where they want to go. Examination of work isn't whimsical; it's based on principles we have talked about during the week." He trimmed the fat from their work; it reminded

me of his self editing, and because editing goes untaught the lesson in it alone seemed worth the tuition.

Many in Abell's generation of Geographic photographers wished the magazine would publish experimental work with identifiable authorship—they wanted the style and point of view of the photographer to come through. In the 1970s, they spent evenings looking at each other's trays, urging each other forward, poring over new photography books, and dissecting Geographic politics. "In the past, we basically shut the door and discussed the same things we discuss now, taking an issue and slicing and dicing it sixteen different ways," photographer David Alan Harvey told me. "The fact that we've discussed it a hundred and fifty times doesn't seem to bother us. We've been having the same conversation for thirty years."

Abell has published several books outside the *Geographic*, including his mid-career retrospective *Stay This Moment* with its accompanying exhibition at the International Center of Photography in 1990. Through the years his photographs have been published in magazines from *German Geo* to *Harpers*. But it is *National Geographic*'s editorial process that has most shaped Abell's way of working. Shaped, but not controlled. I have looked at a lot of his film and he seems to be working in some slender place between consciousness and intuition. He selects situations to satisfy editorial requirements and also to sustain his imagination, often simultaneously.

The Civil War landscape photography he undertook in 1986 is a case in point. The landscape he photographed was my childhood home, and though Abell was raised far from there his pictures show the soft, rolling land to me in a way I had never fully seen it—organic and ageless. Instead of depicting war monuments neglected or trashed, almost mandated by today's fashions in photography, Abell found vantage points and light to convey a poignancy, partly instilled in the statues by their makers but most-

ly seen in them by him. His photographs of statues have the full-blown personalities and life of real people. (Paradoxically, his portraits of people often resemble statues in their monumentality, remoteness, and iconic presence.) At their most accomplished these statue-portraits exist on a fine line between inert and animated, between negative and positive (page 245).

Following the Civil War photography Abell carried these themes of duality into years of work in Australia. In his photographs Aborigines seem cut from stone (page 195), termite mounds look alive, even emotional (page187).

For more than three decades Abell has photographed the spiritual characteristics of space and time, connecting the intimate with the infinite. He has combined the passing moment with feelings of eternity. He has considered mortality.

His careful compositions with their layered, improbable juxtapositions present a silent, compelling world: a patch of unmelted snow, seal pelts in the hold of a ship, a neon sign, a splash of water on an empty floor, a child sleeping on a sofa, a fallen tree—each is a Sam Abell garden, unexpected, ambiguous, but not accidental and not fully fathomable.

On my office wall, next to the picture of the snowpatch, is another photograph I love (page 259). It is of an owl. Like the snowpatch, it recalls a place and an experience.

It tells a story of a summer evening in 1976 on the Alaskan tundra: An owl and Abell surprised each other. The owl flew up from the ground and silently circled his head several times. Abell didn't move or raise the camera to his eye until the owl flew off. When it returned it flew directly at his camera. At the last moment it abruptly flew upward. The setting was indifferent but the moment wasn't. Abell held his composition and made one photograph. The shadowy owl is one of the earliest photographs in which Abell shows us the life he finds behind things.

THE PHOTOGRAPHIC LIFE

There was photography, but there was also the photographic life. I couldn't imagine one without the other and wanted both. The life I imagined was straightforward—documentary photography done for publication. Because I thought those photographs should have purpose, I was drawn to work for an organization whose mission is the increase of knowledge. Work for them put me in the field, on my own, for months and years at a time. It was the life I imagined.

But living it had the power to take me away from another life—the life of observing small details and daily dramas, like this scene of happily drunk French Canadians singing patriotic songs in the men's room of the Montreal airport in 1972. Photographing the scene wasn't part of my assignment; I was on my way to that. But I didn't want assignments to dictate my photography; I wanted life to.

So I began keeping a diary of black and white photographs. (At that time I thought black and white *was* photography.) I kept the images on contact sheets which gave a narrative quality to the diary and, I thought, to my life.

I was interested in learning something from the diary. Were there esthetic and emotional differences between black and white and color photography? Was one form of these separate sides of photography more truthful?

What I thought was separate has turned out not to be. I had the same spiritual stake in the diary as I did in my color work. The two, taken together, express what it means to me to live the photographic life.

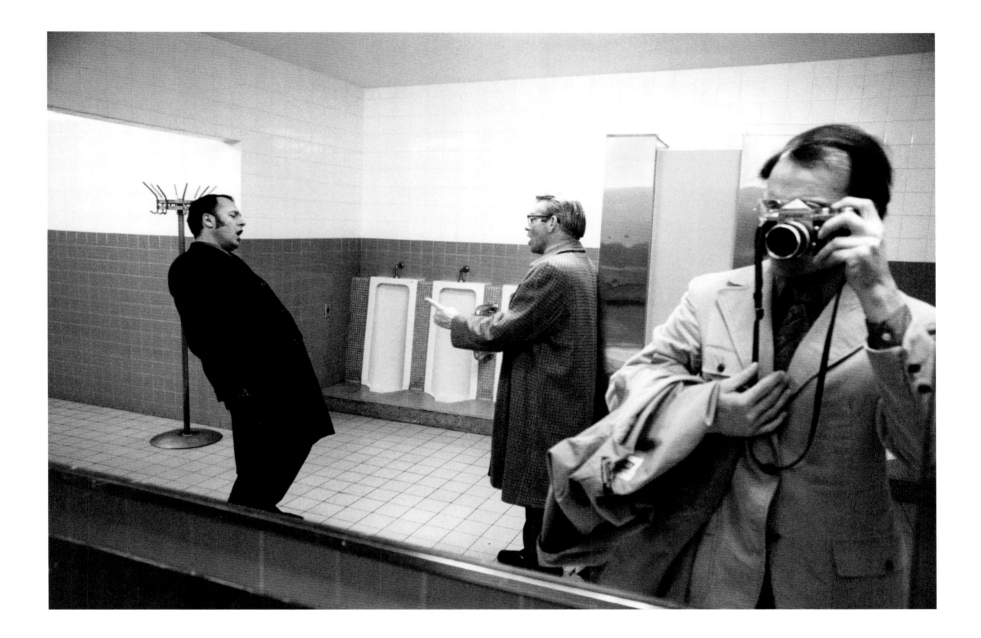

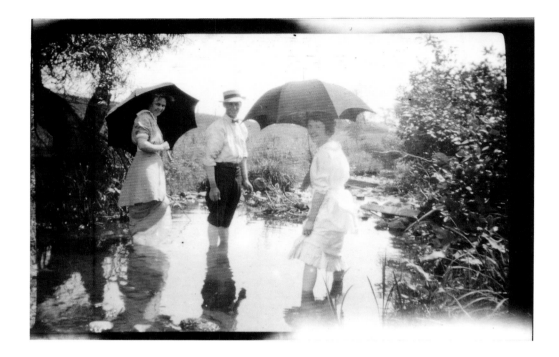

Lake County, Ohio and Larue County, Kentucky, around 1910

Photography had a special place in our family's life. Proof of that is in the albums which have come down through time to me.

On my mother's side the photographer was her father, Floyd Strong Lockwood. He was a chemist whose hobby was photography. He developed and printed his own pictures including this one of himself and his wife Kathryn, left, on an outing with a friend.

On my father's side the album was kept by his mother, Mary Thurman, a school teacher. The photographs are of the life he and his mother lived on their small farm in rural Kentucky. The album is straightforward until the last page, a pastiche of leftover proofs from studio portrait sessions. The photographer, W. L. Van Norte of Leitchfield, made solemn portraits of the men but came alive when his subjects were women—something my father, in his photographic life, was to emulate.

Late in his life my father wrote the names of the people he recognized on their portraits. One of them is Mary, whose youth and strength of expression are striking to me. She was my grandmother and I only knew her as an old person with scarily soft skin. My father once bribed me with a quarter to kiss her cheek.

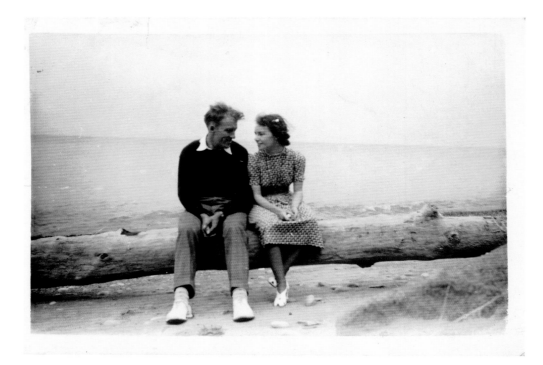

North Perry, Ohio, 1938

My parents, Thad Abell and Harriett Lockwood, were secretly married on May 7, 1938. They eloped to the courthouse in Alexandria, Virginia, while escorting a class trip to Washington, DC. No one knew. In Ohio at that time there were rules forbidding married couples from teaching in the same school. Eventually they were discovered and my father was fired. But for two years they had kept their secret safe, which was not easy in a small village like Mowrystown, Ohio, where they taught.

Two documents survive to tell the story of their courtship. One is the photograph of them at Lake Erie made by my grandfather Floyd Strong Lockwood, our family's first photographer.

The other is a love letter discovered in the family Bible by my niece Mary, in 1999. The letter was in an envelope addressed to my mother in handwriting I didn't recognize. Because they were secretly married my father deliberately addressed the envelope with his left hand. Otherwise his beautiful handwriting would have given him away to the Mowrystown postmaster.

Cincinnati, Ohio
Sept. 7, 1938

Dearest Precious,
On May 7, 1938 I loved
you as if you were the only
girl in the world, and today,
four months later, I love you
four times as much as I did then.
Love more love,
Your Angel

Sylvania, Ohio, 1946 through 1957

The story of our family's growth and aspirations is told in photographic Christmas cards. The cards were my mother's idea. She was the creative director. Despite the three-year age difference between my brother Steve and me our mother dressed us as twins in clothes she made by hand. Our father was the photographer and the calligrapher.

The Christmas cards were meant to portray an ideal of the boys as well rounded and upstanding: sports minded, pious and cultured. The truth is that the tension of producing the greeting cards didn't bring out the best in any of us. Mother stormed off more than once when we rebelled against the roles we were given.

Finally in the mid-fifties, we got to wear our own clothes for the cards. And in 1957 we got the wise idea to "send greetings" to our friends with sly gestures of our middle fingers.

The photographs were printed in the tiny darkroom in our fruit cellar by my dad. I was his helper.

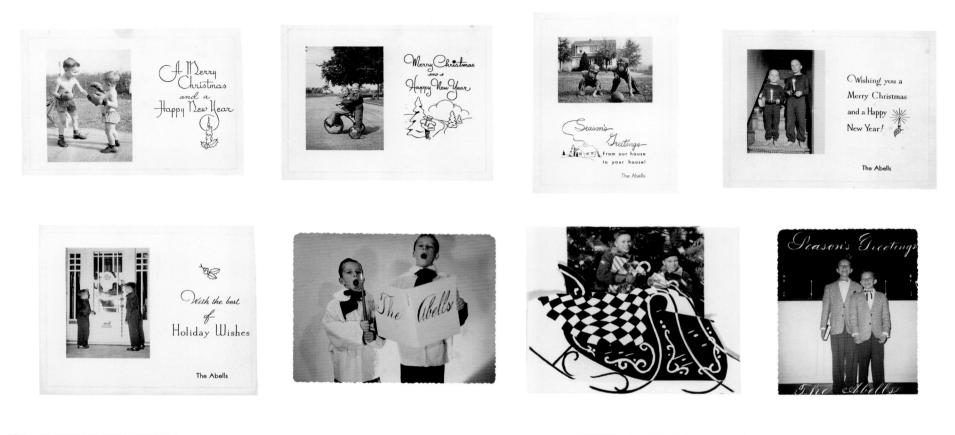

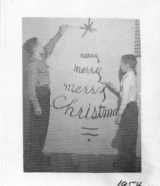

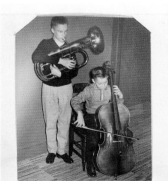

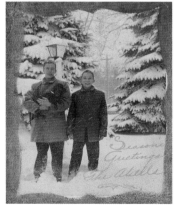

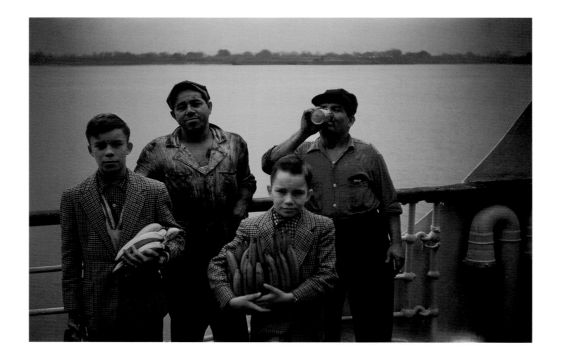

Baton Rouge, Louisiana, December, 1956

 In 1942 when my mother was pregnant with my brother she embroidered a map of the United States. For years the map was displayed under the glass of our coffee table. I sat on the sofa and, while adults talked, looked into the map. I thought of the future and about going places. Today the map hangs on my office wall. Now when I look at it I think of the past—of my mother's life and the plans she had for her yet-to-be-born boys.

 The map represents the ideals of a family of teachers: that travel and learning are good and that they are interwoven. Our vacations were organized to prove that. Every summer we took to the American road on trips that were designed to teach. Thus, in Louisiana, it wasn't enough to stand on the shore and stare at the Mississippi River. Getting on the banana boat was better. And best of all was confirming it with a photograph. This picture is one of my dad's earliest color photos, and is a favorite of mine. He got the light, the composition, the color, the characters—even the moment.

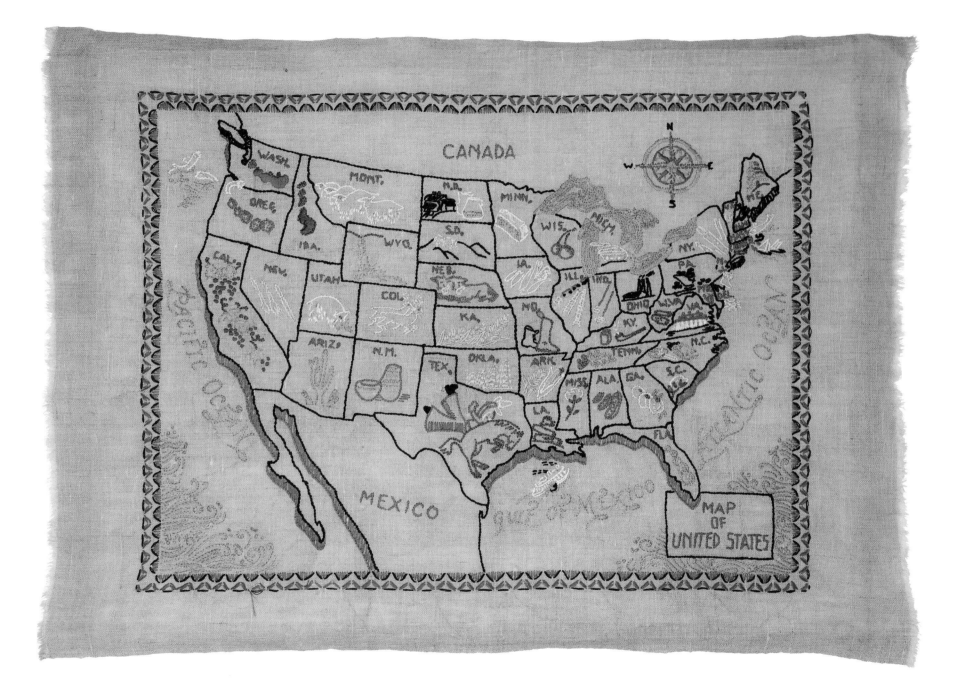

Painesville, Ohio, 1959

The first photograph I made that mattered to anyone other than me is this one, of my father watching a train leave the station in winter.

It's a picture from one of our photographic outings. We'd go to places he liked—circuses, train stations, working quarries, livestock auctions, parades with pretty girls, weddings and prize fights. I liked these places too, so the tone was always easy and light. He was a teacher but never instructed. He'd just say things from time to time, like "Look for strong diagonals", "Remember the 'S' curve", "Keep the sun at your back", "Low angle—full impact," "Bad weather makes good pictures" and a favorite for life: "Up here, not down there."

In 1960 this picture won a small prize in the Kodak National High School Photo Contest. I sometimes wonder what would have happened to my photographic life without that little award.

My father was pleased. The picture has a strong diagonal, the angle is low and the weather is bad.

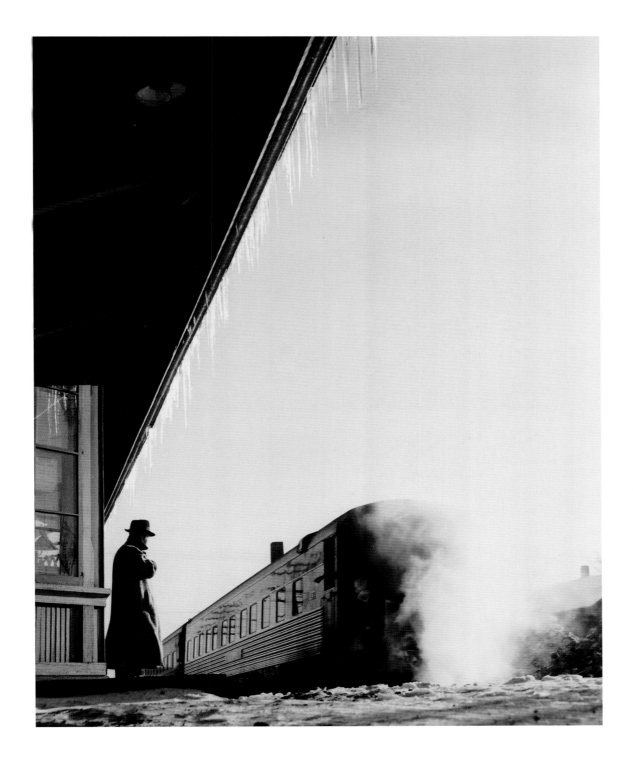

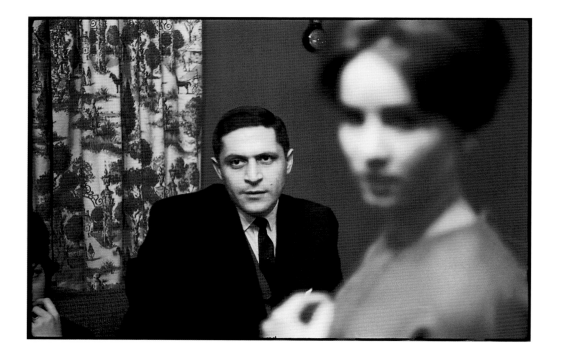

Sylvania, Ohio, 1963 and Lexington, Kentucky, 1967

Other than my father, the man who influenced me most was my high school journalism teacher, Fred Marlo, above. He made me co-editor of both the school paper and yearbook and pointed me toward the University of Kentucky. At the time UK had no photography program. I was paid $25 a week to begin one. I wasn't unhappy that there was no program. It meant I could learn by doing, and from my freshman year onward I did most of the work there was to do, together with my mentor Dick Ware, the resident professional.

Our work culminated in 1967 with the UK yearbook, which I edited and was the principle photographer for. It is a two volume, hardbound, slipcased yearbook, and making it took all of our time. The photograph of assistant editor Tom Graler is an expression of our effort. It's dawn, but he has just fallen asleep after an all night drive to make deadline.

On one hand the yearbook is forward looking. It previews the work I was to do for the next thirty years. But the book also looks back in appreciation to the teachings of Marlo. The night before I saw our high school yearbook he told me, "Tomorrow you'll see the book. There's much to be proud of, but you will only see the few mistakes. Learn from them. And don't point them out to others."

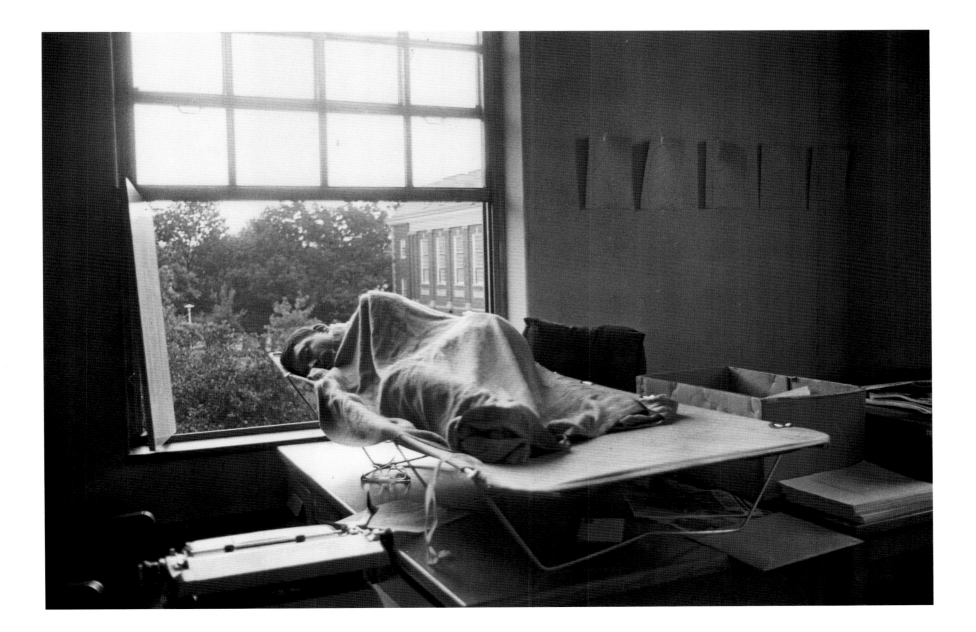

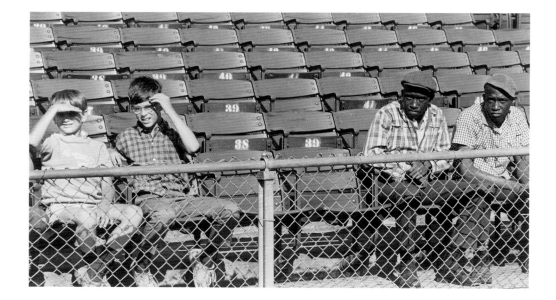

Lexington, Kentucky, 1968 and Athens, Georgia, 1988

There are paths in the photographic life and these pictures represent one not taken. They are of the social landscape, a subject I was attentive to only intermittently, as here at the University of Kentucky and again twenty years later at the University of Georgia.

It wasn't only the persistent social situation that made me attentive. I was also taken up with the structure of the scenes.

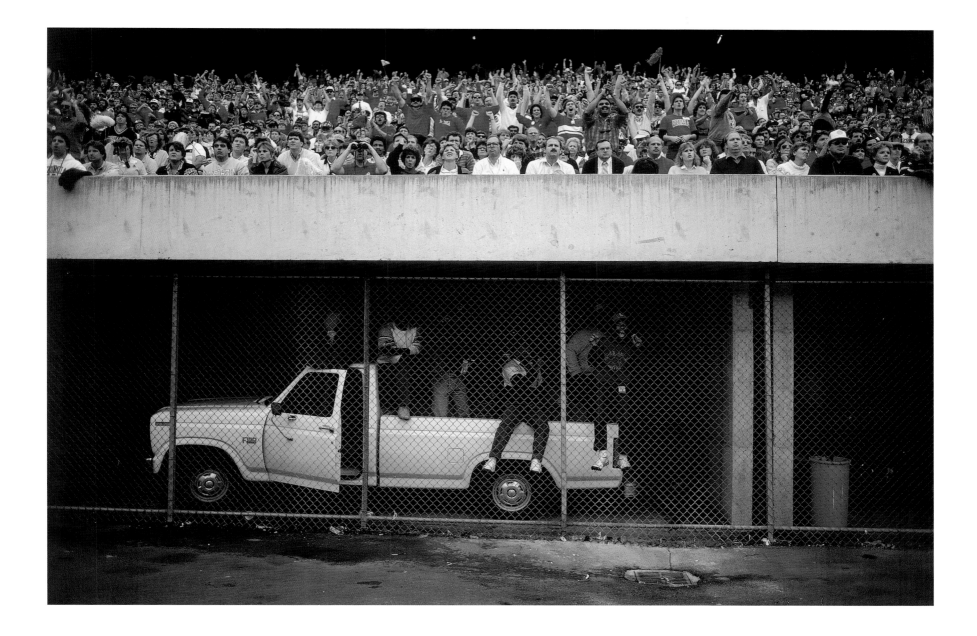

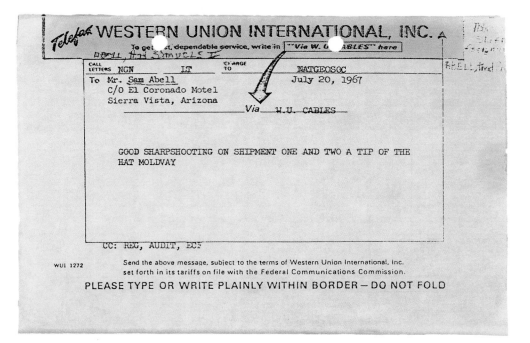

CALL LETTERS NGN LT CHARGE TO NATGEOSOC

To Mr. Sam Abell July 20, 1967
 C/O El Coronado Motel
 Sierra Vista, Arizona
 Via W.U. CABLES

GOOD SHARPSHOOTING ON SHIPMENT ONE AND TWO A TIP OF THE
HAT MOLDVAY

CC: REG, AUDIT, ECF

Washington D.C., January, 1967

In 1967 I won a summer internship at National Geographic. I stretched it into autumn, then winter. Finally I had to return to school, but I'd done some decent work, gotten a good break and seen the future.

The break came from a staff photographer, Albert Moldvay. When I was fifteen my dad took me to hear Moldvay speak at Kent State University. Seven years later I showed up at Geographic as an intern and sought out Moldvay. He took an interest in my work and even sent me a cable commending my first photographs. Staff photographers don't do that for summer interns.

But they do something else. They set a complex example of how to live this life. That year the staff photographers gathered with Melville Bell Grosvenor, the editor, for a photograph. Bob Gilka is seated at the far left, Albert Moldvay is standing, far right. Two prominent photographers, Dean Conger and Bates Littlehales, are absent.

The staff is at its greatest strength and its finest work is just ahead of it. In time I would be a part of that; for now it was a vision of a chapter of life that was about to be written.

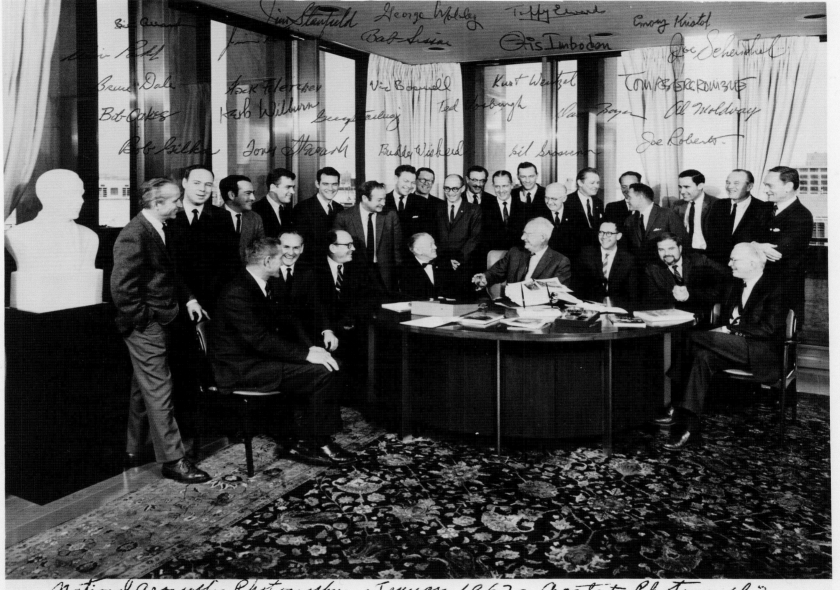

National Geographic Photographers — January 1967 — Greatest Photographic Team in the world — Boy wren — Melville Bell Grosvenor. Photo by Jim Russell (behind lens)

North of Novaya Zemla, the Siberian Arctic, August, 1967

A clipping from my hometown newspaper, *The Toledo Blade*, tells most of the story of the big assignment of my summer internship, but not all of it. The Russians thought our round-the-world expedition was about espionage and now I see they were probably right. But I believed what Captain W. K.Earle told me—that circling the Arctic was "the last voyage of world significance yet unaccomplished."

We were stopped twice, first by the ice, then by the Russians. I photographed Captain Earle when the ice was thickest. It was quiet on the bridge. Occasionally he would say something cryptic to the engine room about the route, but even I could see it was hopeless.

In retreat we were caught by a four-day gale in the North Sea. The flat-bottomed ice breakers were easily tossed about by the storm. Stress from non-stop seasickness caused my neck to lock. I couldn't raise my head from my chest. Finally the ship's doctor, braced by two sailors, gave me shots of muscle relaxer in the neck. When that didn't work he gave me a shot in the hip and I passed out.

When I awoke a day later it was sweetly still. We were in Rotterdam.

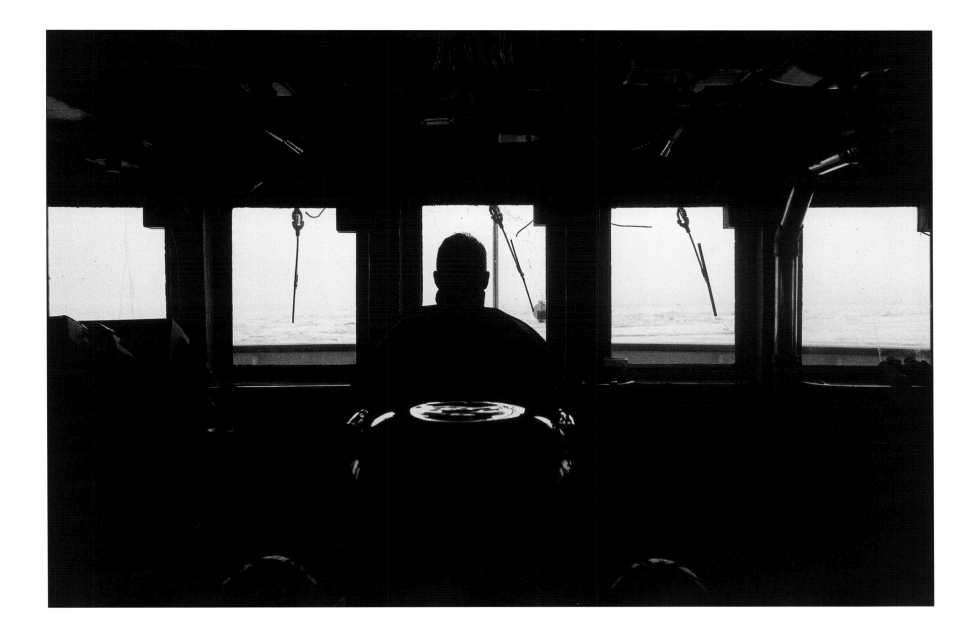

Hazard, Kentucky, 1968

The first paid professional photography I undertook was for the Rural Electric Cooperative. They wanted photographs that documented the need for "the war on poverty." It was a several-day assignment in Appalachia. By this time I had traveled a good deal and felt I had seen poverty. But I was unprepared for the depth and immediacy of poverty in the Appalachian coal fields.

A man drove me around in his car. I wasn't afraid of what I saw, but I was afraid to get out and photograph what I saw. In front of this house I asked the driver to stop the car and lean forward. I made a fast photograph from behind his back, then we drove on quickly.

When I first printed the photograph I cropped out the car door. I felt that it showed my fear. Now I think it's the most interesting part of the picture.

Lexington, Kentucky, 1969

Photography wasn't the problem at this time of my life; I was devoted to it. Going to classes and, more to the point, graduating from college was the issue. Graduate and I follow in my parent's footsteps as a teacher in Toledo, Ohio. Fail to graduate and I get drafted into the army.

It came down to my last class in summer school. I needed a D in linguistics to meet the minimum requirements for graduation—a 2.0 in my major, English, and a 2.0 overall.

I made it, just. But for awhile there was doubt. It helped to receive this letter from my dad. Just to make sure I knew the letter was affectionate he signed off with the nickname I always called him by. Then he added three more thoughts.

July 13, 1969

Dear Sam

As I see it, you are to mail out, at once, two (2) envelopes(letters) - one to Schultz in enclosed, stamped addressed envelope, and one to Personnell office, Toledo Bd of Ed.

As you can happily see, I have filled out all the forms for you, except page two to Schultz, which you will have to fill out by yourself.

Sign all forms, indicated to you by red check, look for others that I may have overlooked.

Return all forms to the mail today, not tomorrow.

Decide that you are going to pass Linguistics. Study hard and pull out all stops:

1. Look alert(Don't sleep in class)

2. Lean forward from the hip line toward Prof.

3. Show more than average interest at all times.

4. Scout the teacher. Find out what it is he wants and let him have it.

5. Scout the opposition (other students) Be more dynamic than they.

6. Consider the course a challenge. Cope with the challenge.

7. Most Profs will not fail a student who in their opinion really tried to pass the course

8. Come Hell or high water -- P*A*S*S !

Daddy Boy

9. Take notes or pretend to be taking notes.

10. Ask to sit closer

11. Give him a bottle of liquor as a going away gf.

Della Drive, Lexington, Kentucky, 1969

My best friend in college was Jim Burns. On weekends, then on longer breaks, Jim and I went on camping trips which for me were fresh photographic opportunities. The freedom of these trips contrasted with the claustrophobia of college, especially for the strongly independent Jim, who was in medical school.

One day Jim surprised me by saying he was dropping out of med school to enlist in the army—to get both school and the Vietnam draft off his back. For the first time I knew life wouldn't be the same.

I gave him a ride to the induction center. Just before we left I asked him to stand for a portrait, He's in his backyard. In front of him is a remnant of the pyramid of snow put there months before by the two of us so we would have the last snow in Lexington, Kentucky.

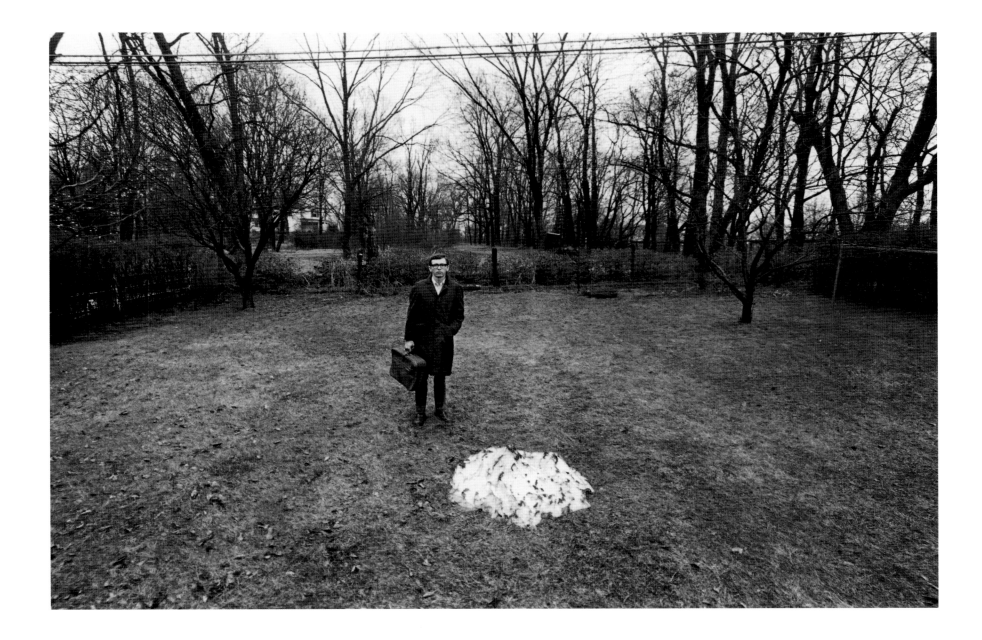

Avalon Peninsula, Newfoundland, 1972

When I left Geographic at the end of 1967 Bob Gilka said "Graduate from college, work for a good newspaper, then come back and see us". By 1970 I'd done that and was back.

Gilka sent me to Newfoundland. It's hard now to think of that time and place with anything other than unblemished affection—until I look at the film. It reveals that I made mistakes as a fieldman and hit lows as a photographer that I haven't hit since.

I often slept in my car to be near the next day's work at dawn, but sometimes I had to drive all night to be there in the morning. On one such night I became half hypnotized by the fog and when my friend Rob Parker said "here comes the turn," I turned.

The next morning fishermen from a nearby outport pulled our car from the ditch with a school bus.

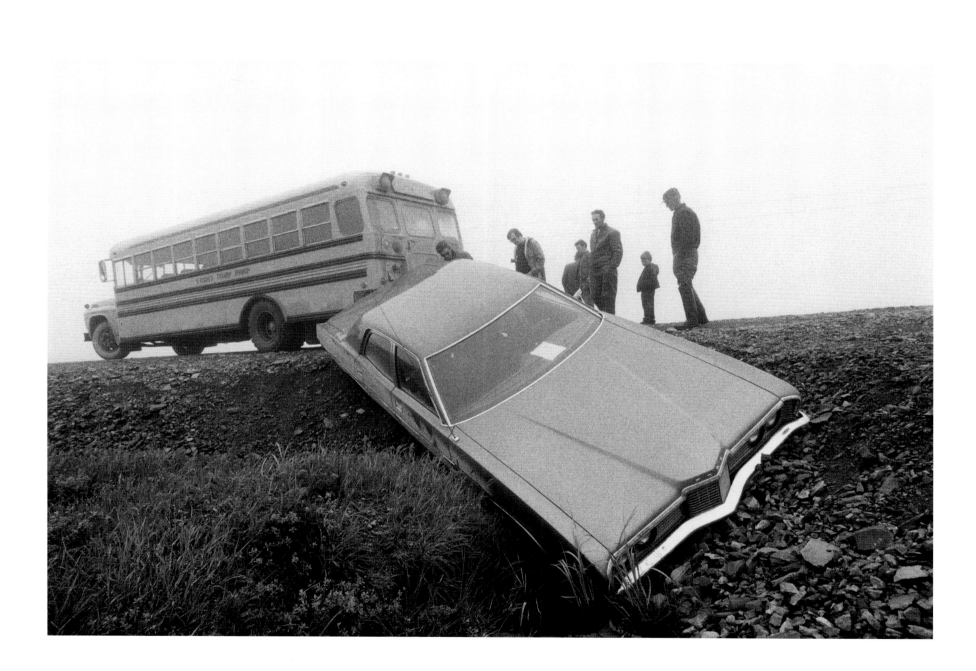

Trans Canada Highway, Newfoundland, 1971

Gilka, and my editor Jon Schneeberger, gave me a lot of rope on the Newfoundland assignment. I needed it.

One of the reasons is that learning to live and work on the road takes time. For me photography had always been a gregarious and socially involving activity. I was surprised that on assignment it was the opposite. I felt isolated and was often immobilized by indecision. With everywhere to choose from, where does one go? Sometimes nowhere.

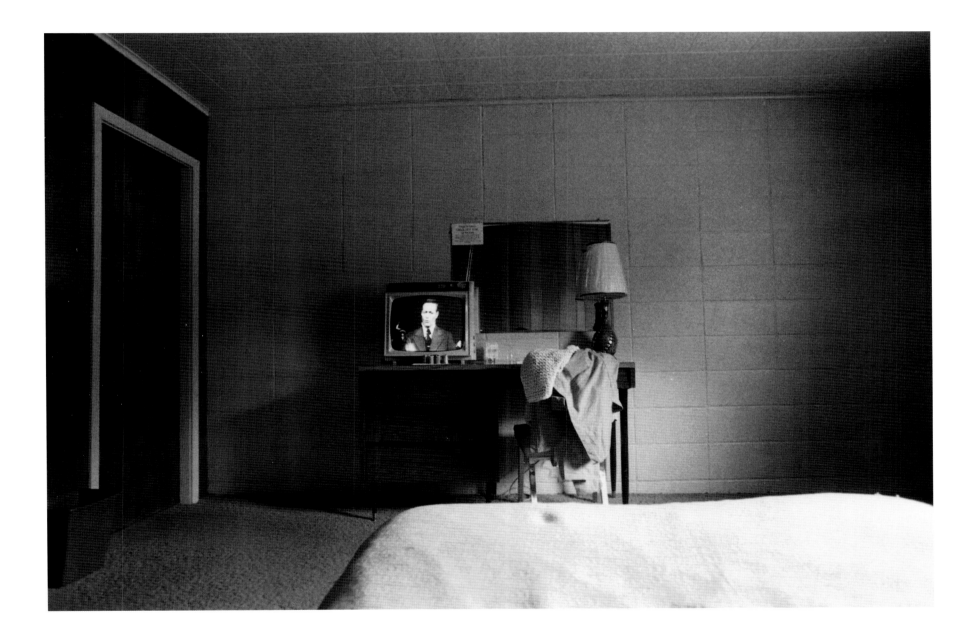

Salmonier, Newfoundland, April 1971

To break my photographic block I went to the Art Museum in St. Johns to see the paintings of Christopher Pratt. I was moved by his work and bought a serigraph he had made based on a Newfoundland five-cent postage stamp.

Buoyed by this I called Pratt at his rural home and arranged to meet him there. He seemed direct—possibly stern—and at once assailed *National Geographic* for "its lightweight position on the environment." I was taken aback by that. I'd come to talk about art. When I managed to mention that I'd bought the serigraph of the stamp things settled down. The conversation shifted to work and to Newfoundland, about which Pratt had strong opinions.

After lunch we went to his studio and while Pratt made some measurements I took a few photographs of him. I was struck by how he, and his studio, were like his work—spare but intensely alive.

It was a pure atmosphere of art and breathing it for those few hours changed my life.

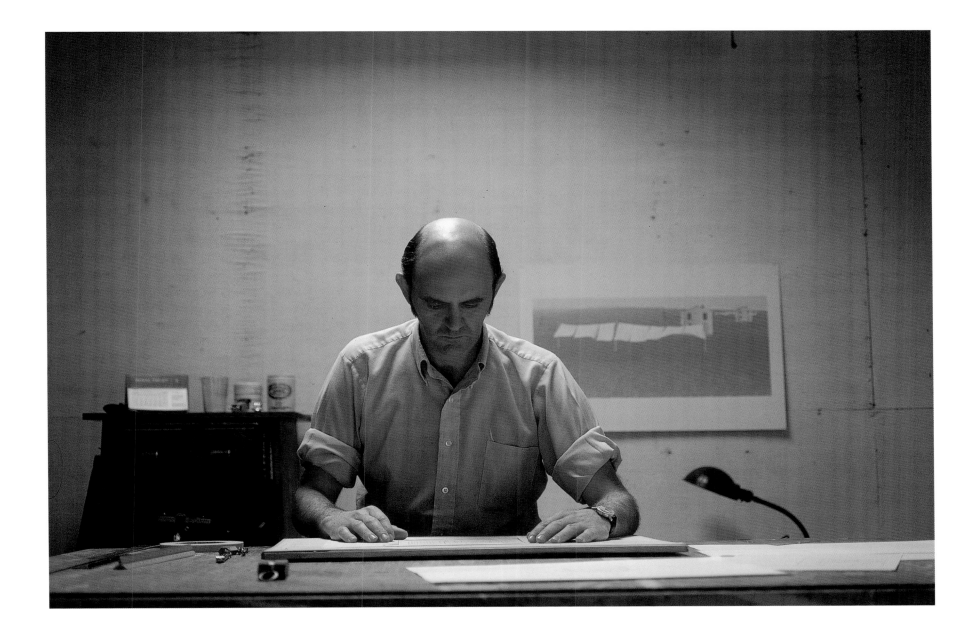

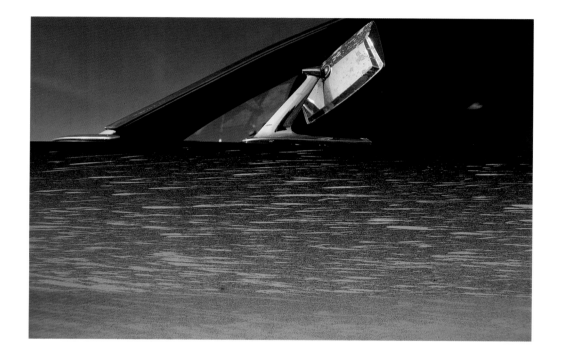

Colinet, Newfoundland, April 1971

Within minutes of leaving Pratt's studio I began photographing in color with more confidence. Two of the photographs involved my car, the thing most immediately around me that afternoon. Eventually one of those photographs was published on the cover of the Swiss magazine *Camera* together with a portfolio of Newfoundland work.

The afternoon was meaningful in more ways than one. Back at the Pratt household Chris's young son Ned began playing with some camera gear I'd left behind. Years later he greeted me after a lecture I'd given in New York City. He had become a photographer.

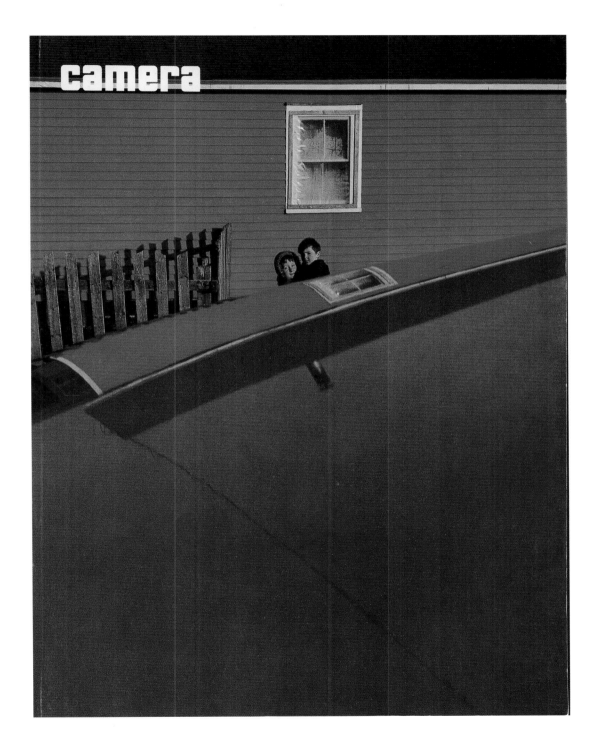

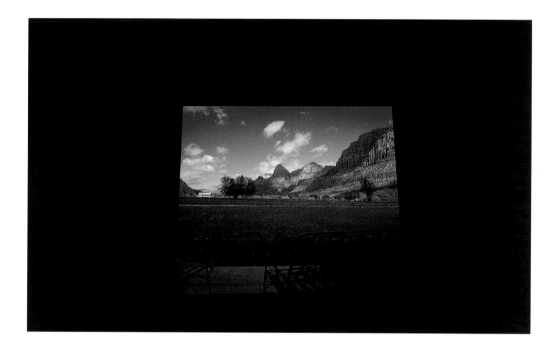

Springdale, Utah, 1972 and 1976

 Assignments were so long and involving in the 1970s that you felt you could return years later and pick up where you left off.
Four years after leaving Springdale I returned. It was easy to remember the choices I had back then: Out one window was the assign-
ment, Zion National Park, beckoning like a drive-in movie. Out another window were my friends Louise and Candy by the pool.

 Four years later the surface of life looked the same. But the faraway expressions on the faces of my friends told me things weren't the
same, that the story had changed and they had moved on.

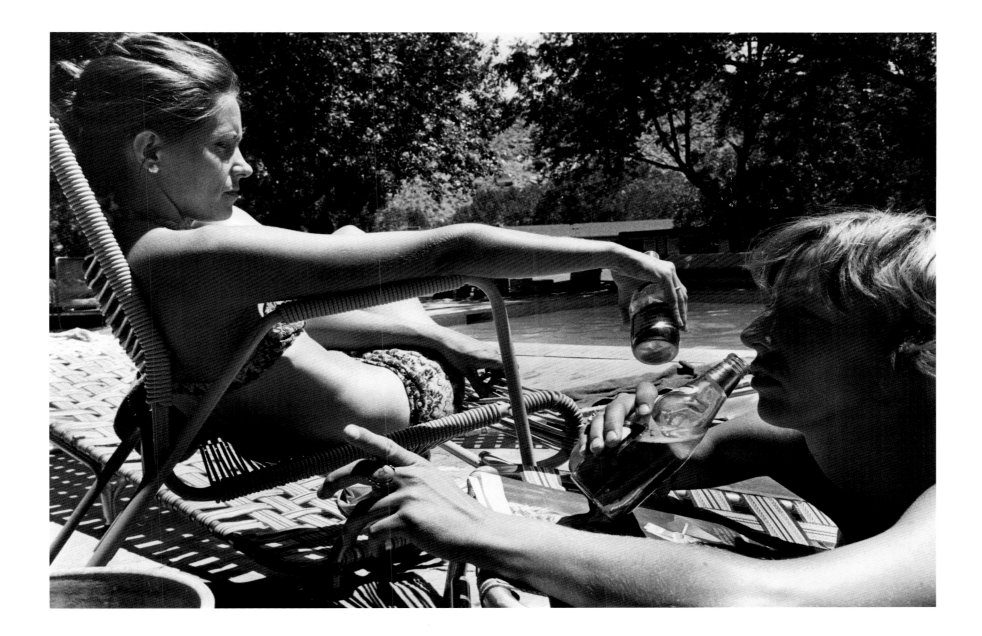

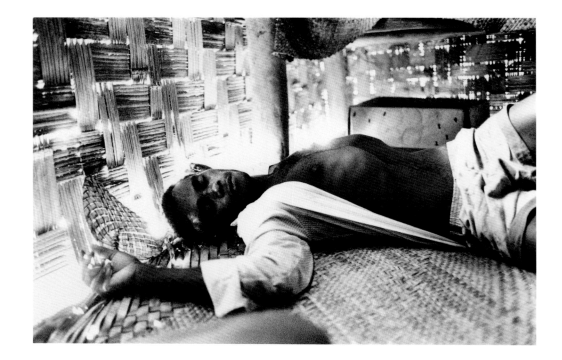

New Hebrides (now Vanuatu), December 1973

I spent a quiet month with the Namba people high in a rain forest island of the south west Pacific. Despite being powerfully built, the Namba men were gentle and soft spoken. I learned one sentence of their language: "Mi laik go blong gaten tete." ("I'd like to go the garden today.") It was the only place *to* go, and our days there passed peacefully. Theirs was a life of primary experience. If they heard music, saw art or ate a meal it was because someone close to them created it. I envied this life and part of me wanted it.

But they wanted my life, or what they thought was mine. They knew one English word, "road", and wanted to take it to the city. When we got there I was sick with malaria. The last time I saw Chief Metak he was wearing western clothes and passed out from an all-night binge. It was a scene from the story of the century—people from the hinterland coming to the city for a better life.

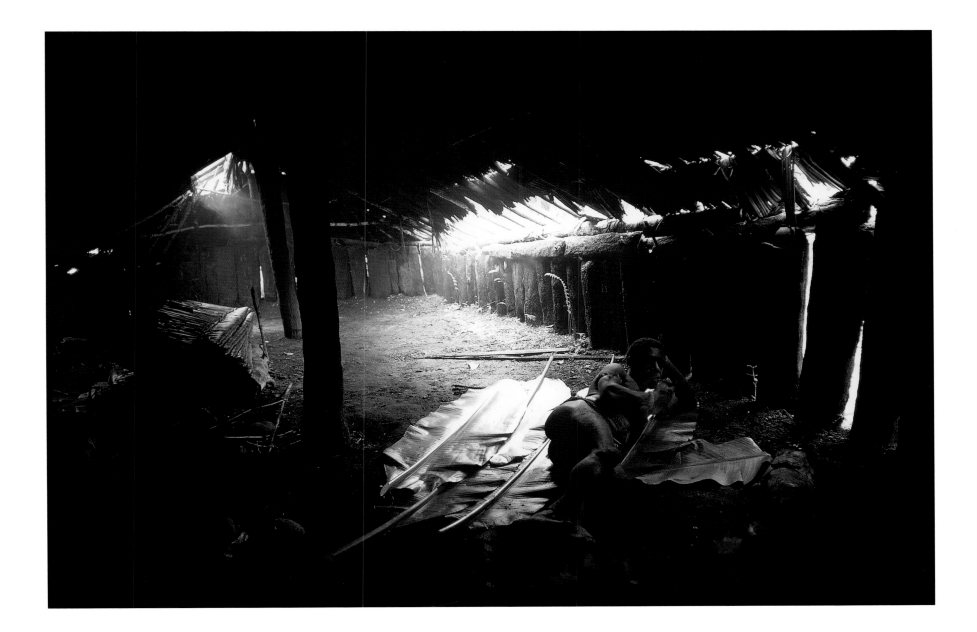

Cooper Spur Inn, Mt. Hood, Oregon, August, 1973

In May, 1963, Barry Bishop became the first journalist and photographer to reach the summit of Mt. Everest. The climb nearly took his life. Together with three other climbers he spent a forced night, unprotected, just below the summit, a situation universally regarded as unsurvivable. But the next morning he crawled off the mountain with badly frostbitten feet.

At the time I was a senior in high school and followed Bishop's progress closely. Besides being a *National Geographic* photographer Bishop was from Ohio which meant something to me.

Ten years later I arranged a reunion climb for Bishop and his Everest partner Lute Jerstad on Mt. Rainier. As a warmup Bishop and I climbed Mt. Hood. I asked him what his thoughts were that night on Everest. "I thought we wouldn't survive. But I knew they'd find my camera and in it the film of the summit."

When the climbs of Hood and Rainier were over Bishop took off his boots and socks and held up his toeless foot. "Take a picture of this Sam. When I'm gone I want people to see what the *Geographic* cost me."

The Goat Rocks, Washington, 1974 and 1973

In 1973-4 Will Gray and I undertook a hike, and a book, on the Pacific Crest Trail. The trail extends for 2,600 miles, from Mexico to Canada, through the mountains of California, Oregon and Washington. We hiked 1,500 miles of the trail so we weren't 'through hikers' who walk end to end in one six-month season.

I admired the through hikers, especially Denise Myers from Colorado Springs. She was hiking with her boyfriend Hal Simmons and another couple. We first met by chance when her group was stopped in southern California with badly blistered feet. Months later we met again. By the end of California their group was down to two—Hal and Denise—and she and I had fallen in love. Still they hiked on and finished the trail in October. That month Hal took a photograph of Denise camped directly on the trail where a year earlier I had photographed Will battling the wind. Denise and I planned to meet soon after the trail but an accident, then time, intervened.

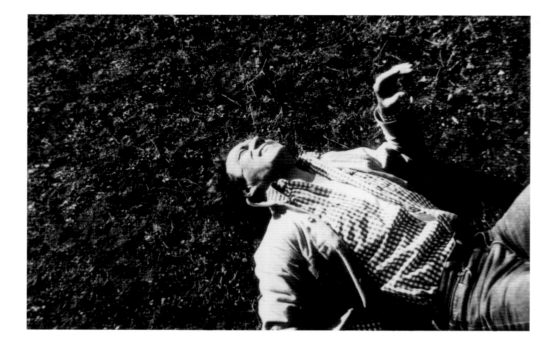

Missoula, Montana, March 1975

Documentary photography requires being present with one's subject, so it wasn't unusual for me to want to fly alongside the hang gliders I was photographing.

I got together with my friend Johnny Craighead and he suggested we go out for a test flight. He stood on a small mountain south of Missoula and placed his hands on the wind, feeling its force and direction. "You're going to fly today," he said, and I did. It was the landing we hadn't perfected and I crashed on my first flight.

Johnny had my camera and made a full record of the afternoon's events, which ended with me in the hospital with a broken back.

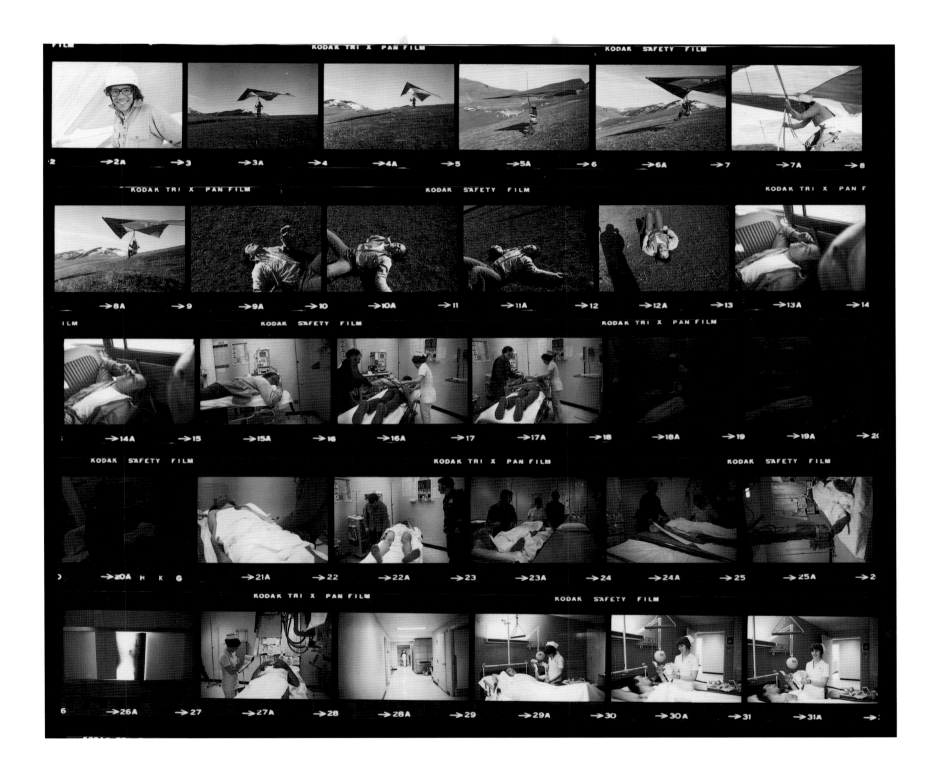

Missoula, Montana, March 1975

In the aftermath of the hang gliding accident I considered my career might be over, or at least altered significantly. My work in the field had been physical; now I could hardly walk.

But I still had black and white film in my diary camera and while recuperating at the Craighead's house I photographed their life and scene.

They were well-known wildlife biologists whose home was a refuge for injured and orphaned birds of prey. Every day a pygmy owl roosted on the curtain rod and watched me shower. I identified with the injured bird's existence and one day, with difficulty, stood on the edge of the tub and rose above the rod to take a portrait of the owl.

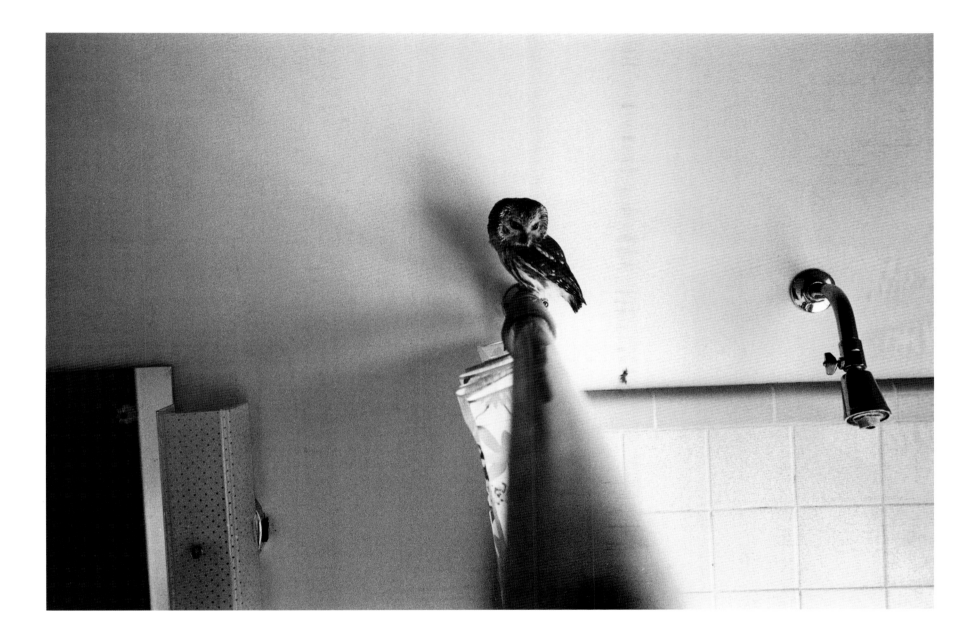

Venice, 1975

 I was often at work far from my photographs so I kept a list of my favorite pictures in my back pocket. I'd get out the list when I wanted to mentally edit my work or needed inspiration. I made this list when I was injured and couldn't work.

 At the top of the list is the portrait of Susan Smith, made in Italy. We were traveling together at the time and I knew her well so the photograph rose from within my life.

 It is a private moment made meaningful by Susan's expression and gesture. In it I see Susan, and also an image of the measure we take of ourselves.

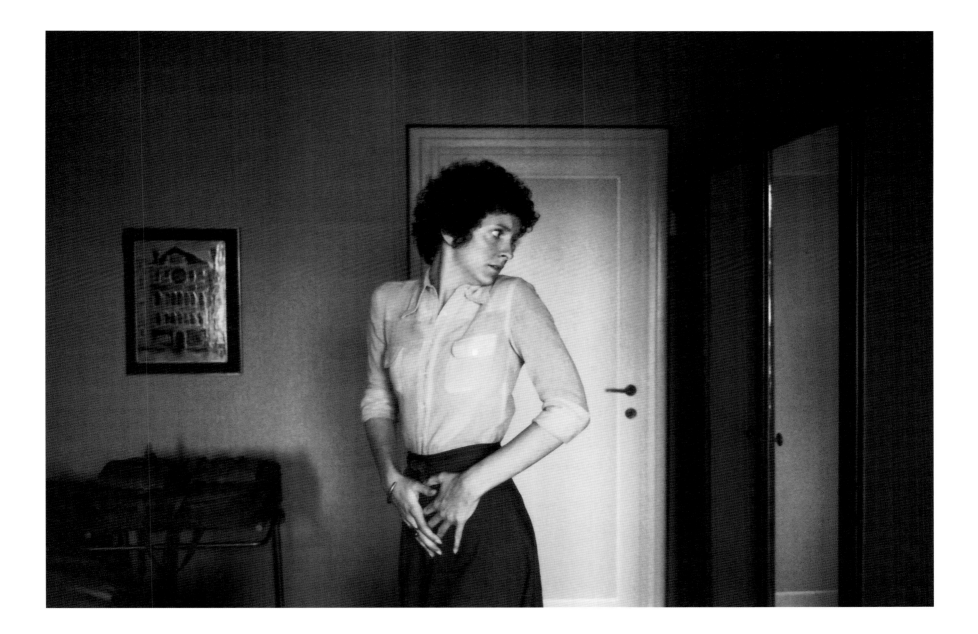

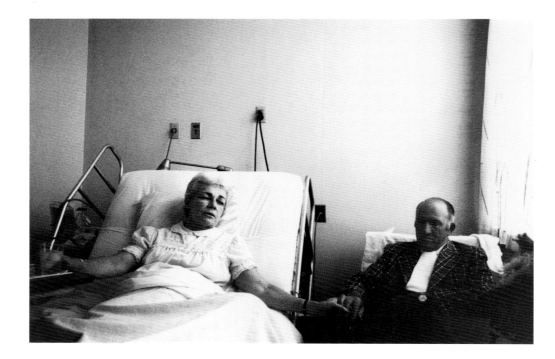

Flower Hospital, 1975, and Garden Park Drive, both Sylvania, Ohio

I was injured, but in Ohio my mother was slowly dying. She had emphysema, which was only referred to as asthma in our house.

She was an esteemed teacher of Latin and French and the strongest-willed person I've known. She just wasn't stronger than the unfiltered Luckies she smoked in bed every night while grading papers.

She died coming in the back door of our house where I'm standing to take a photograph of the yard. I see now how small the yard is. It never seemed small when she was alive. It was here that she planted and harvested, canned, mended and hung the clothes to dry. On long summer evenings she sat in the yard at a treadle sewing machine and made rag rugs for the whole house.

It's always been easy to explain my father's influence: He taught me photography. Strength to live the life comes from my mother.

Garden Park Drive, Sylvania Ohio, 1976

My dad lived alone when Mother was in the hospital, and after she died in 1981 he didn't move or remarry.

He wasn't unhappy living alone and I wondered about that. Perhaps it was a return to his happy boyhood where he had been mostly alone, just he and his mother on their little farm in Kentucky.

So one time in the darkroom—where you could bring up such subjects—I asked him, "When was the happiest time of your life?" After a long silence he said, "I guess when your mother and I were courting."

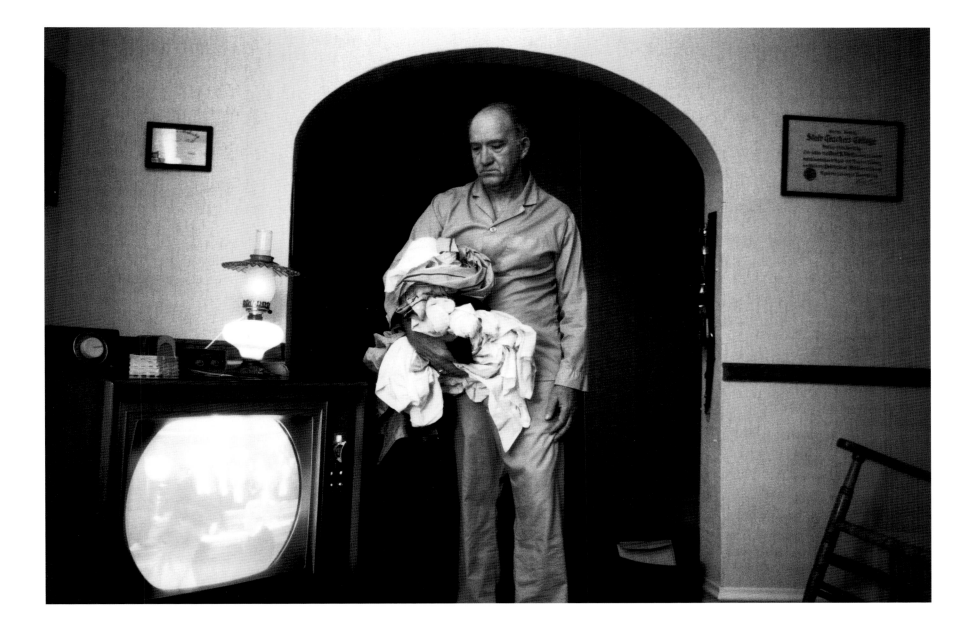

Noatak River, Alaska, 1976

The assignment that restored my health and photography was a fourteen month book project done with writer Ron Fisher (in the stern of the canoe in this double portrait) on canoeing in America.

I made sacrifices to get this assignment because I felt there was an aesthetic connection between canoeing and photography. They seemed modest and personal in the same way to me.

I did my truest work on this assignment. For that reason, and others, it is the one I think of most often. Within the assignment the three-week trip down the Noatak was my favorite.

When I mentioned this to Ron recently he said, " Are you misremembering that trip? We ran out of coffee, then food. You lost your cameras in a capsizing. We fired that unspeakable guide and ended up alone at night on the Arctic Ocean."

All true. And all subsumed, then and now, by what Ron himself wrote: "I've never been in a place where the sense of vastness and solitude was so overwhelming, so humbling. Often the only sound was the beating of our own hearts."

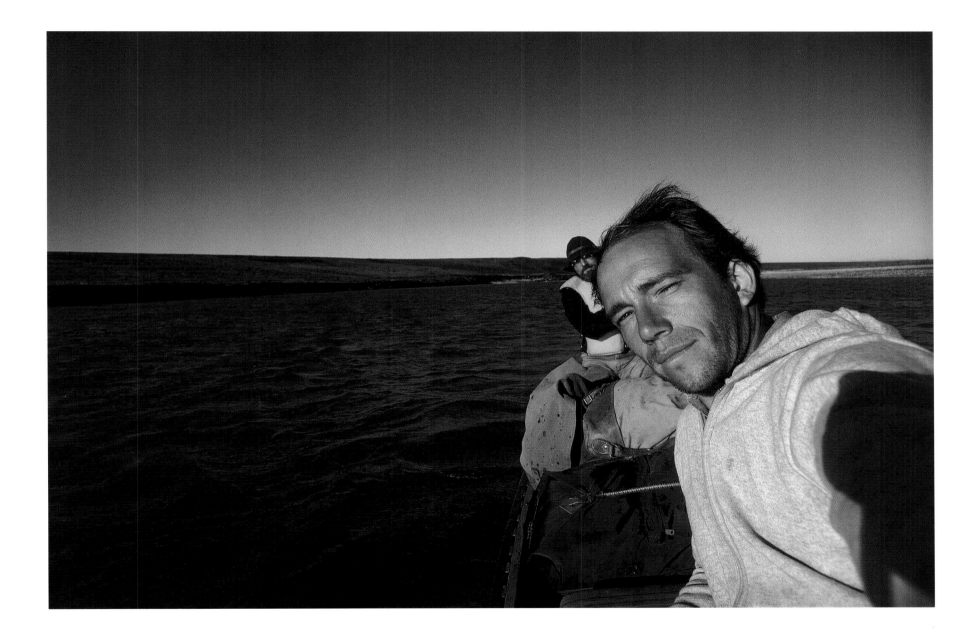

```
SAM ADELL

MAILGRAM SERVICE CENTER                 western union  Mailgram
MIDDLETOWN, VA. 22645

THIS MAILGRAM IS A CONFIRMATION COPY OF THE FOLLOWING MESSAGE:

 7035496080 TDMT ALEXANDRIA VA 12 12-16 0503P EST
PMS LYLE AND JULIA MYERS, DLR
2701 NORTH HANCOCK
COLORADO SPRINGS CO 80907
MARRIED TODAY IN ALEXANDRIA VIRGINIA ALL MERRY CHRISTMAS AND ALL OUR
LOVE
   DENISE AND SAM

17:03 EST
```

Mauna Loa, Hawaii, June, 1977

There was a lot of time to think on the long canoeing trips of 1975-76 and the person I thought of most was Denise Myers. Two years had passed since our meeting and we had lost touch with one another. I found her again in Vermillion, South Dakota and we arranged to meet in Ohio where I was teaching in January 1977. We've been together since then.

Being together meant making decisions. Denise forsook a career and we both forsook becoming parents. There was a design to the decisions. We wanted one life not two, and for twenty years we have traveled together living out the life we imagined.

When I made the picture of her on the summit of Mauna Loa I was down with altitude sickness; Denise was on top of the world.

Six months later we eloped to the same courthouse in Alexandria, Virginia where my parents were secretly married forty years earlier. They had kept their secret for two years. We kept ours for two hours.

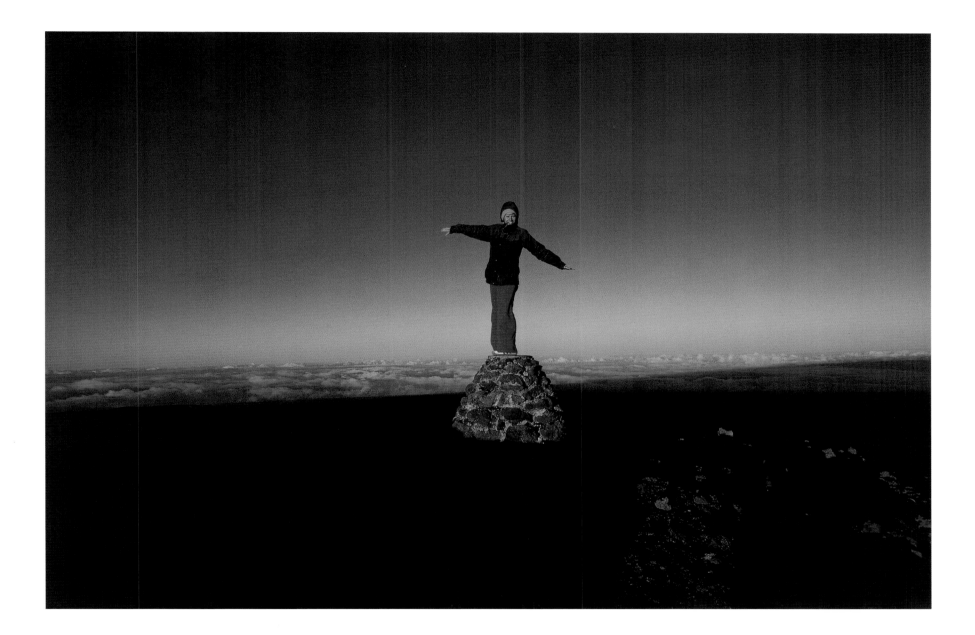

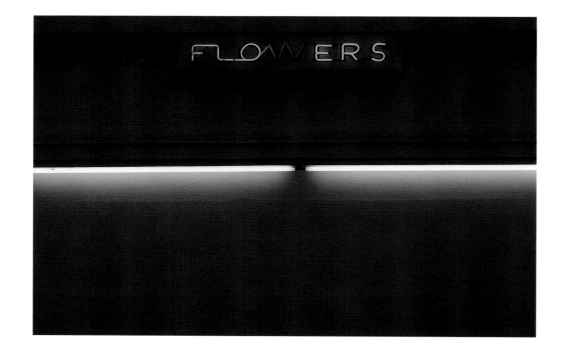

Sudbury, Ontario, 1978 and Moscow, Russia, 1983

Denise and I moved from the city to the countryside of central Virginia in 1978. One of our ideas was to build a life around a garden. But twenty years of work and travel together made that impossible.

I compensated by photographing found gardens. In 2000, these pictures were collected in the book *Seeing Gardens*, the text for which concludes: "These were gardens of the passing moment. But seeing them made me stop and take their picture. Photography, to me, is an act of appreciation. By taking my time I extended to these small gardens my thoughts. Often we are far from the garden of our dreams, but nearby may be a reminder of it., waiting to be seen."

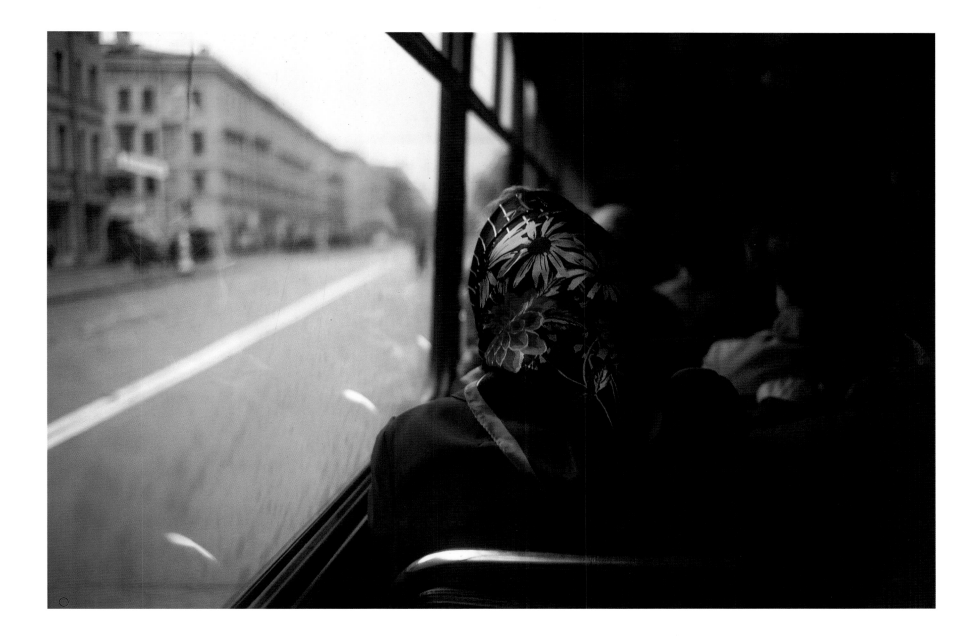

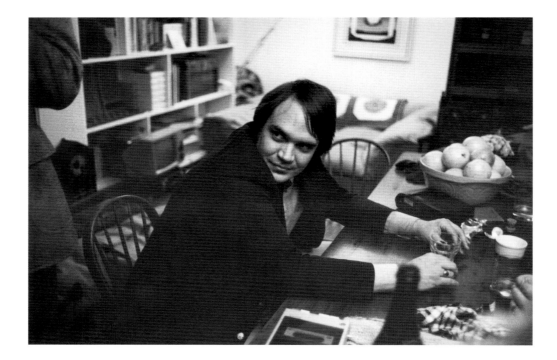

Washington, D.C., January 1976 and Moscow, June 1983

I woke up this morning thinking about Gordon Gahan. He was the most urbane and accomplished of the young photographers at National Geographic and he was supposed to be here in Moscow instead of me. In 1982 he successfully proposed a story on the life of Leo Tolstoy but the editor hadn't given him the assignment. So he quit to become a studio photographer in New York City.

In 1983 I inherited his assignment and this day was in the hotel where Gordon once stayed. He had photographed from this very room. With him in mind I made a Polaroid of the pears in the window and put it in an envelope with a note saying I'd try to live up to his standards on the story. I know Gordon received the letter, his girlfriend told me.

But I never saw him again. He died that year in a helicopter accident in the Carribbean while photographing sailboats for Pan Am.

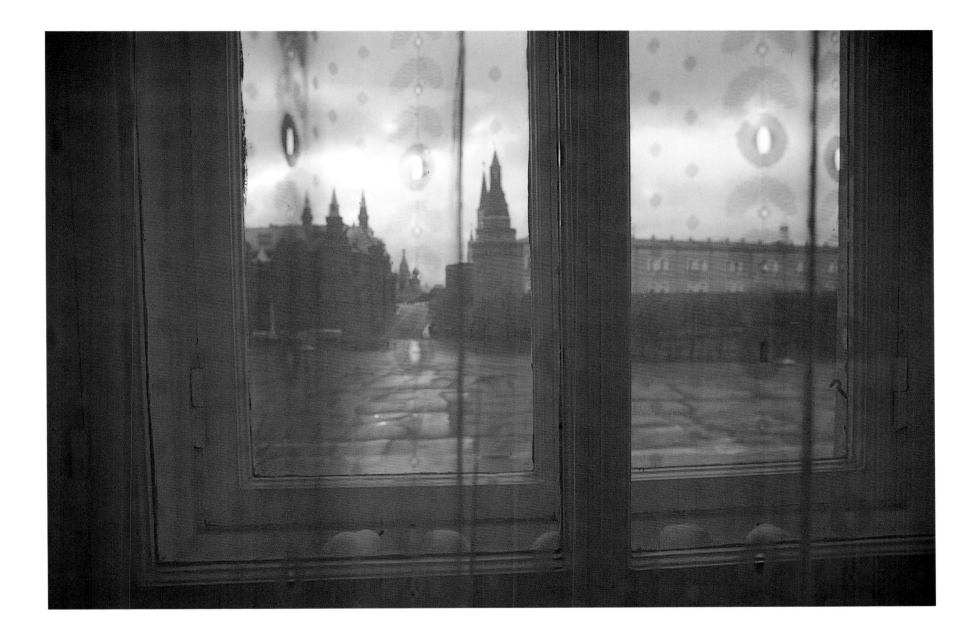

Chamberlain Ranch, Mussellshell River, Montana, 1984

Photographic biographies, of which I've done seven, require me to find photographs in the present that are relevant to the past. It means looking. It also means overlooking.

This biography was on the life and times of Charlie Russell, the cowboy artist of Montana, whose beloved work idealized a way of life that barely existed when he was alive at the turn of the century. Russell wanted to realize in his work a west that wasn't there. We had that in common.

But there was a point when I stopped overlooking what the west was becoming, and this is a picture of that moment.

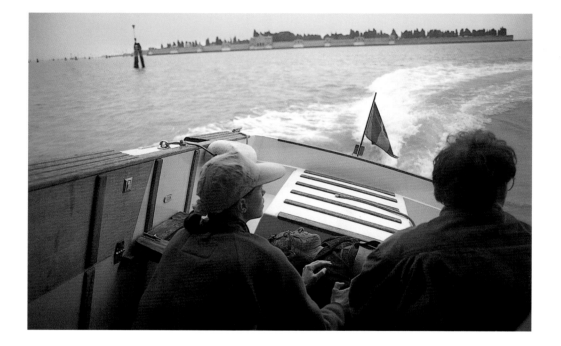

Venice, 1994

The old fisherman was wailing "E morte! E morte!" and frantically waving for us to stop. We pulled over to his dory and saw why. The dark and bloody body of another fisherman was in the bottom of the boat with the fish.

Just moments before, their dory had been sideswiped by a hit-and-run speedboat. When the old man swerved and struck a piling his friend catapulted from the boat and hit the piling head first. We pulled his heavy body into our boat and sped back toward Venice.

En route to the hospital the fisherman flickered back to life for a moment. As we accelerated past the Island of the Dead I took a fast photograph. Maybe the old man would survive.

It was not to be. Three days later we attended his funeral. It was a stormy day with gusts of wind so strong the flower bearers struggled to stay on their feet.

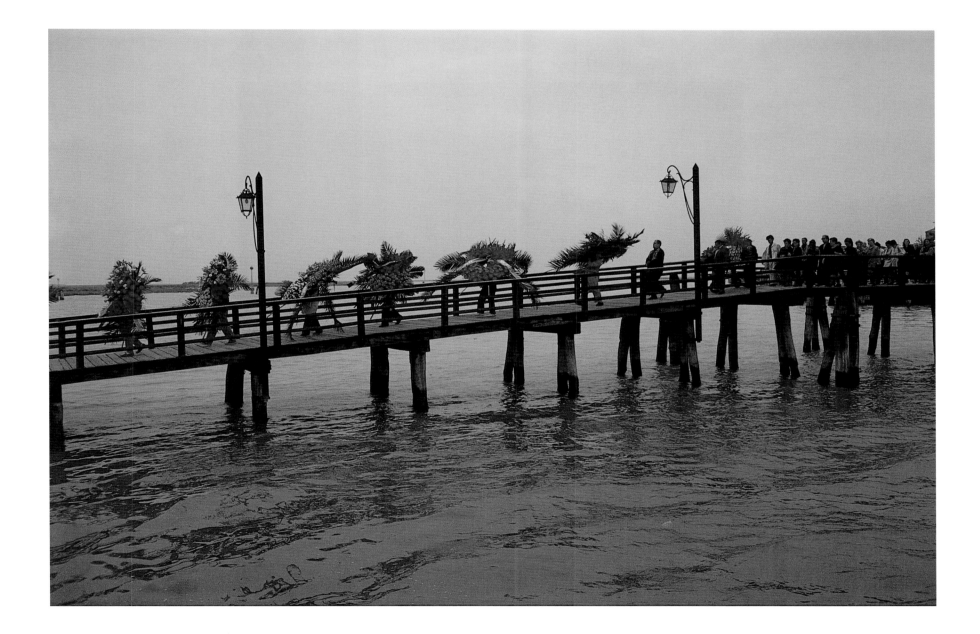

The Kimberley, Western Australia, 1990 and 1992

From 1989 to 1995 I spent as much time as I could in the north of Australia. It is an austere and almost empty land, but offered me the most important, though illusory, ingredient for my imagination: I felt as though I were the first photographer there.

The emblem of the Kimberley is the boab tree. It only grows there. My friend Mike Osborn found this one for me to photograph. The boab was so old it had turned white. When my picture of it was published Mike returned to re-photograph the tree with my published tree beneath it. He intended to surprise me with the gift of his photograph. But the surprise for both of us was that the tree, after 900 years, had been struck by lightning.

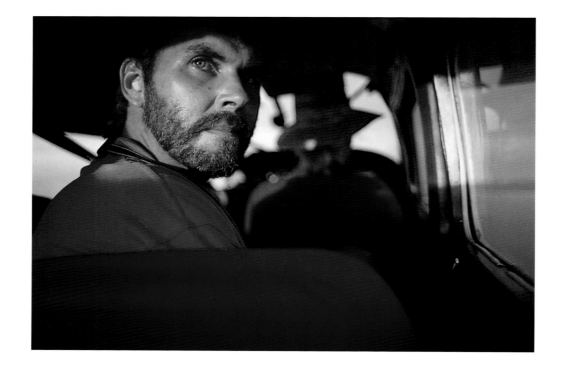

Timor Sea, Australia, 1995 and 1990

I took these photographs to settle myself and also because I thought they might be the last pictures I made and I wanted to feel that. For weeks Mike Osborn and I had been looking for a cyclone to photograph. We finally chartered a plane and found one far out at sea. I told the young pilot to stay on the edge of the storm but we were suddenly overtaken by it. It seemed we couldn't survive. But we did.

Mike and I made a grateful vow: never again would we allow photography to push us to the edge. We allowed it five years later. On a four-hour flight between Kununurra and Darwin I got over involved with photography. When I looked up we were facing a boiling electric storm blocking our path to Darwin one hour away. We had to punch through the black wall but our pilot was afraid.

So were we. I made a portrait of Mike as we sickeningly flew along the edge of the storm, postponing the inevitable punch through.

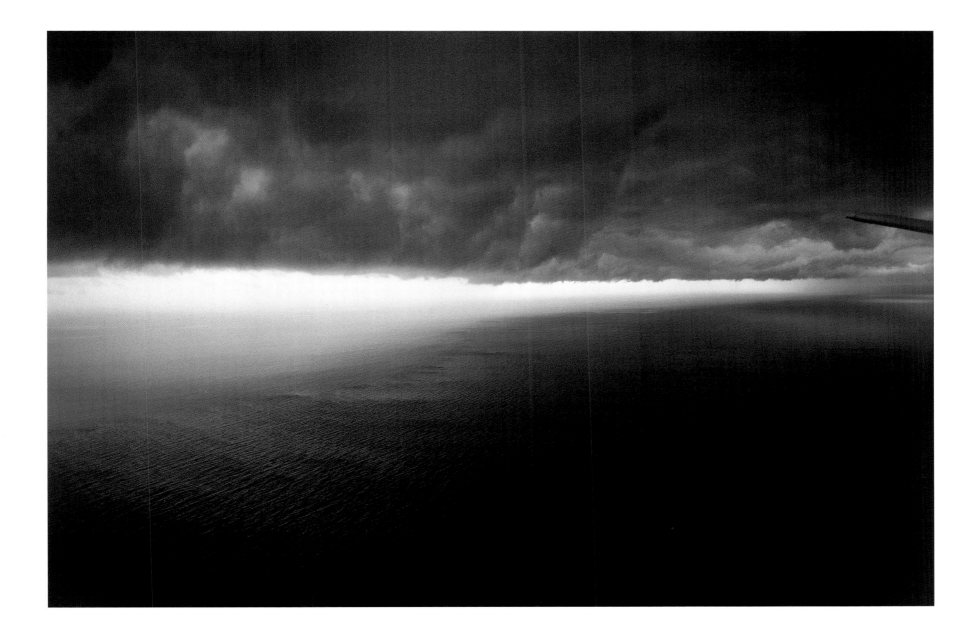

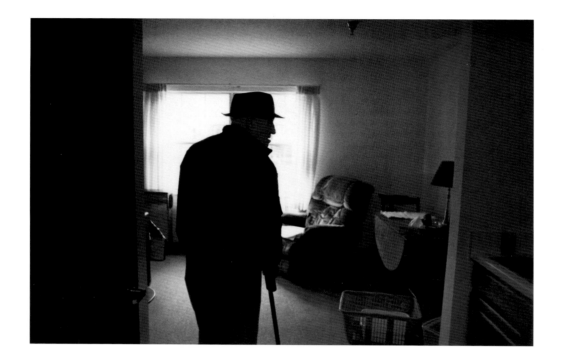

Sylvania, Ohio, November, 1998 and Millington, Virginia, October, 1998

In 1998 my brother and I moved our father from his house to a nursing home. I photographed my father seeing his new room for the first time. That same autumn Denise was given a grave diagnosis. She is shown taking her first walk at our house after surgery.

Nearly four years have passed. Denise has improved; my father has declined. In time he was moved to Texas to be near my brother and his family who continue to care for him.

Eventually there was little left of my father's memory but the distant past. He no longer knew us. Once, when my father and I were alone, I tried to connect with him. I sang, "Oh the sun shines bright…" and after a moment he sang, "…on my old Kentucky home."

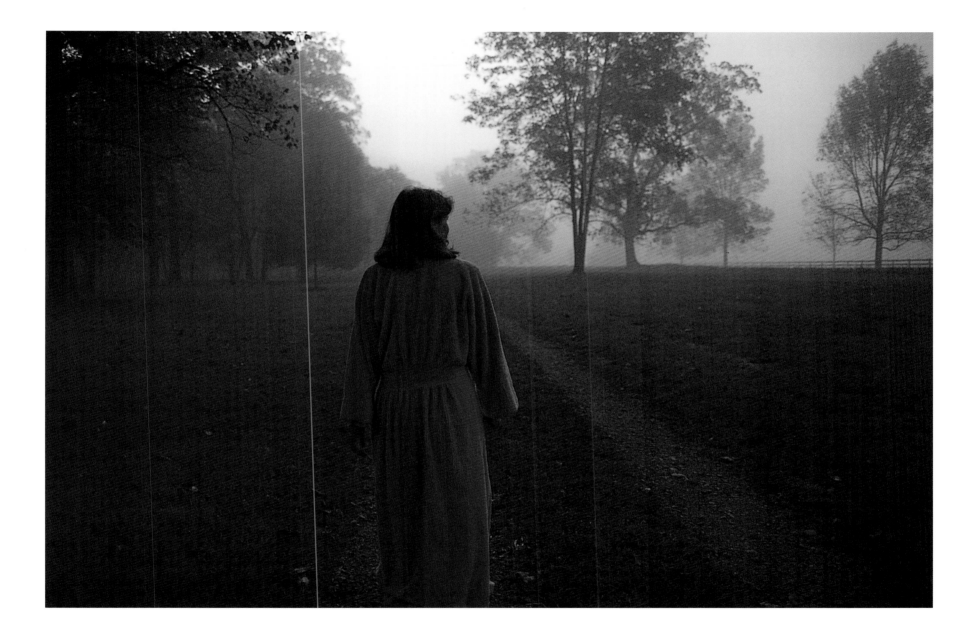

Tokyo, Japan, May, 2000 and November, 1999

　After 1998 I took on only one assignment, my last for National Geographic magazine. It was to photograph life within the Japanese Imperial Palace. The writer was Robert Poole, executive editor of the magazine.

　It was the hardest work of our careers. We had no access. During our third month, officials allowed us to enter the main Palace on two conditions: one, it must be empty, and two, no photographs. When Bob requested an interview with the Emperor, officials smiled.

　On our last day we showed slides to Makoto Watanabe, Grand Chamberlain to the Emperor, whose office was the former bedroom of Emperor Hirohito. My only portrait of the current Emperor concerned Watanabe. It was a grainy, big-brother image on a giant TV screen. "Can you come back in three weeks?" he said, "The Emperor is planting a tree in Kyushu. I think I can get you access."

Planting ceremony, you must choose only one among seven spots. However, number 1
can move to number 2 after Emperor's arriving. Number 6 can move to number 5
when leaving. Number 3 can move to numver 7 when leaving. Number 6 can shoot the
direction drawn in the map, but cannot shoot Emperor and Empress's profiles from
their sides. Where do you choose, Sam?

Kyushu, Japan, June, 2000

The detailed email from Kaori Fujita, our Tokyo colleague, meant I had a decision to make. But did it matter where I stood? The real message of the email was: you're not going to photograph the Emperor, at least not in any meaningful way.

Nevertheless Mr. Poole and I flew back to Japan out of respect for the effort Watanabe-san and Kaori had made on our behalf. Even if the tree planting ceremony didn't work out perhaps something else would.

The ceremony was even less than I imagined. A blazing sun and the Emperor under a canopy a hundred yards away. I toed the line with dozens of other photo-dogs and got harangued by an official with a bullhorn.

Tokyo, Japan, June, 2000

On our last day in Japan, Grand Chamberlain Watanabe arranged for me to photograph, from a distance, the Emperor, Empress and Princess while they stood on a path in a remote section of the Imperial Palace and birdwatched. My picture captures the subtle deference everyone, even his family, pays the Emperor. Otherwise it was an ordinary situation and soon finished. The Emperor's entourage moved down the path and I began to swallow my disappointment. The year of working and waiting to photograph the Emperor was over.

As I packed my camera a Chamberlain approached and led me to the path where the Emperor had been. He told me to proceed alone down the path. As I walked, the Emperor separated himself from his family and stepped toward me. We met in the middle of the path.

I gathered myself to bow but the Emperor extended his hand to me and said in soft but sure English, "Mr. Sam Abell, how do you do? Is everything alright?" The humility in his voice erased the year of disappointments. I took his hand and shook it. "Yes, Your Majesty, everything is fine. Thank you."

Sussex, England, December 31, 1932 and New York City, November 29, 1990

 I suppose everyone has a moment in their lives they wish could 'stay'. This would be mine. I'm with my dad at an opening of my work at the International Center of Photography in Manhattan. My dad is the guest of honor. I've asked him to stand. The applause makes him emotional and to keep from crying myself I grip his shoulder, smile and look down. We are a long way from our tiny darkroom in Sylvania, Ohio.

 The title Stay This Moment is drawn from a diary entry of Virginia Woolf on New Years Eve 1932. In assured, swift script she writes, "If one does not lie back and sum up and say to the moment, this very moment, stay you are so fair, what will be one's gain, dying? No: stay, this moment. No one ever says that enough."

 But photographers say it when they make a heartfelt photograph, as this one by my friend David Alan Harvey proves.

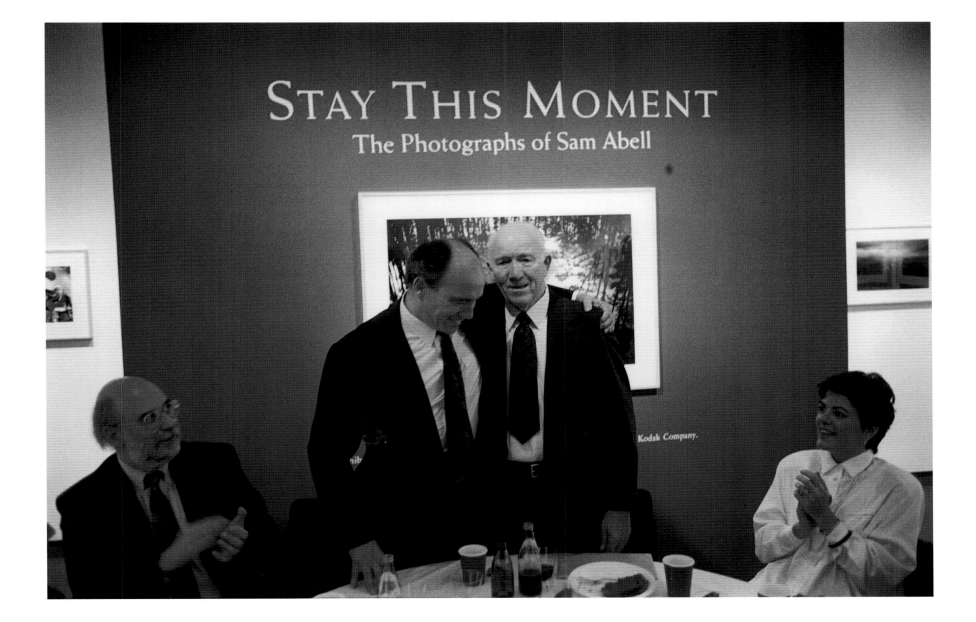

SEEKING THE PICTURE

When I imagined photography what I saw were photographs. If I imagined the process of photography at all it was pleasantly. But the reality of fieldwork woke me from that reverie. Seeking the picture is the complex process that dominates documentary photography, and in the seeking there is often a story. The story varies. At its best it is magical; at its worst it is bitterly frustrating —you see the picture, but can't get to it.

That was the situation on the most important picture of my first magazine assignment in Newfoundland. The traditional maritime way of life was coming to an end and the government was relocating many of the small isolated outports. There were tales of entire fishing villages being tugged by barges along the coast in summer, but I never saw any dwellings being moved despite an all out effort. So I reluctantly gave up on this picture possibility.

Months later I was flying to Little Bay Islands. It was a scheduled, full flight in a plane outfitted with skiis. As we approached the island I saw two distinct lines of men pulling a house across the ice. I immediately saw the picture I had been seeking: It was a concentrated composition of men, the house and the ice—nothing else. I had to have it.

I bolted into the cockpit and shouted for the pilots to help me. They were startled but heard me out. Over the roar of the engines I yelled that we needed to go back and fly low over the ice—or could they land and let me out? The pilots shrugged and, to the amazement of the other passengers, began turning the heavy plane around. They flew back and made a slow circle over the scene. But too much time had passed. The strong lines of men had broken up. And we were still too high. Back at my seat I pressed a camera against the weathered glass and took a photograph anyway. For thirty years I never looked at it. It was too painful.

But now I find it curiously interesting in its inclusiveness. It reminds me of the beginning of a lifetime of seeking the picture.

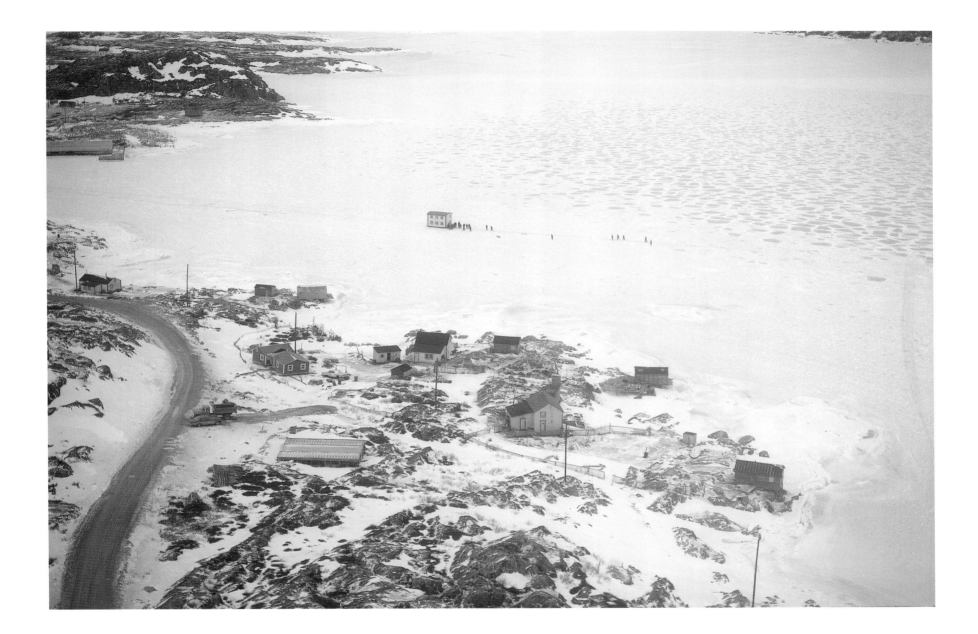

Brigus South, Newfoundland, 1970

 These four frames are from the seventeenth roll of film from my first extended assignment. Handling situations was something I was learning, and on this morning I felt in the way of the fishermen. The routine of the men, father and son, was based upon a close rhythm of work. There was no place in it for a photographer. But I worked as intently as they, and this, at least, they understood. We were both seeking something.

 I was after a layered photograph that gave equal emphasis to both men. The composition was resolved when the son turned toward me and, simultaneously, a swell lifted his father's dory briefly above the horizon.

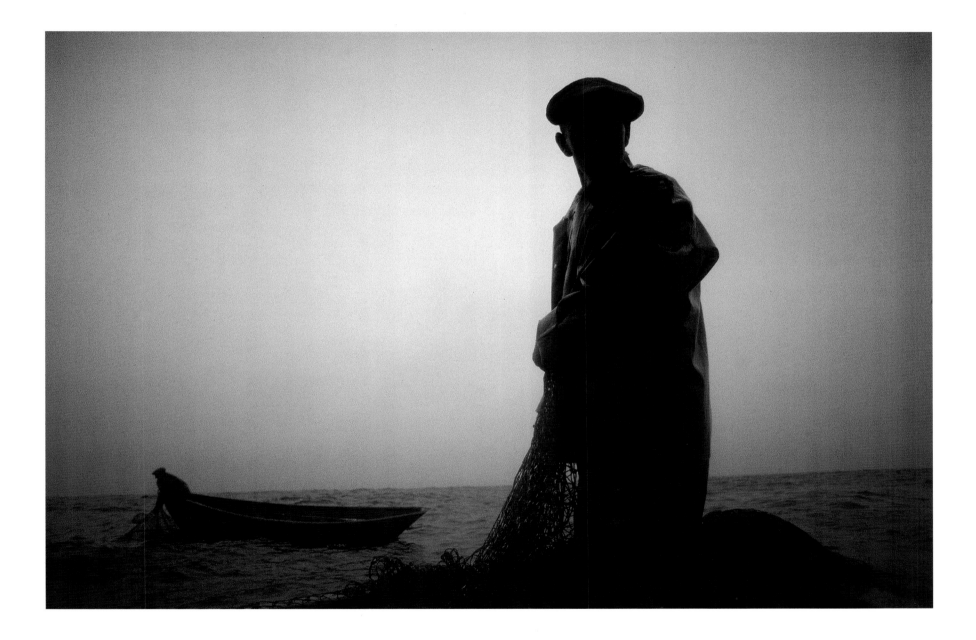

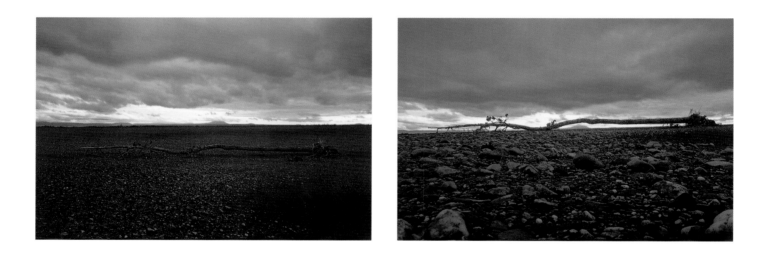

Noatak River, Alaska, 1976

Halfway through a month long canoe trip in the Arctic I lost my reflex cameras and lenses in a capsizing. I was left with a rangefinder camera, one lens, and a little film. Photography seemed finished. But in the weeks that followed I found my limited equipment caused me to see differently: I became interested in linking picture elements and through that linkage finding a new way to photograph landscapes.

One dull afternoon I came upon a solitary tree left by spring floodwaters on the now-dry river delta. I made three exposures, finally concentrating the composition in such a way that the elements of the photograph were slightly abstracted and the relationships between them transformed.

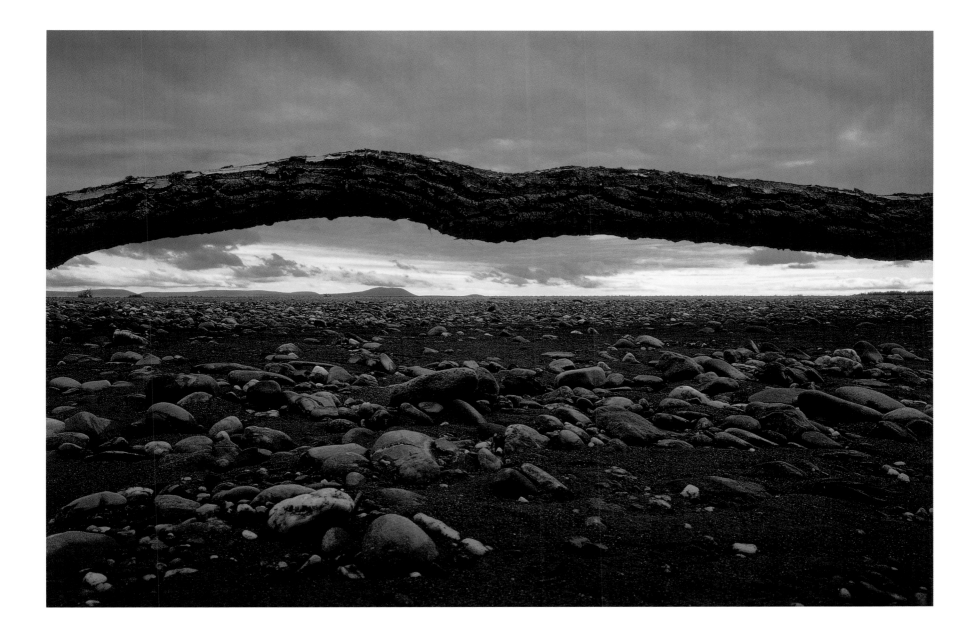

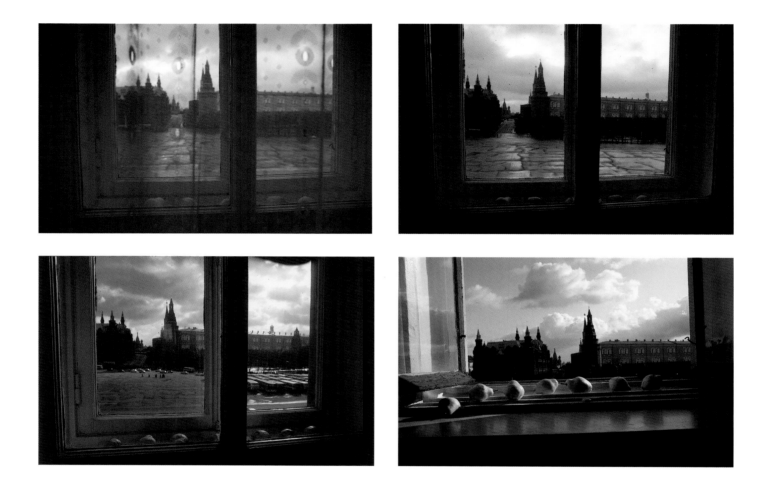

National Hotel, Moscow, 1983

I'd been in Russia for a month working every day on the street with an entourage of interpreters. Finally I took a Sunday off and spent it in my room photographing pears. Arranging them was engaging, but uncharacteristic of my documentary photography. Still, it was careful camera work, and contemplative, and on that day it was what I needed. In the final frame, middle ground is excluded. Then sunlight strikes the pears and the cupola of St. Basil's Cathedral as a breeze lifts the hem of the curtain into the composition and holds it there.

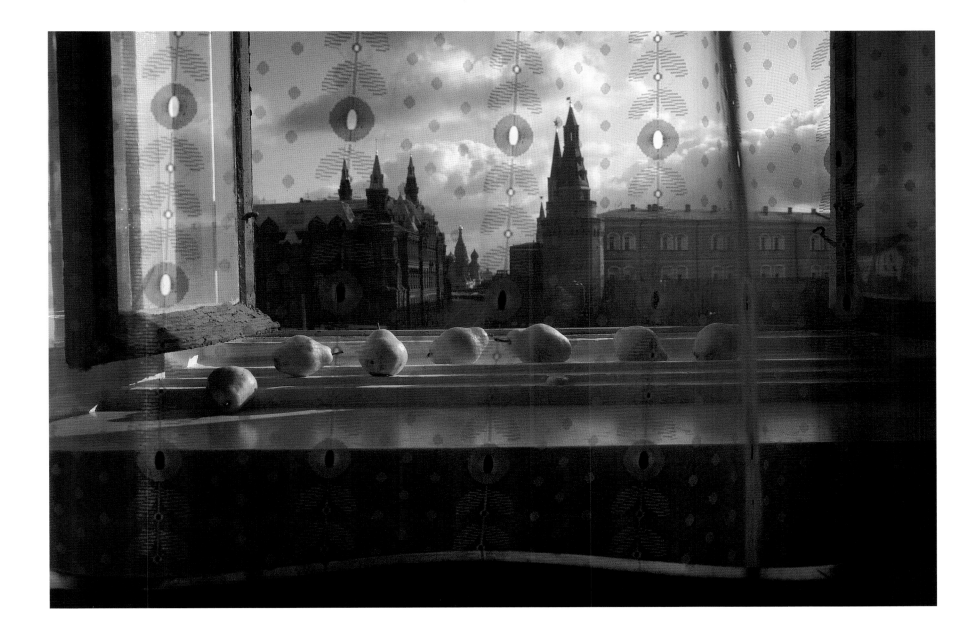

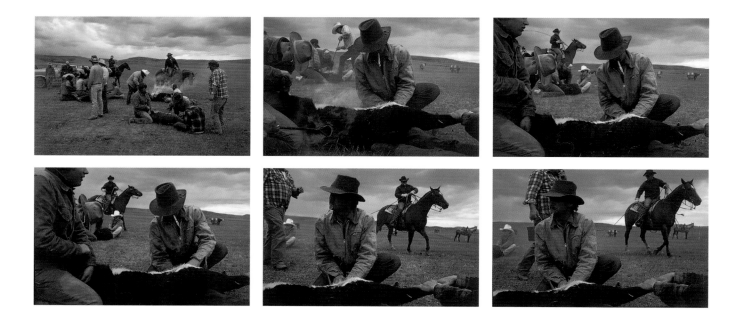

Utica, Montana, May, 1984

 All the elements for the finished photograph are present in the first frame. Of these the most important is the deep background where prairie and sky meet on a clean and graceful horizon. On this foundation the photograph is built.

 I concentrated the composition on one cowboy and the action around him. I was after a layered picture and thought circumstances were best for this when, in frame two, the calf was branded. But layering depends on separation of elements and that didn't exist at the top of the frame.

 Without moving, I turned my attention to the horse and rider and swung the composition rightward as they moved off. A man approached from the left carrying a bucket, spoiling the exit of the rider. I recomposed on the cowboy and made the final frame as, simultaneously, a new tableau of cowboys appeared in the distance and the bucket swung to the edge of the frame.

 My colleagues like this picture for its complexity but I want something more in it. I want the branding iron.

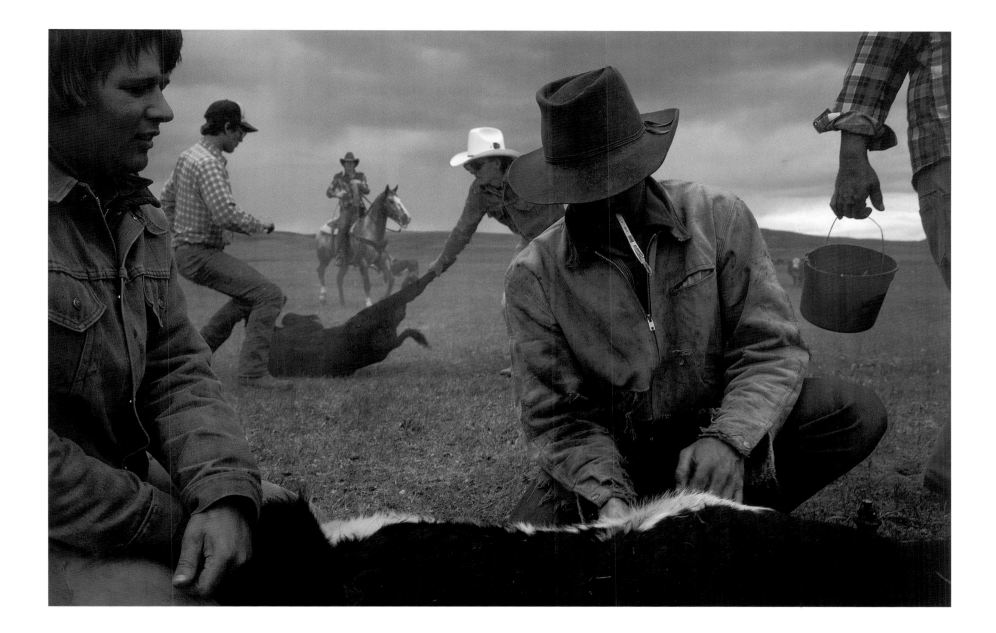

Dingle Bay, Ireland, 1993

I'd been mugged and robbed in Dublin. I left the city and drove diagonally across Ireland to the Dingle Peninsula and holed up in an inn while it rained for a week. One day the innkeeper offered an outing on his sailboat to see Fungi, the wild dolphin who lives in the harbor. He said Fungi and his dog had "a relationship." I saw no future in this outing. Seasickness possibly, but no pictures.

For awhile, things went as I expected: nothing. Then, abruptly, Fungi shot straight out of the water high over our heads, looking down for the dog. Pandemonium. The barking dog went for the railing. The innkeeper shouted, "Grab the dog!" The cook collared the dog before it jumped. Fungi disappeared.

I got serious, and built a composition in three layers: the dog in the foreground, the hills in the distance, and the middle empty. Then I awaited the dolphin.

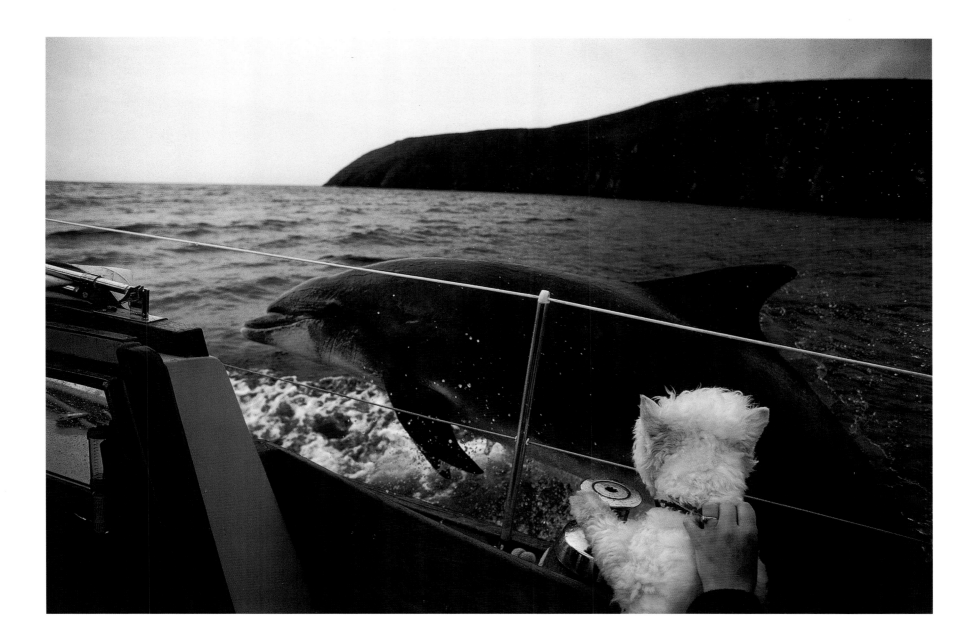

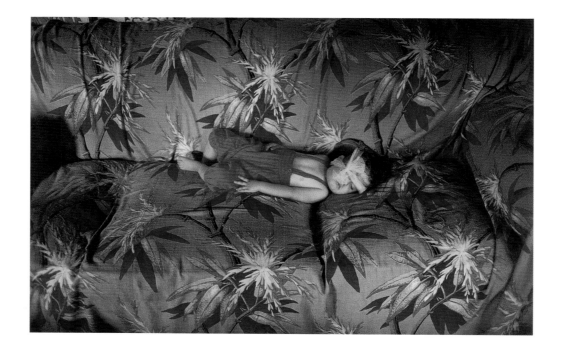

Seattle, Washington, 1991

 While friends prepared for an outdoor party the guest of honor, a baby girl named Azzurra, was put down to sleep on the sofa. The party went on without her. Sometime later I passed through the living room and saw her sleeping.

 The photograph of Azzura was straightforward but I devoted a roll of film to refining the composition anyway. The film reveals that I began with a contained composition, attempted to expand the space, then returned to the original composition at the end.

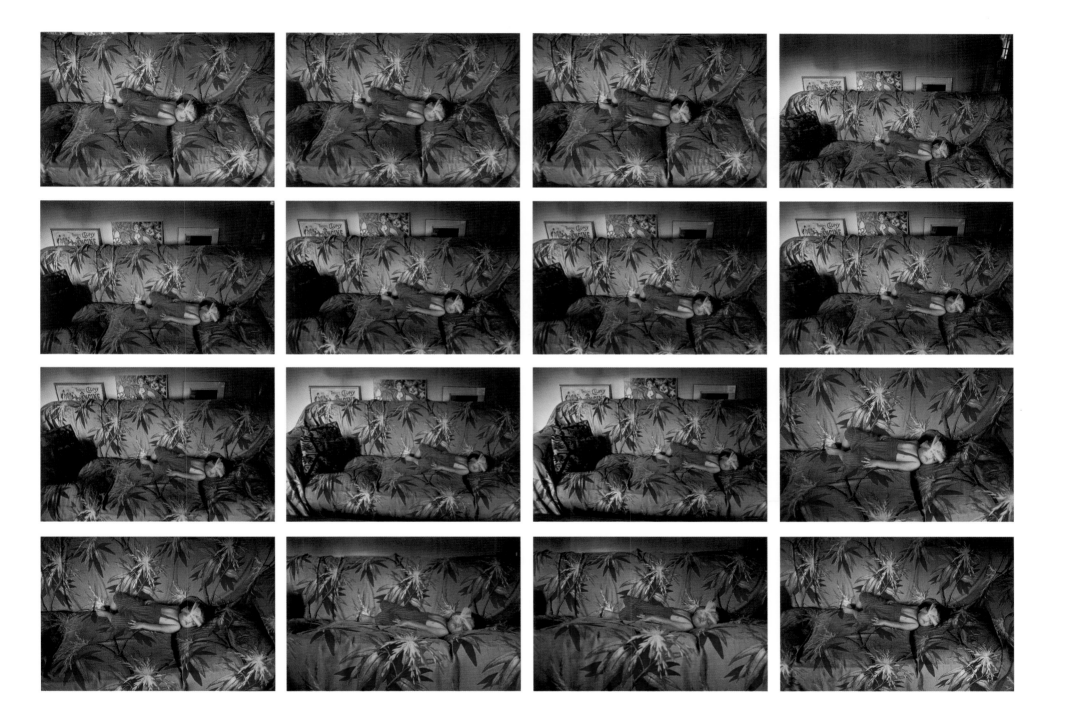

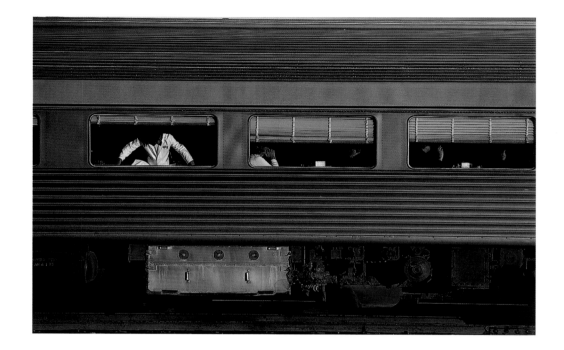

Thunder Bay, Ontario, 1977

 I forced myself out of the hotel room when I saw a storm sweeping over the city. I followed it toward the grain elevators where I was stopped by a railroad crossing gate. The gleaming eastbound trans-Canada train was coming through.

 As it approached the crossing, a porter began pushing down the steps. I jumped out of my car and made a single fast photograph. Then I followed the train to the station and set up on a tripod to make some slower photographs. I watched the hands of the diners move as they talked and smoked and shielded their eyes from the sun. A waiter unfolded a fresh tablecloth and spread it.

 A moment later the sun set, dulling the scene as the train left the station. I watched it depart, drained by the excitement of how everything had come together and then had disappeared.

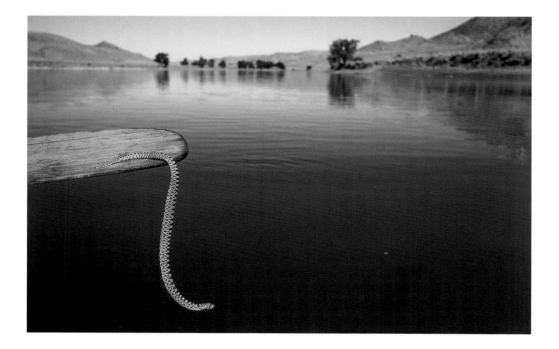

Missouri River, Montana, 1976

We encountered a water snake attempting to swim across the river and my cousin Craig gathered it onto his canoe paddle. My first instinct was to photograph the snake and paddle in such a way that they linked to the landscape of the river and countryside. I then concentrated the composition on the snake and paddle only, exposing in such a way that the color and texture of the river darkened and disappeared.

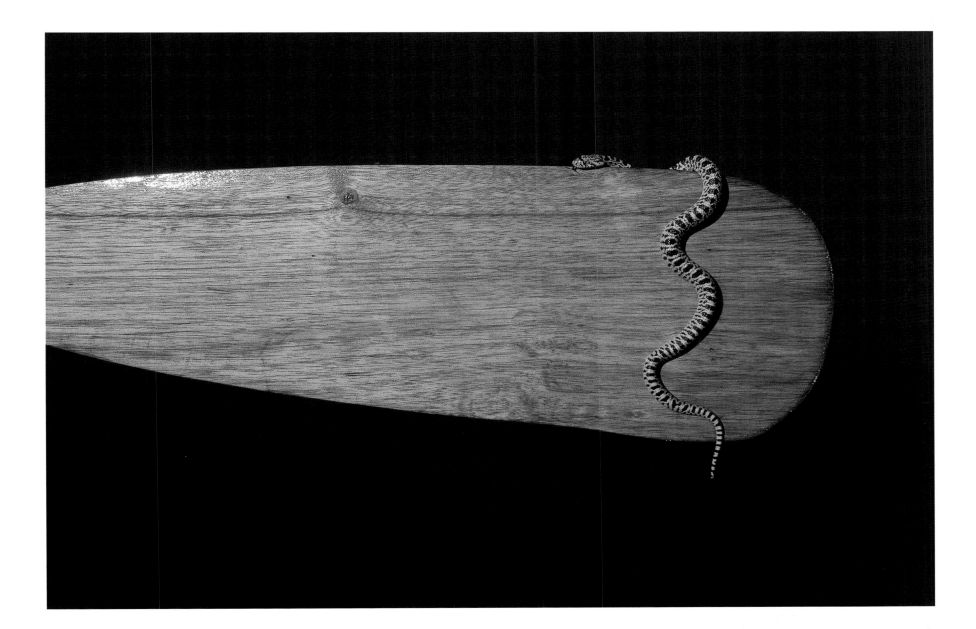

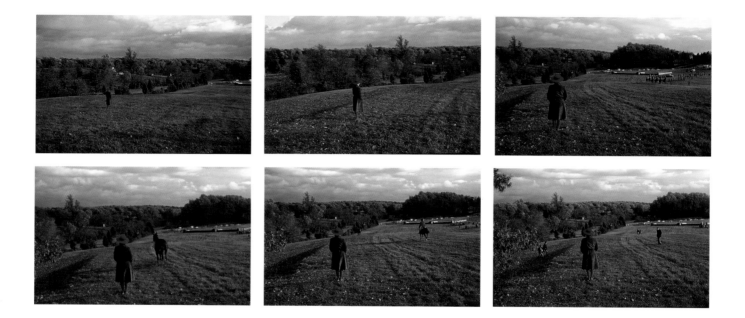

Montpelier, Virginia, 1985

 At a steeplechase race I saw the striking figure of a woman standing alone in the distance. I made a photograph, then approached, made another and took a position behind her. I wanted a photograph that expressed both the woman and what she was watching. It would be a photograph about looking.

 As we now both waited, and watched, the racehorses came past. Then unexpectedly, from behind, a riderless runaway horse galloped past and was pursued by a red-coated rider.

 Finally other spectators crossed the course in front of the woman. She never moved.

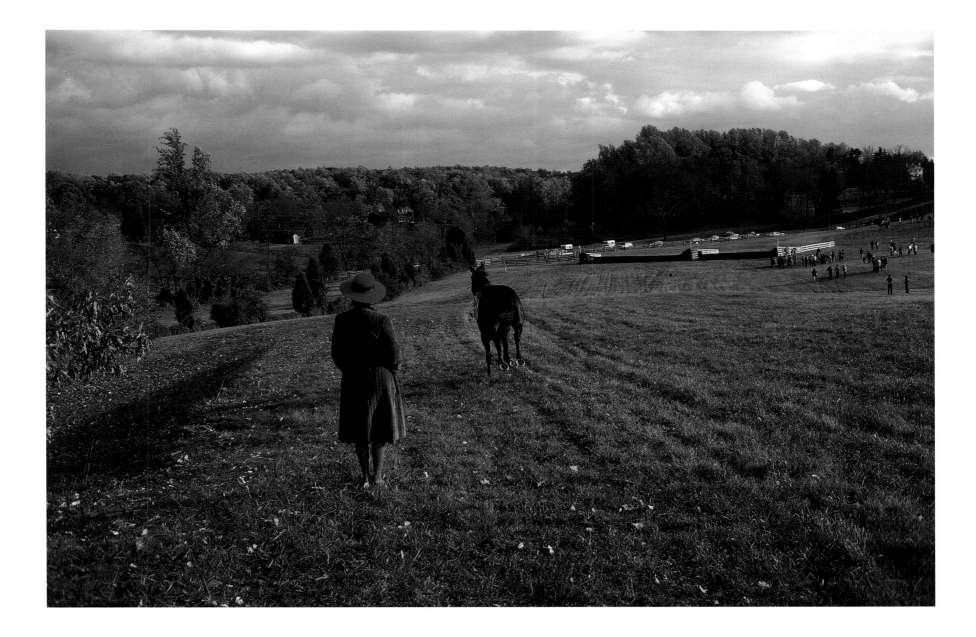

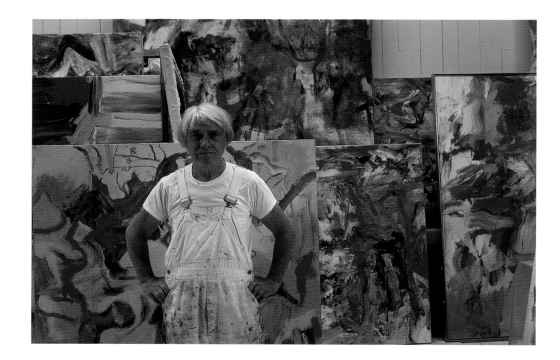

The Springs, Long Island, New York, 1978

 I visited the reclusive Dutch-born deKooning briefly and he cordially agreed I could return the following day for a portrait session. I didn't fully trust his memory so left a large reminder note behind on his breakfast table.

 The next morning I knocked on his kitchen door. He was inside, near the note, but didn't hear me. I knocked again. Finally he came to the door carrying a basket of hot coffee grounds and bumped the door into me. "Vhat is it! What are you doing here!" Then he saw my cameras. "No! No way! Der's not a focking ting in it for me!" He flung the grounds forcefully into the garden near my feet and slammed the screen door. I so wanted to leave.

 Instead I spoke to deKooning through the screen and pointed to the note. He read it, softened a bit and invited me in. We spent half a day together. I made a portrait of him with his work and also an informal portrait. By some measures he was the most influential artist of our time, but seen apart from his work he just looked comfortable, less like an artist, more like a house painter.

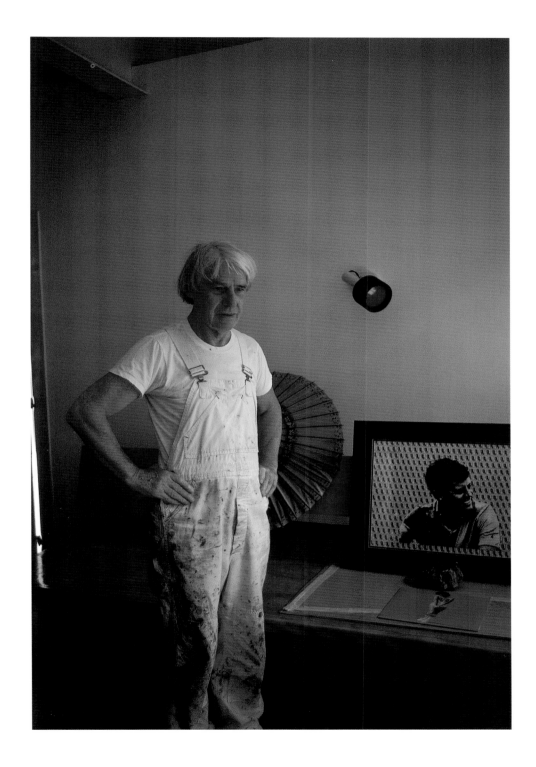

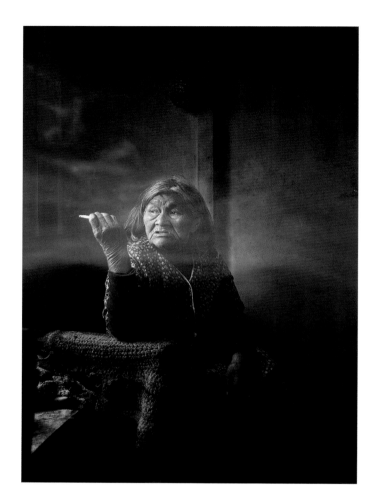

Tierra del Fuego, Chile, 1989

 Rosa was the last full blooded Yahgan Indian in Tierre del Fuego. She lived alone in a one-room hut that seemed to have little potential photographically. In addition to being dim there was a stifling odor that made the hut seem smaller still. I set up near the door where there was a current of air and photographed Rosa through tobacco smoke. She had dignity in this setting and the picture was published. But a more complex portrait went unpublished. It shows Rosa's few belongings and her in scale with them.

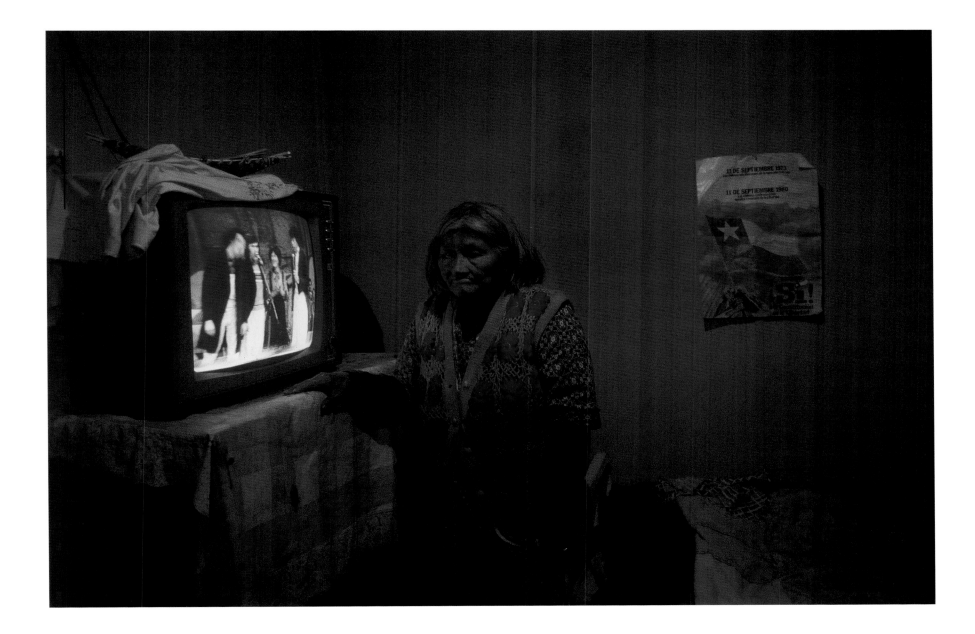

Hagi, Japan, November, 1979

I spent a month in this remote and traditional town on the southwest coast of Honshu. The weeks spent there were among the most productive of my photographic life. I identified with the everyday esthetics of the culture, but more to the point I had no car.

I learned about the town by walking the intricate maze of small streets in the oldest neighborhood. My goal was to select a site that I could return to often. I chose this corner because of its character and also because it was well lit morning and evening.

People living on the street grew used to my presence and weren't uncomfortable about photography. One afternoon two women emerged from a house and slowly walked past me toward the corner. For a moment I followed them, then stepped back out of politeness.

I continued my photography from a distance while they said goodbye to one another in an ancient and affectionate way.

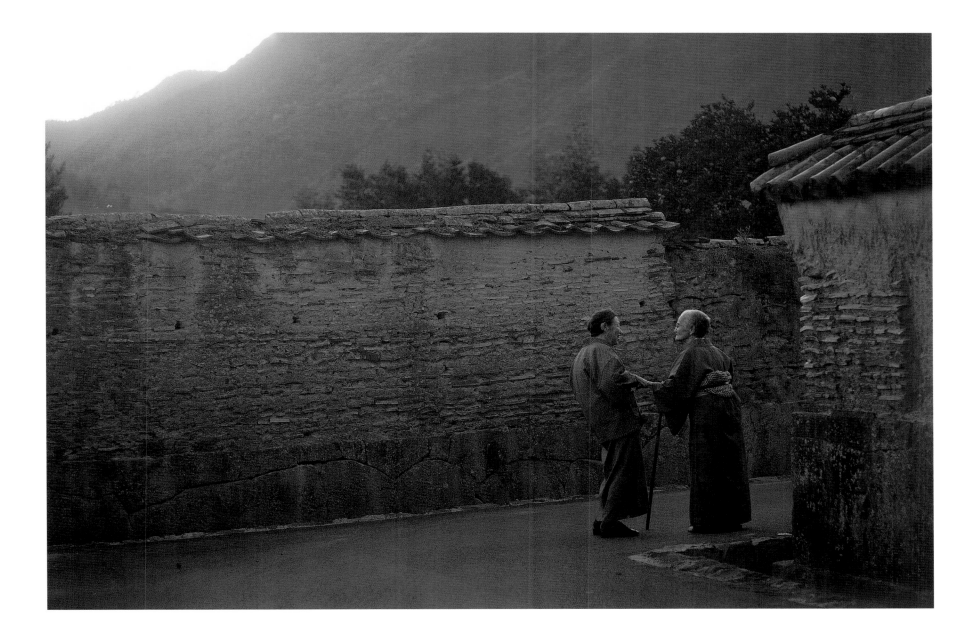

Yorkshire, England, 1990

Charles Dodgson (Lewis Carroll) is the most quoted author in the English language and also one of the most controversial. What clouds his reputation is the closeness of his relationships with the little girls he sought out for companionship and to be the subjects of his photography. Those photographs include a small number of nudes.

Were these figure studies a natural extension of his artistic aspirations? Defenders of Carroll accept his explanation. In a letter to a parent asking for permission he wrote, "If I did not believe I could take such pictures without any lower motive than a pure love of Art, I would not ask it."

Or was Carroll finding in photography yet one more way, a magical and intimate way, to be with his young companions?

For more than a month I debated this with Edward Wakeling, a leading Carroll scholar, as we pursued a photographic biography of the author. Our conversations were inconclusive but I determined to at least find a way to ask the question in the documentary work I was doing.

The opportunity arose after an opera of "Alice in Wonderland." I was backstage making a portrait of the White Rabbit in costume when a half-dressed young actress wandered into the composition, oblivious to me or the picture session.

Her presence transformed the situation, turning it from a straightforward portrait into the layered, question-asking photograph I wanted and believed was necessary in this biography.

In the end the photograph went unpublished which is too bad because, at a minimum, I think it is the picture Charles Dodgson would have found most interesting.

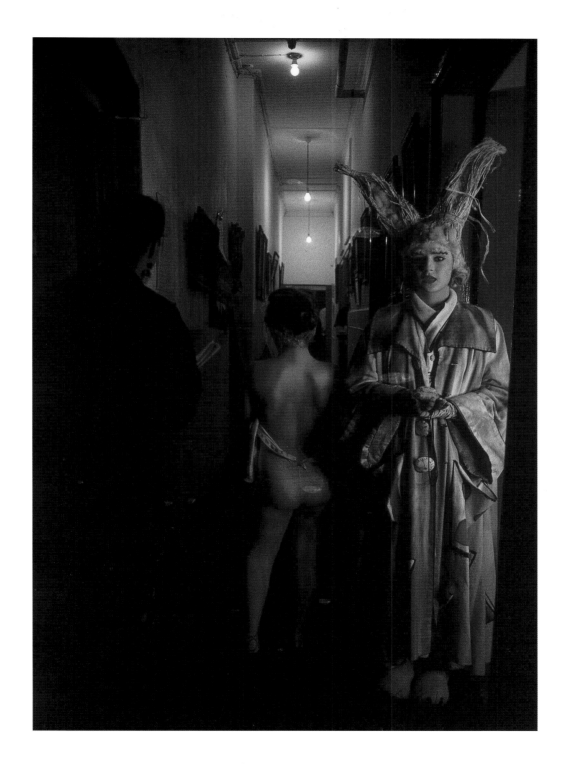

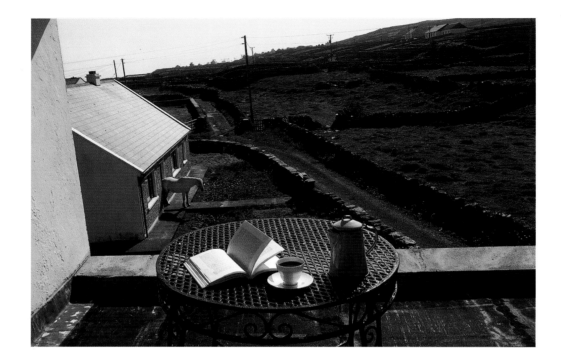

Aran Islands, Ireland, 1993

I saw the sleeping horse from the roof of an inn where I was reading and taking in the rare sunshine. The scene below looked eccentrically interesting so I made a few photographs. When I moved on I forgot about it.

In the night I awoke and climbed out the bedroom window to take in the moonlight. The horse was still there. Moonlight transformed the scene. What had looked eccentric in the afternoon now looked mysterious. I climbed back into the bedroom and in the dark put my camera and tripod together.

The night was still—rarer even than sunshine in the Aran Islands—but during the long exposure the horse's head blurred as it nodded off and on. When I finished photographing, the horse was still standing there, but in the morning it was gone.

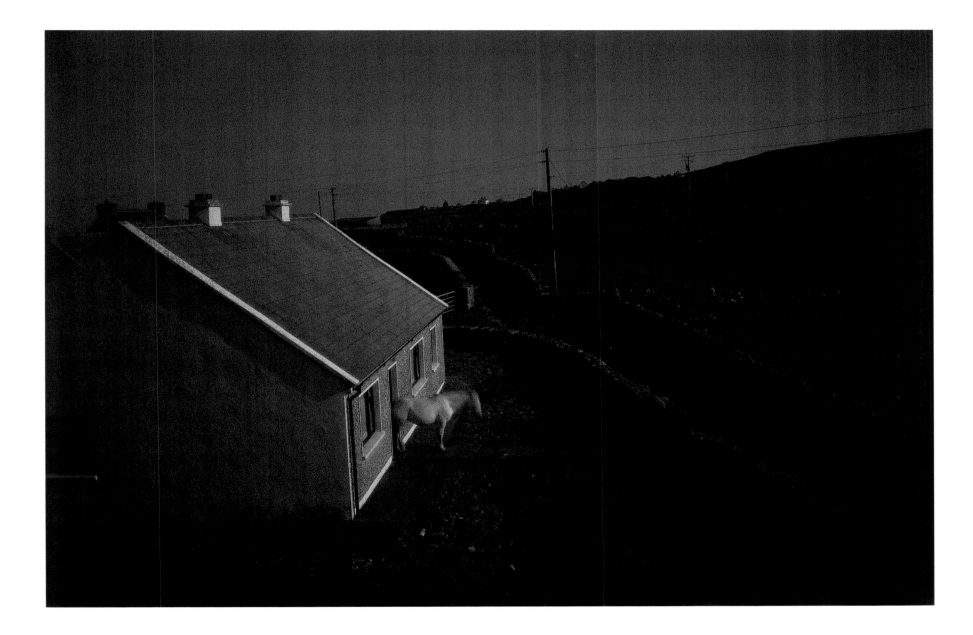

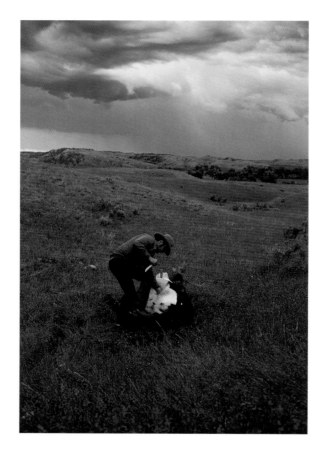

Chamberlain Ranch, Mussellshell River, Montana, 1985

 One overcast afternoon I rode out with two cowboys to photograph them shooting a dry cow for a barbeque. The first bullet glanced off the cow's skull and it bolted. A cowboy pursued, firing from horseback. He needed to drop the cow on dry and level ground, not in the slick ravine where we ended up as a squall approached. Now it was a race against rain. If it began the beast would be impossible to move. The cowboys were thinking 'bad luck'. I was thinking 'good light' and settled in to photograph the butchering.

 Just then the cowboy looked over and barked hard "Buddy drop that damn camera—get over here and help me!"

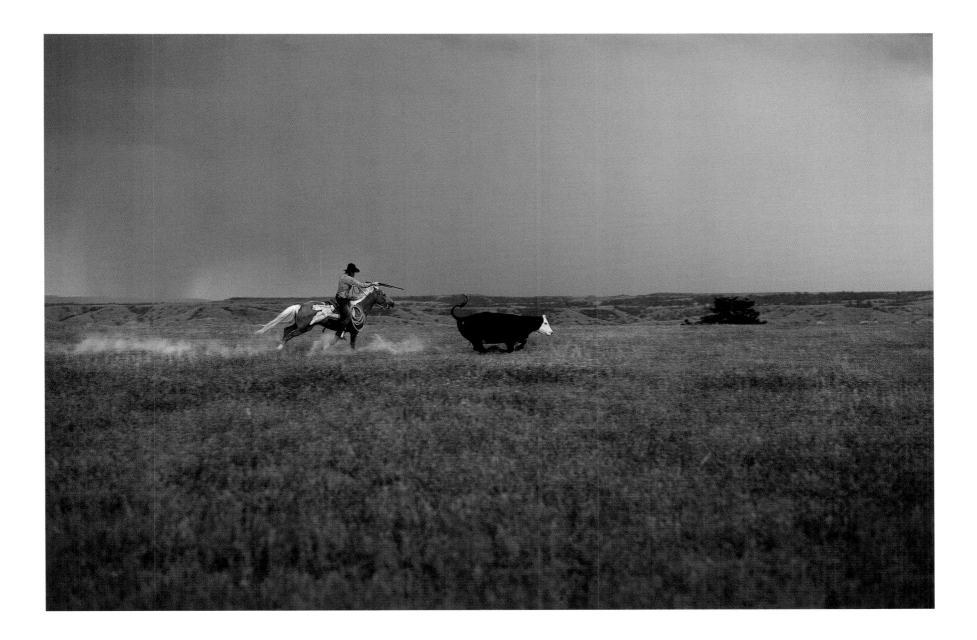

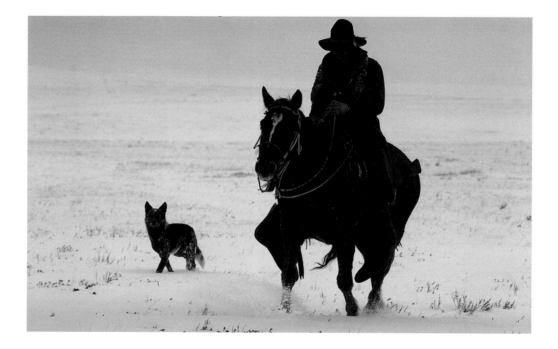

Little Belt Mountains, Montana, 1985

Gerald Mack, the winter keeper for Ken Perry's ranch, wasn't home in the mountains when Ken and I came calling. We found him riding up a long valley. As he approached, head down, I made several photographs of him.

Ken wasn't happy. "That horse is overheating," he said to me. When Gerald dismounted Ken said the same thing to him, but sternly. Gerald kept his head down. So did his horse and dog.

I composed the photograph and waited for Ken to finish. When he did the horse shivered, alerting the dog. Gerald looked up. I made the picture.

A year later, after the picture was published, Gerald wrote me: "Would you send me a print of my photo. It's only fair."

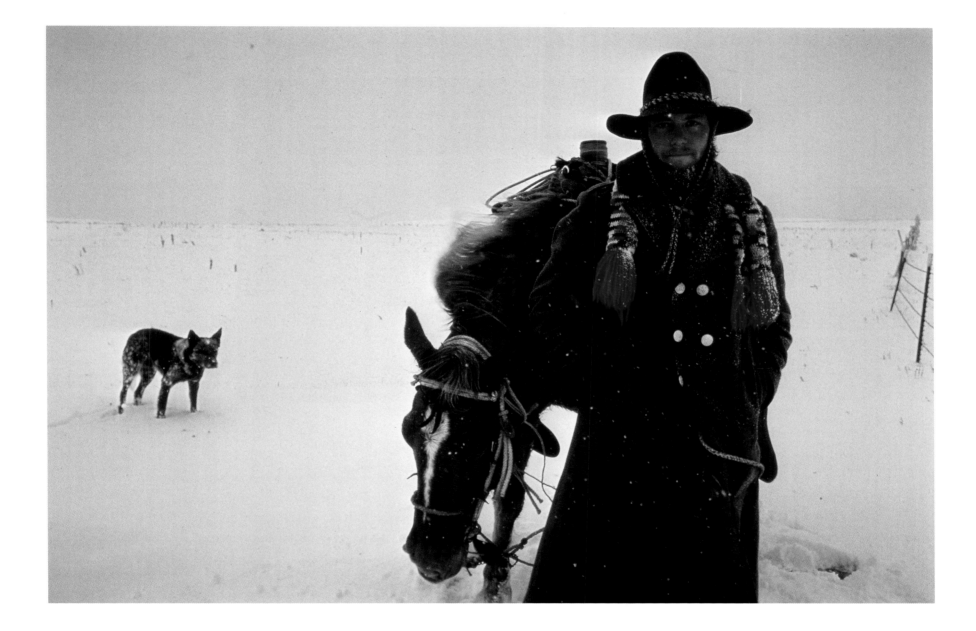

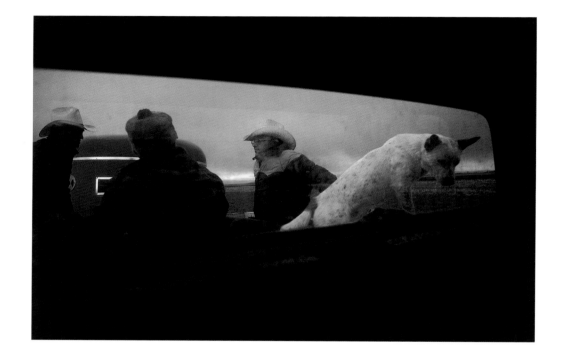

Square Butte, Montana, 1984

The rancher Hugo Turek wanted to move horses to new pasture in the ancient, empty river bed of the Missouri River and invited me to go along. As we bumped along the high plains, I kept seeing the face of a dog pop up in the rear view mirror. I turned to my right but the dog was on my left. A moment later it popped up on my side of the truck. I swung around tightly to make a portrait.

It was like there were two trips being taken—the ranchers' absorbed in their closed conversation about the dry weather, and the dog smelling the rain.

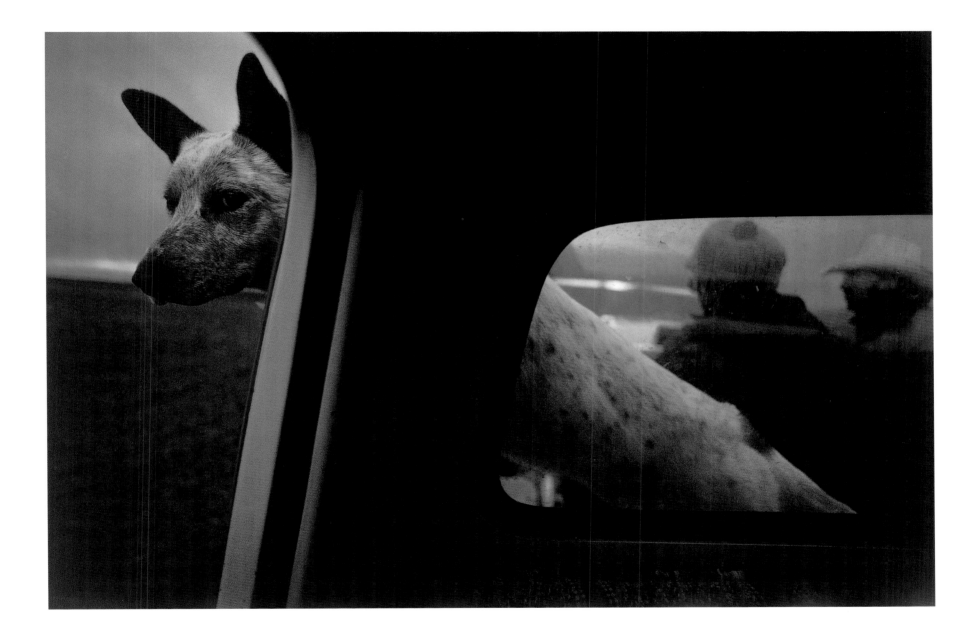

Standoff, Alberta, 1984 and 1985

My year-long search to find bison skulls for the concluding photograph in an essay on the life of Charles M. Russell ended on a dry Canadian prairie. After photographing the skulls in the grass I considered my work finished. But the results were flat and I persuaded my editor, David Arnold, to send me back six months later.

Conditions the afternoon I arrived were harsh and marginal—bitter cold and only moments of light left. As I framed the still life a bull bison unexpectedly strode into the background, animating the picture in a way Russell himself would have appreciated.

Dillon, Montana, 1997

There would be no "seeking the picture" this day. The subject I was seeking—Lewis and Clark's most important campsite, Camp Fortunate—was under the water of a reservoir. It was a typical day on this project. In the two hundred years since Lewis and Clark's epic adventure their campsites, landmarks and the route itself have been flooded, plowed under and destroyed by development. But opening the country for development was what their trip was about in large measure. Still, I often wished I could stand with Lewis and Clark and their patron Thomas Jefferson and say, "Is this what you wanted?"

I was in that mood when I took the photograph of the sign. It features the two pioneers in their famous westward-seeking pose.

Minutes later, still in a mood, I was on the other side of the reservoir looking down on their drowned campsite. When two bikers with beers came to the edge of the overlook I stepped back, composed the scene and waited.

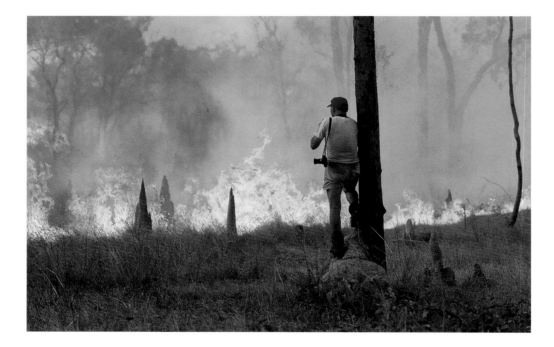

Strathburn Station, Cape York Peninsula, Australia, 1995

From an early age I've made photographs a certain way: compose and wait. The pleasure of working this way goes back to outings with my father and to his easygoing advice on how to see ("Look for strong diagonals"). Working this way means 'seeking the setting' and composing the setting as though it were the subject, then waiting for the actual subject to appear and finish the photograph.

Kerry Trapnell's photograph catches me near the end of this process. I'd been stopped by the arrangement of termite towers and dry grass and took a position slightly above the scene. Using different lenses on separate cameras I made two predetermined compositions, then waited.

The sequence of pictures shows the setting being consumed by the subject with such intensity that new content is created. But beneath the flames the transformed landscape is structurally still the same.

In Kerry's picture I'm about to switch cameras and compositions, but just for a moment I'm taking in the scene.

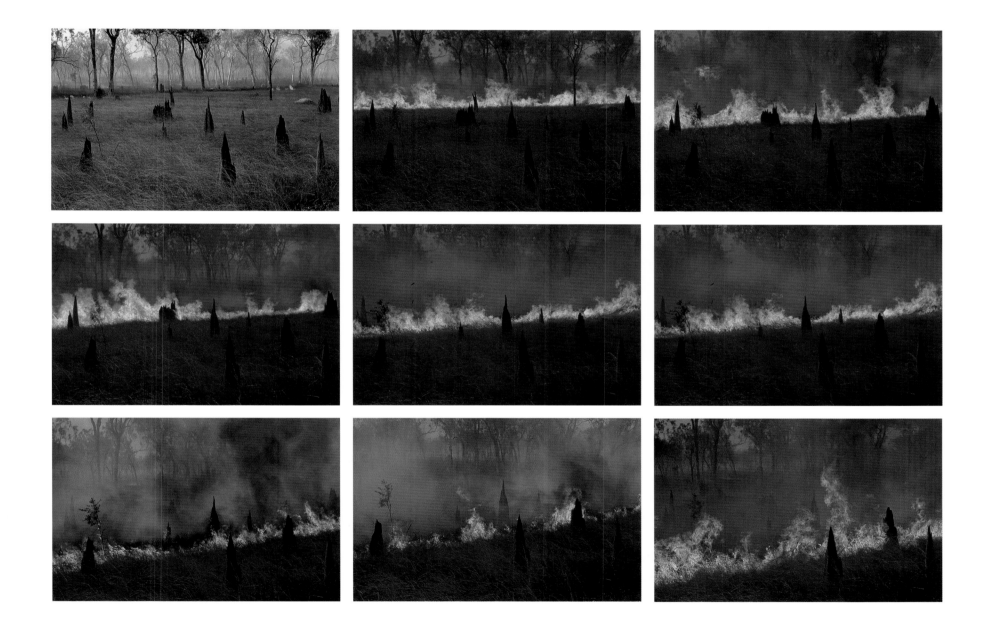

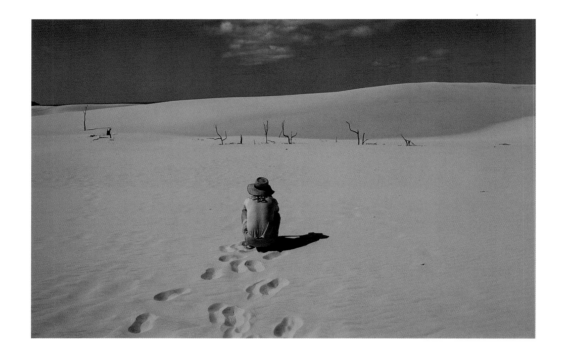

Fraser Island, Queensland, Australia, 1995

The composition of the trees and sand dunes was strong enough to see from a low-flying airplane. But when Kerry Trapnell and I hiked in, a meaningful photograph of the trees proved elusive. We made several trips to the remote location and eventually camped there. We studied and photographed the scene in every condition of light, even moonlight.

Besides the light there was the question of scale. Part of the power of the scene was the relationship of the few trees to the vast dunes. But in the end the composition had to be concentrated and every element articulated. Kerry is seen studying that.

At least the scene was a still life. But moments matter even in the stillest and most studied of landscape compositions.

The problem was resolved not when light fell on the trees, but when it didn't. That happened the moment the sun dropped low enough to cast shadows on the trees, inking them darkly and snapping their shapes sharply against the sand.

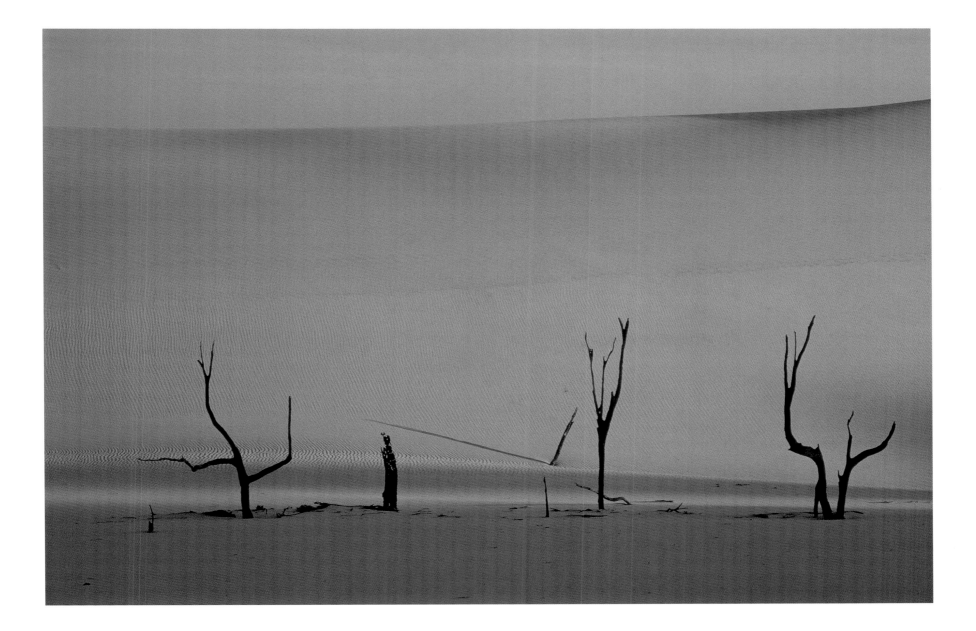

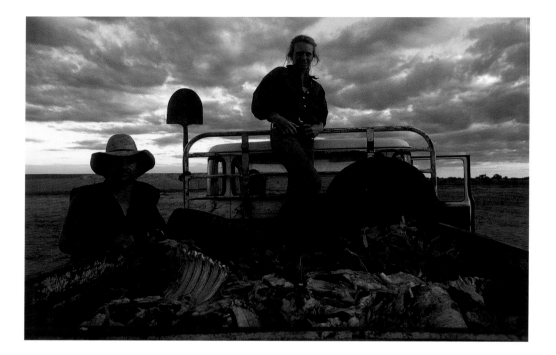

The Kimberley, Western Australia, 1989

"Son, you can photograph anything you want on this cattle station except the girl." I said ok and left.

But now "the girl" was in front of me and I badly wanted to photograph her. My promise not to was now hours, and many miles, behind me. All I needed was a moment of light. But clouds on the western horizon were blocking the sun which would soon set. I photographed despite that believing irrationally that it would cause the sun to shine. It worked. Light struck the scene, I made the photograph and the station manager drove up, all at the same time.

"Son, what'd I tell you about not photographing the girl? Now we've all got a problem." The problem was that she was Canadian, not Australian, and had no work permit. I made another promise; this one I kept. When the picture was published I didn't reveal her name or the name of the station. By then she had returned to Canada. Constant exposure to the sun had given her a rare skin disorder. She'd never again be able to work in Australia.Her mother wrote from Saskatchewan asking for a print as a gift for her daughter. "Working on that ranch was the happiest time of her life."

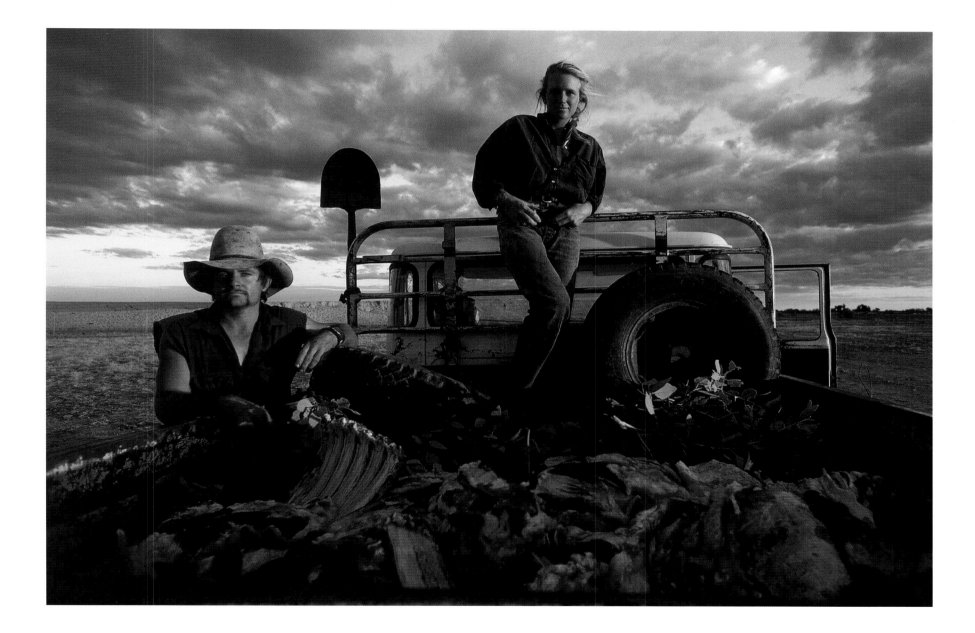

Drysdale River Station, The Kimberley, Western Australia, 1989

The idea is this: Drive a cut down and armored Suzuki through the bush until you see a bull. Accelerate and give chase until the exhausted bull can be knocked over and pinned down by the vehicle. Jump out, tie the bull to a tree, get in the car and repeat. Other than by horseback (page 190-1) it is the only way ranchers can round up free ranging bulls and bring them to market. And since bulls bring the most money it is serious business.

It's also unfair. Or so I thought until one of the pinned bulls slowly rose up and flipped the Suzuki over with me in it.

It was a reckless day and I made the camera mistakes of a month during it. But I also made a photograph. I did so by getting above the scene, seeking a horizon and placing the action on it.

Twenty years earlier I had reacted to a far different but equally tough situation in almost the same way (page 183). The compositions are almost identical, down to the accidental inclusion of my shoe.

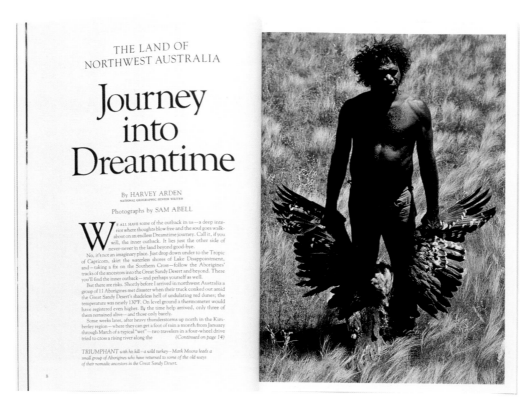

THE LAND OF
NORTHWEST AUSTRALIA

Journey into Dreamtime

By HARVEY ARDEN
NATIONAL GEOGRAPHIC SENIOR WRITER

Photographs by SAM ABELL

W E ALL HAVE some of the outback in us—a deep interior where thoughts blow free and the soul goes walkabout on an endless Dreamtime journey. Call it, if you will, the inner outback. It lies just the other side of never-never in the land beyond good-bye.

No, it's not an imaginary place. Just drop down under to the Tropic of Capricorn, skirt the waterless shores of Lake Disappointment, and—taking a fix on the Southern Cross—follow the Aborigines' tracks of the ancestors into the Great Sandy Desert and beyond. There you'll find the inner outback—and perhaps yourself as well.

But there are risks. Shortly before I arrived in northwest Australia a group of 11 Aborigines met disaster when their truck conked out amid the Great Sandy Desert's shadeless hell of undulating red dunes; the temperature was nearly 130°F. On level ground a thermometer would have registered even higher. By the time help arrived, only three of them remained alive—and those only barely.

Some weeks later, after heavy thunderstorms up north in the Kimberley region—where they can get a foot of rain a month from January through March of a typical "wet"—two travelers in a four-wheel drive tried to cross a rising river along the (Continued on page 14)

TRIUMPHANT with his kill—a wild turkey—Mark Moora leads a small group of Aborigines who have returned to some of the old ways of their nomadic ancestors in the Great Sandy Desert.

Yaga Yaga, Western Australia, 1990

When a photograph is published it gains a life, and also loses one. The life it loses isn't small. Publishing formalizes a photograph and takes it another strong step away from its complex, often chaotic origins in the field.

The episode of photographing aborigines hunting in the Great Sandy Desert began with a discussion the night before. I suggested—for reasons of light—the hunt take place at either dawn or dusk. It took place at noon in crushing heat and light. The hunter Mark Mora killed the bush turkey with a single shot fired from within my truck, then got out and began dismembering the bird. The hunt was over before it began. My mind raced. Was a portrait possible? I asked Mark to pause, looked for a setting and saw the grass. From on top of the truck I made a fast photograph of Mark, using the hard light to semi-silhouette him against the grass.

I then took a photograph of the whole scene to remember where photographs actually come from.

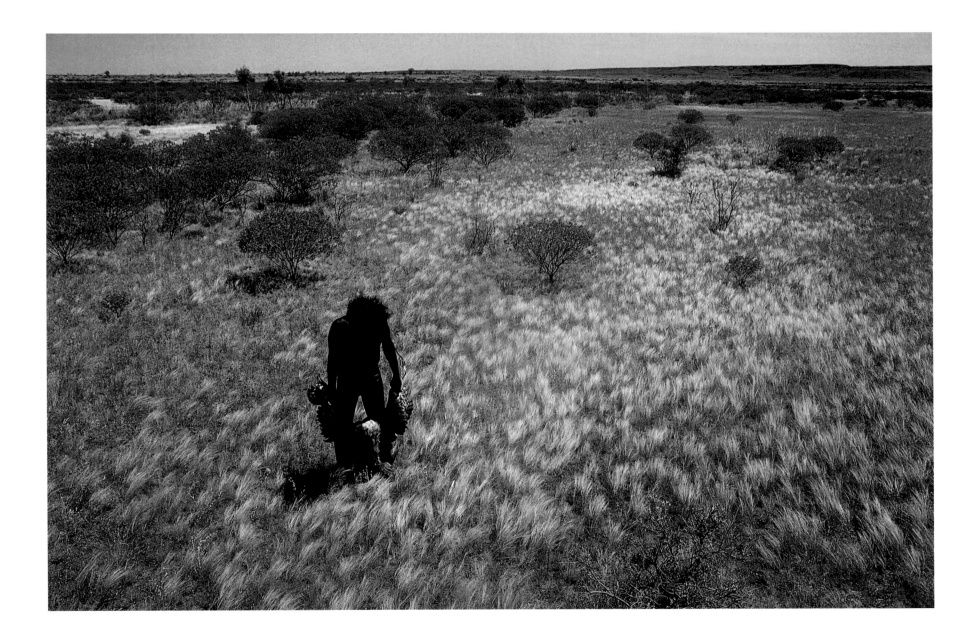

Twenty five years have passed since seeing but not successfully photographing the scene of men hauling a house across the ice in Newfoundland (page 105).

I'm now in a small, chartered airplane over the tropical coast of far north Queensland. There is no door on the plane. Below me is a scene not much different than the one I saw in 1971. Once again I see the picture in my mind. It's of men, their bogged truck, sand and the dazzling sea. Nothing else.

The men are Australian Aborigines who are in peril. The incoming tide will soon flood their bogged truck and they are far from home. With a mixture of excitement for the photograph and misgivings for the men's safety, I swiftly compose and photograph the scene.

While I work, the pilot radios for help. We fly off. An hour later the men and their truck are rescued.

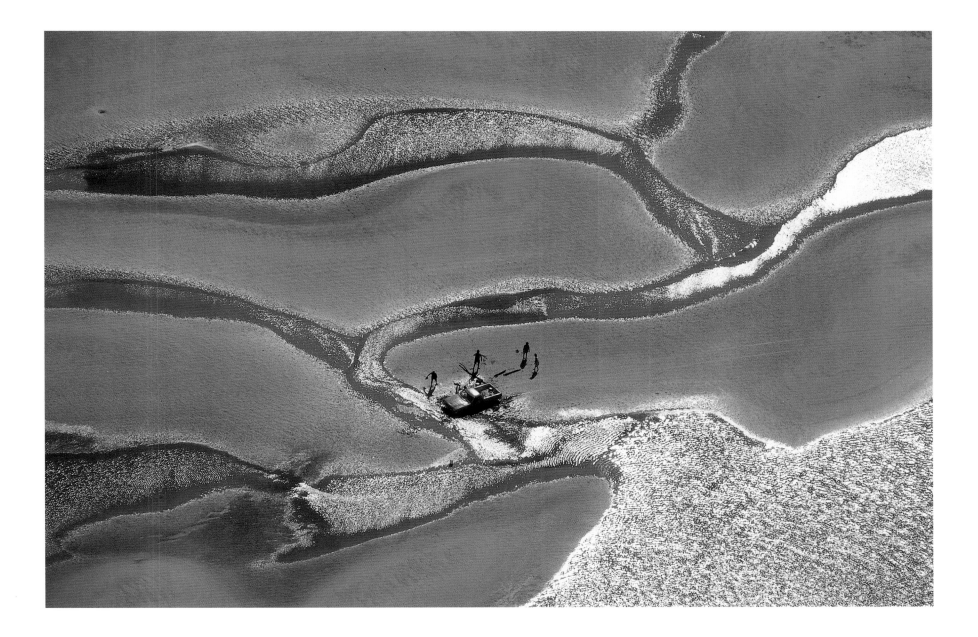

THE PHOTOGRAPHY OF PLACES

Growing up and photographing in Ohio gave me the idea a place could be known by seeing its structure. The structure of Ohio was straightforward and strong. The world was divided by an ever-present level line that split the world equally—above and below, near and far, known and unknown.

When I left Ohio for those unknown places the structure of it stayed with me. A level line is at the center of my seeing and gives to deeply different places a common ground.

But placeness itself varies. Serene Shakertown stands forth from rural Kentucky as much as the Imperial Palace does from downtown Tokyo. They are islands as surely as Newfoundland and Venice are. So too is a cattle station set in the scrub of Australia or a canoe on a lake in Maine.

I had an affinity for these places and took the time to see them. I looked at their structure—the chair rails of Shakertown, the gondolas of Venice, the patterns of ice in the Atlantic and termite towers in Australia, and the inward-curving intimacy of a canoe—because I think form gives identity and character to a place.

One year in Japan I was kept from working freely, as I always have. Restrictions were placed on photographing the Imperial Palace and a portrait of the Emperor was forbidden. At the Imperial tree-planting in Kyushu I was kept far away from him again (page 99). But nearby was an emblem of the Emperor. The bowl-shaped hole and three small mounds of dirt—miniature Mt. Fujis—spoke to me of where I was. I stepped forward from a long line of photographers and made a simple photograph of shape.

The Emperor and I symbolically meet in this photograph. The ceremonial circles signify his presence. The faint, level lines in the grass are my signature.

JAPANESE IMPERIAL PALACE

The Japanese Imperial Palace is in downtown Tokyo and looks like a medieval fort, which it once was. It is guarded by a complex of moats, massive walls and closely watched bridges. It takes about an hour to walk around the outside of the Palace and a common thought during the walk is: I wonder what goes on in there.

Not that much, I thought after my first visit. But after many weeks there I came to another conclusion. The Imperial Palace is the center of traditional Japanese life, a sheltered place where the ancient skills that give the culture its distinctive character are nurtured.

My favorite place in the Palace was the Imperial Archery Pavilion. Something subtle but strong was going on there. On my last visit I asked Tsugihiro Osaki, the master, what the essence of Zen archery was. He said: "Don't aim. Forget the target. Concentrate on form. If form is correct the arrow will find the target."

Months later I gave him a photograph (page 164). I was pleased with it but he wasn't. "My form isn't right. My head is too far forward". I thought he was being a little picky. Then I noticed a fraction of the power outlet in the wall just visible over his shoulder. Why hadn't I excluded that? My camera had been too far left.

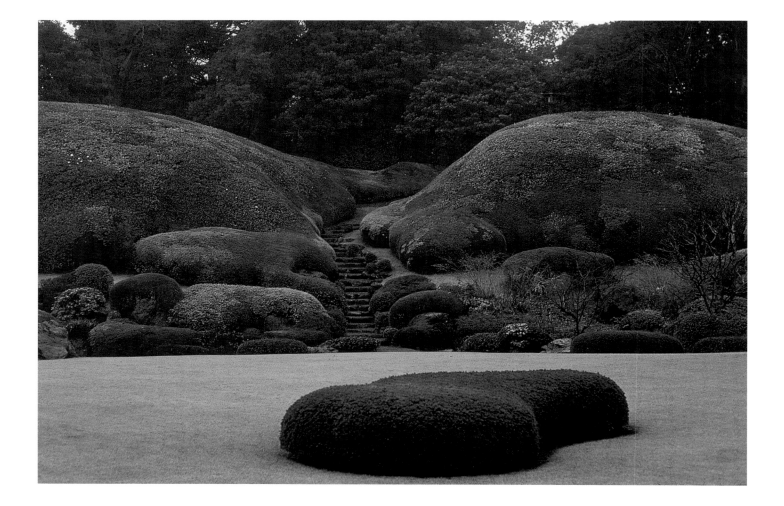

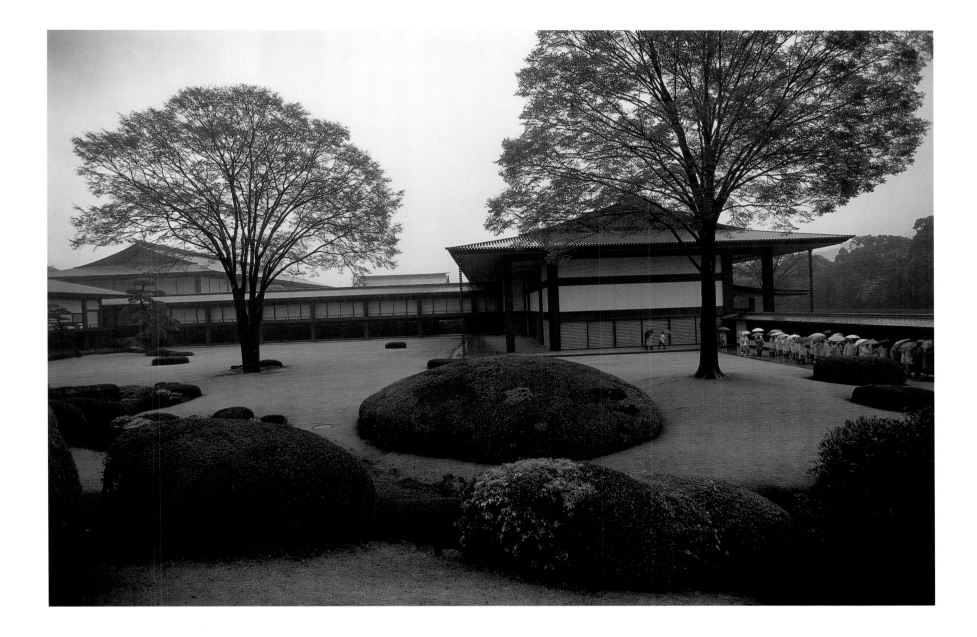

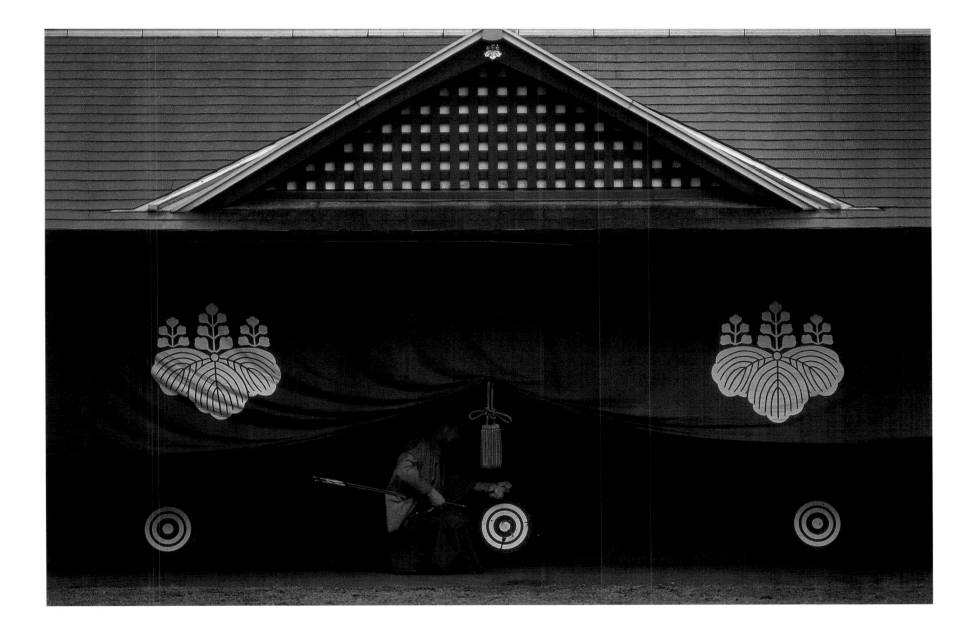

VENICE

Venice is one of the world's most seductive cities. But I wanted to see if there was anything authentic beneath its theatrical surface.

The city long ago lost its standing as the center of a now-vanished empire. Floods of water and of tourists threaten it annually. As these tides wash in the population of Venetians declines. Worst of all Venice isn't an island any more. A causeway connects it to the mainland.

And yet the city commonly casts a lasting spell on visitors. That is because Venice was built by people who loved beauty, and beauty in decline has its own power.

For my photography I spent time where the Venetians gather—on rooftops, in cemeteries, in the shelter of buildings under slow repair, and in churches and convents, and out in the empty lagoon. Coming and going by water I often met Venetians quietly traveling, as they always have, in their own worn gondolas.

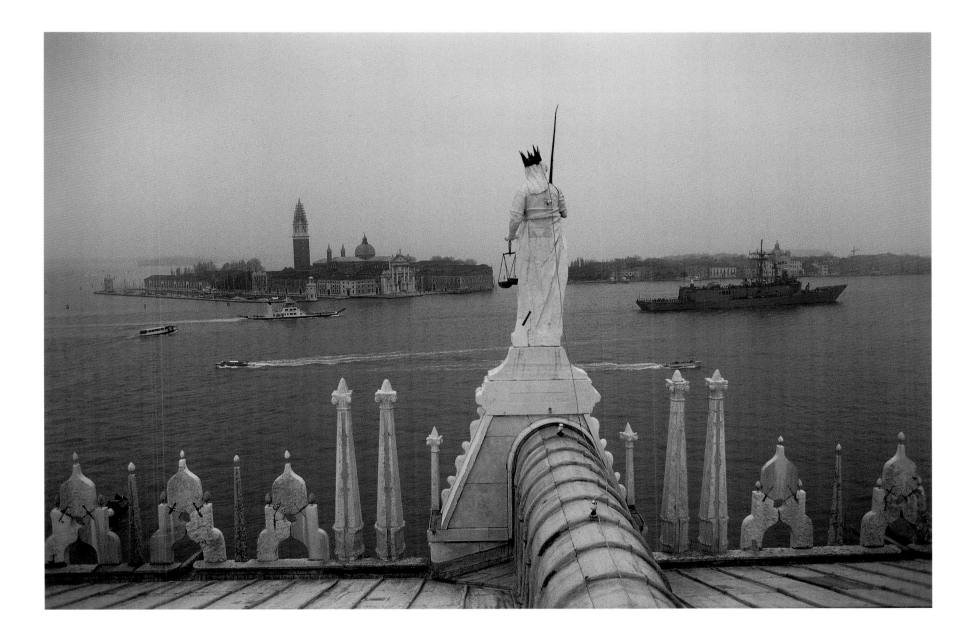

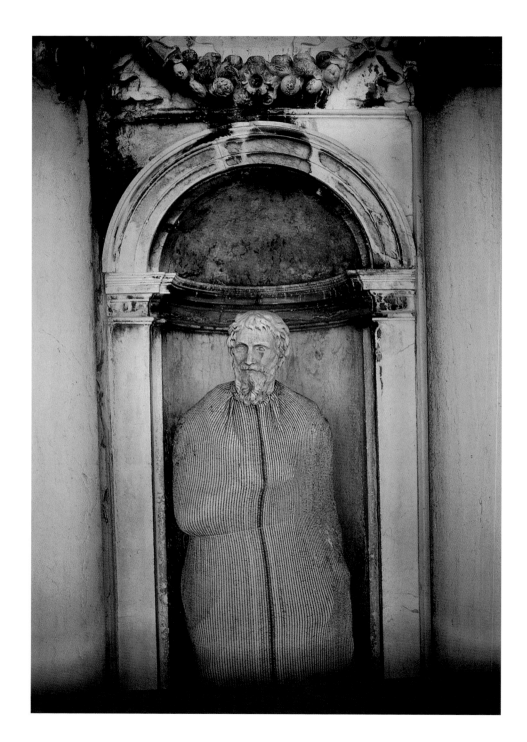

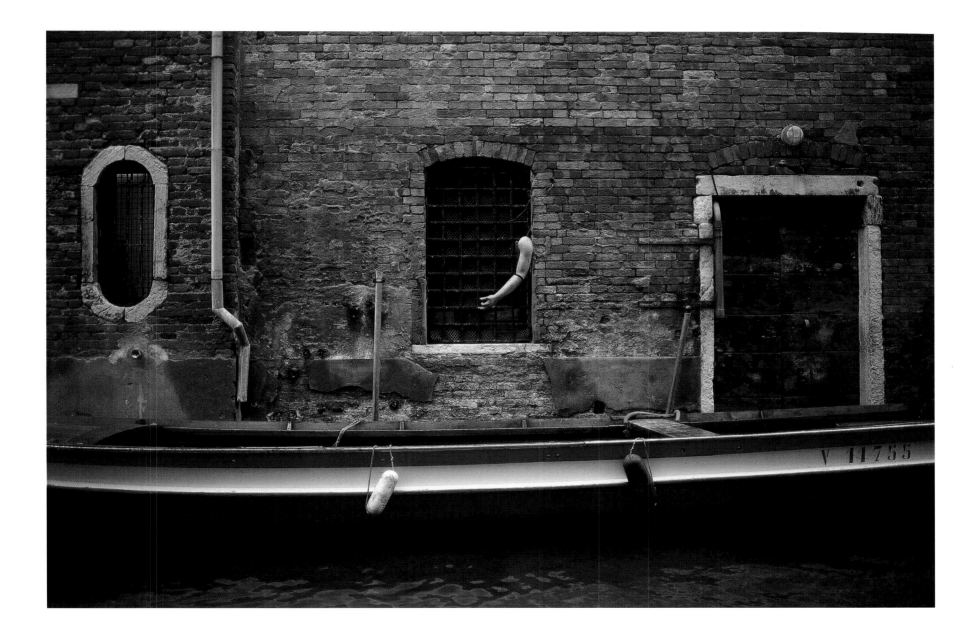

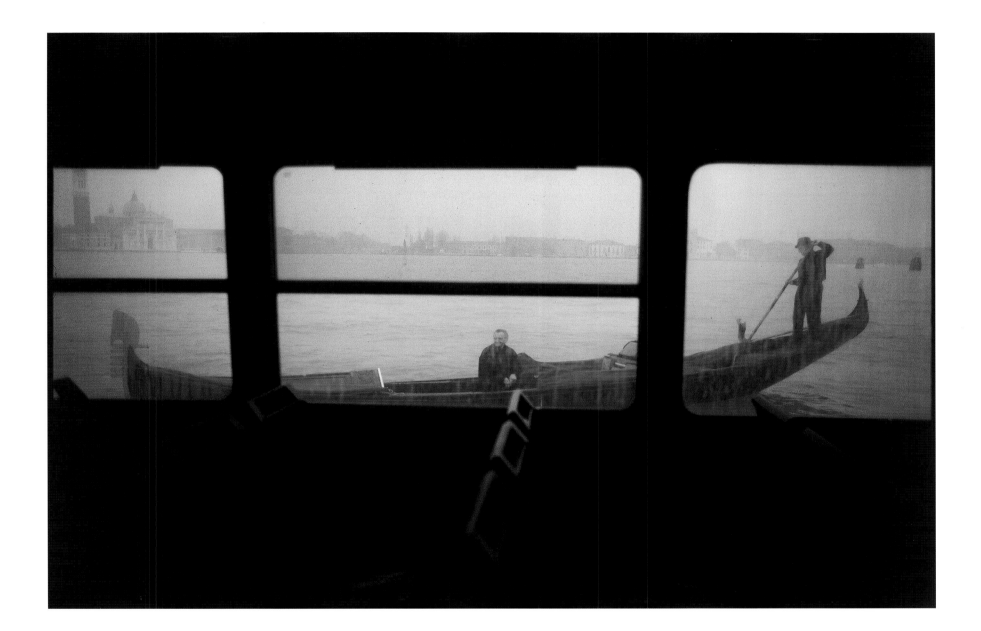

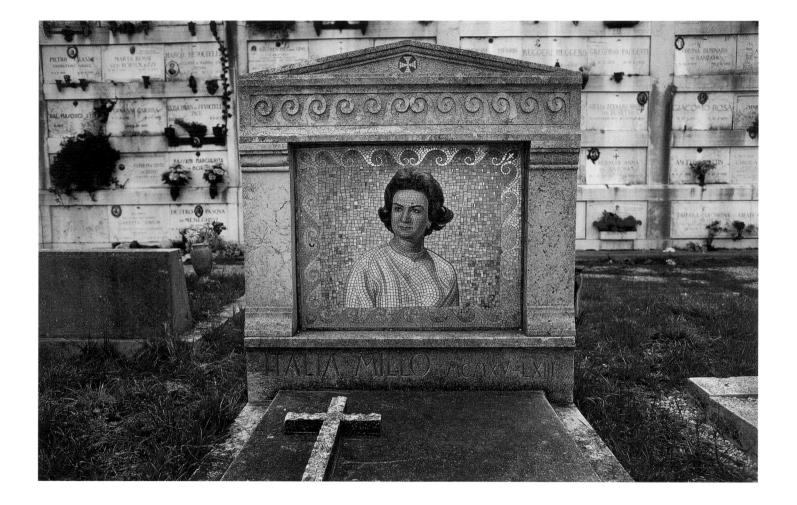

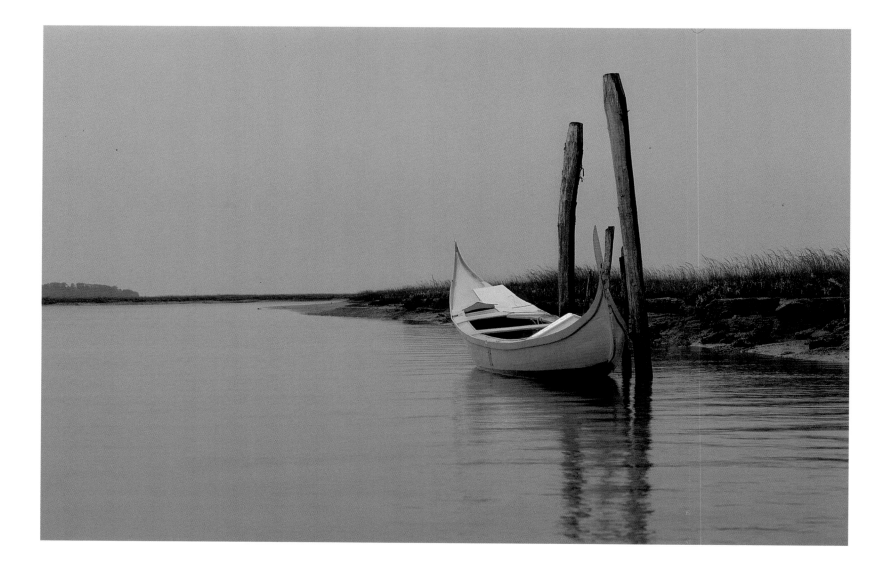

NEWFOUNDLAND IN WINTER

Newfoundlanders have winter to themselves. No one comes to visit then. The short days are dark and the landscape black when it isn't white. In this austere setting authenticity asserts itself. Newfoundland in winter is more of an actual place than most places are in any season. Boys play hockey on frozen ponds, men take seals from the ice and women in winter coats gather inside at the end of the day to visit. Often I was the only outsider. But I was there long enough to feel that weather itself can be a place.

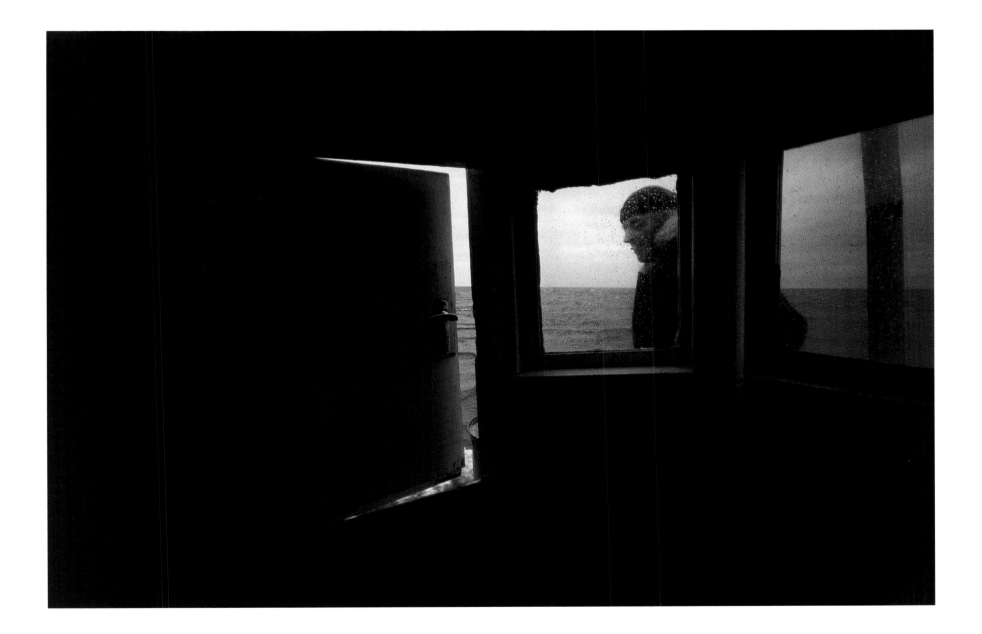

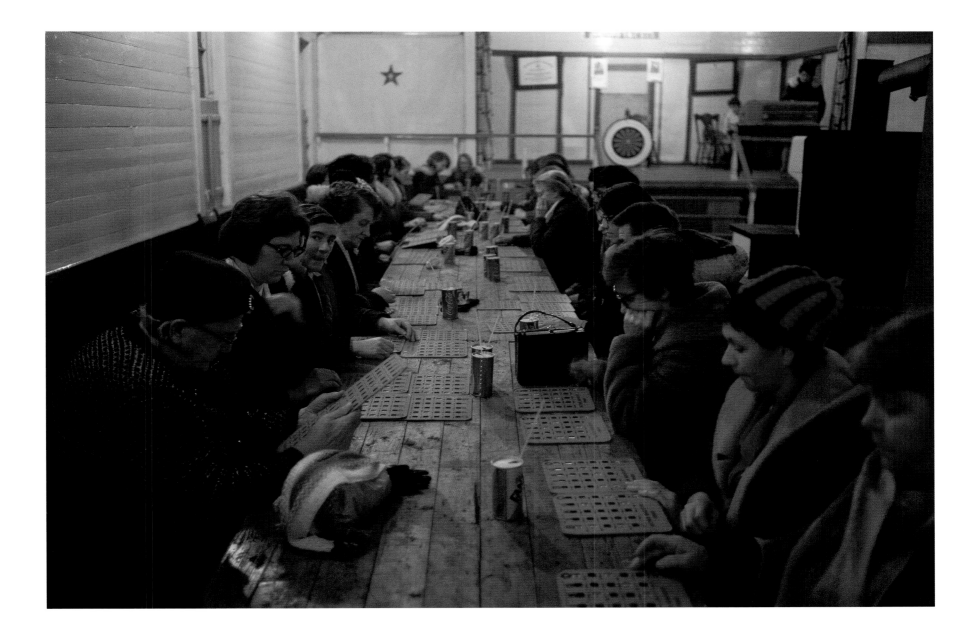

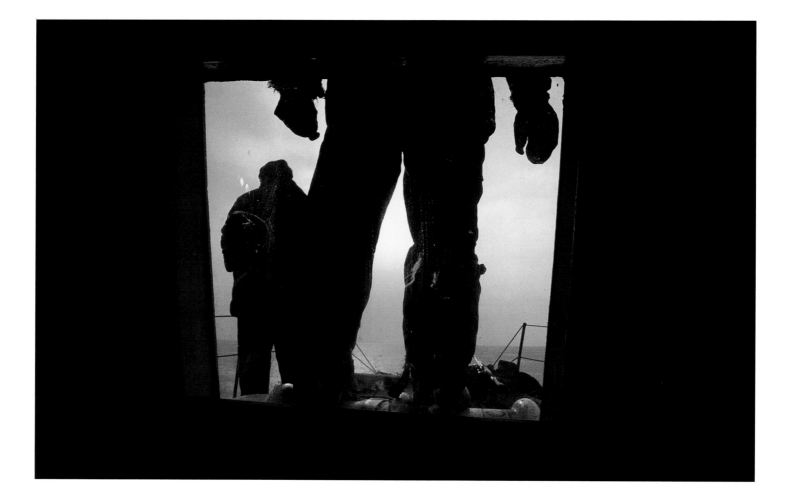

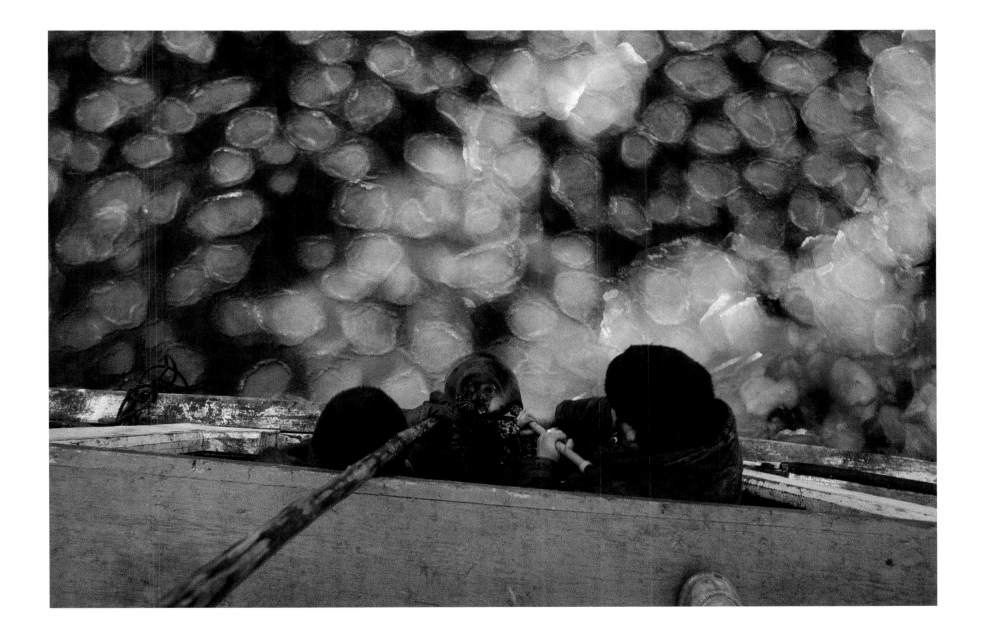

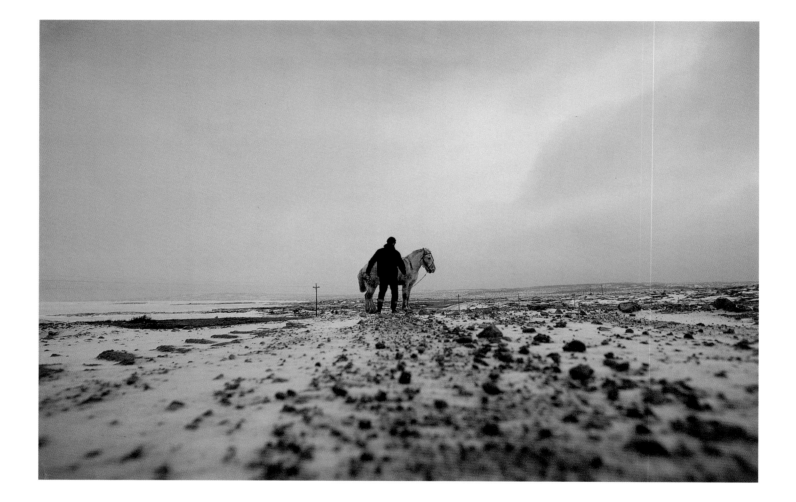

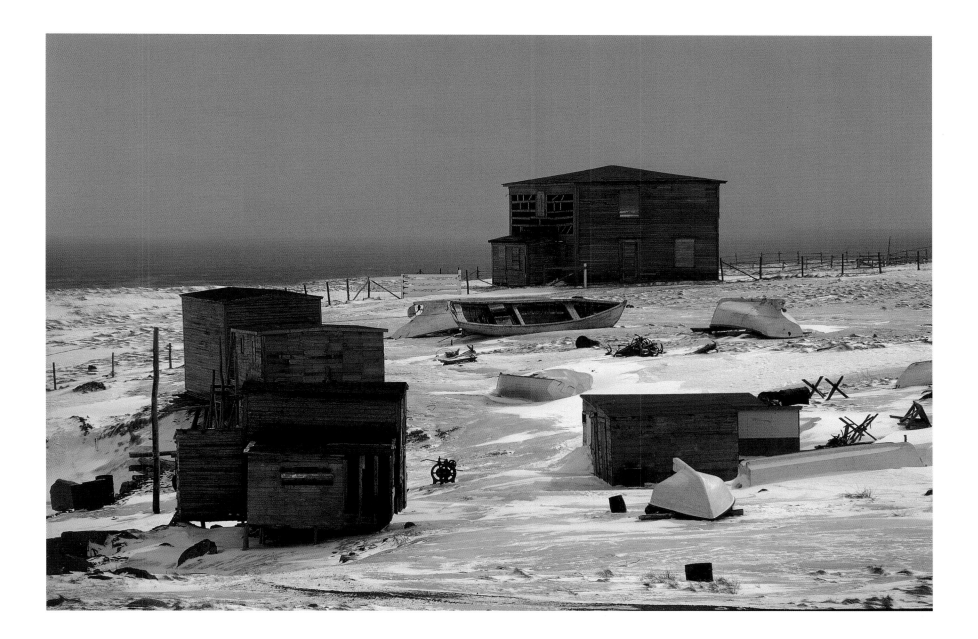

STRATHBURN STATION

Strathburn cattle station was on fire the day I arrived. It was still smoldering a week later when I left. The cleansing fires laid bare the worn, reptilian beauty of the north Australian landscape and the hard life lived there.

Under a canopy of gum trees, bleached termite towers stud the black burned-over bush. Soot deepens the dark skin of an aborigine tired from fighting the fires. Scorched leaves litter the burned ground around an aboriginal cowboy cradling the head of his dying horse. In a standoff with a wild bull the horse, and the cowboy, lost.

Relief from the scorching sun comes from behind shade cloth or in the waters of a billabong. There one day a young man casually smeared clay on his face, stared at me for a moment, then swam off.

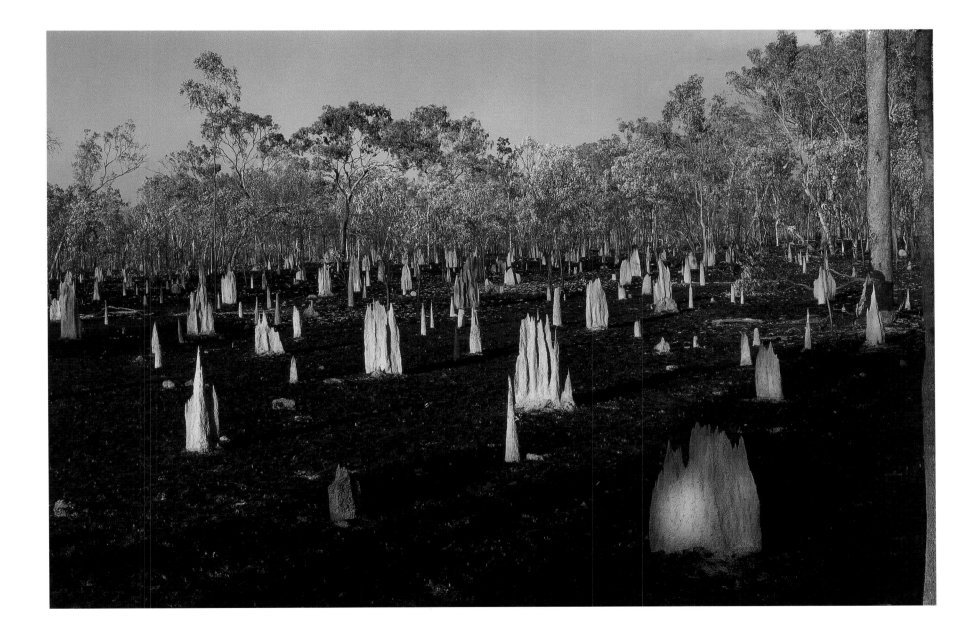

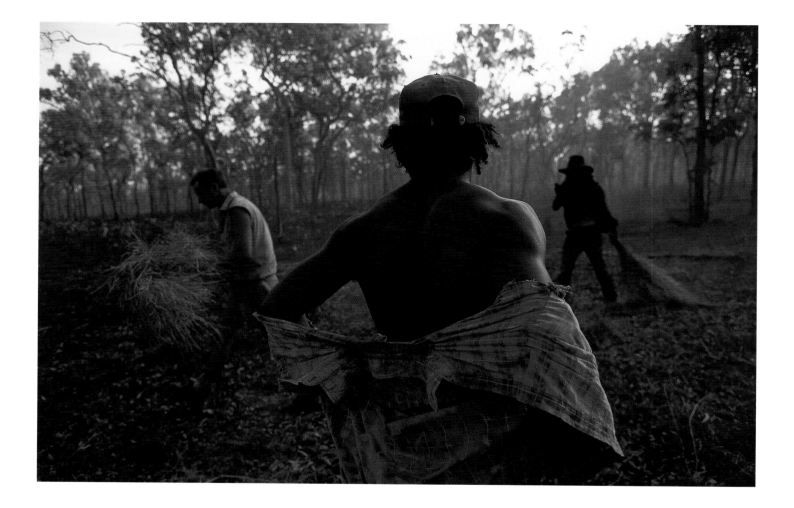

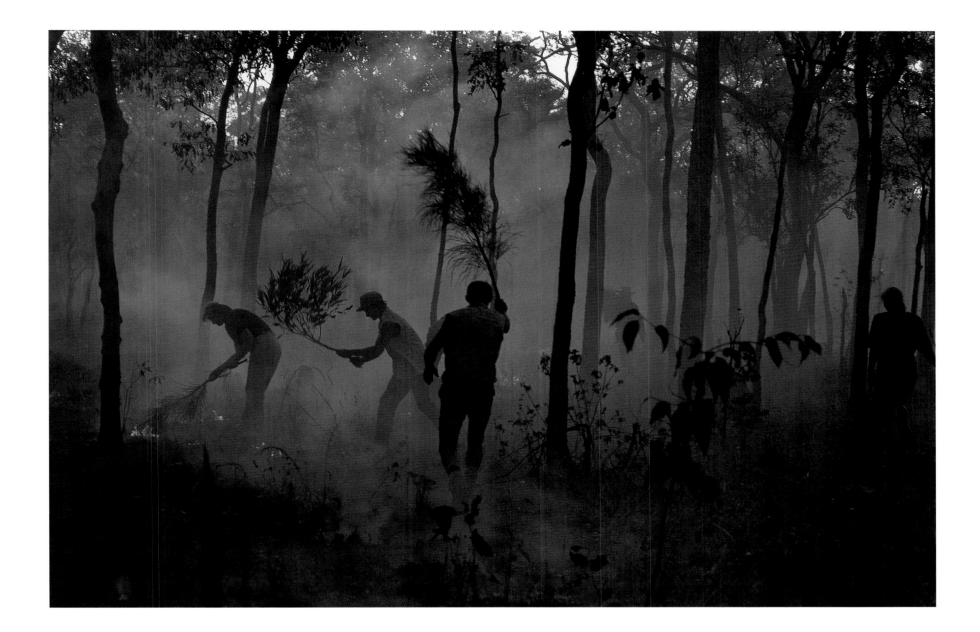

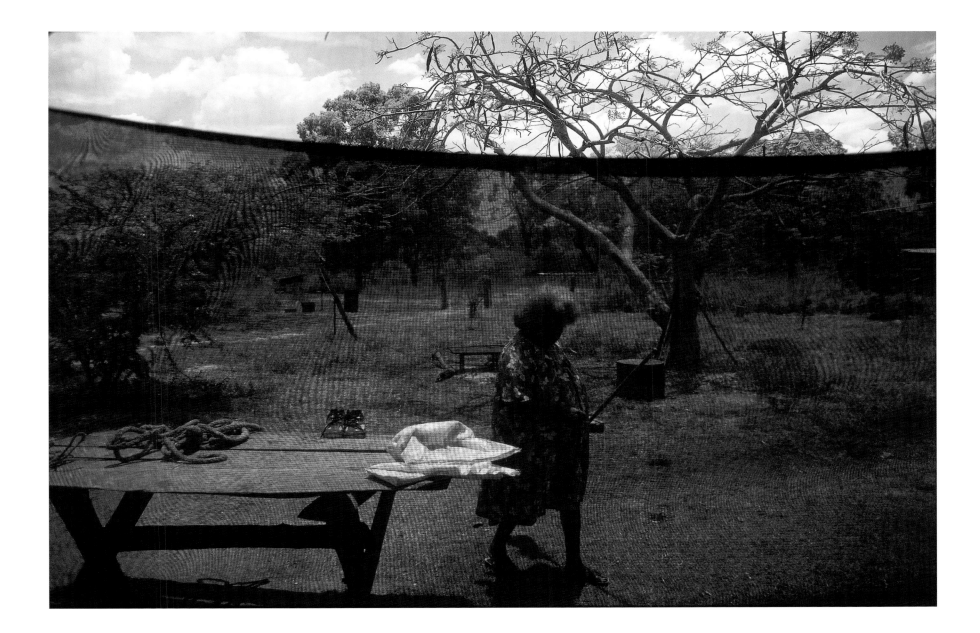

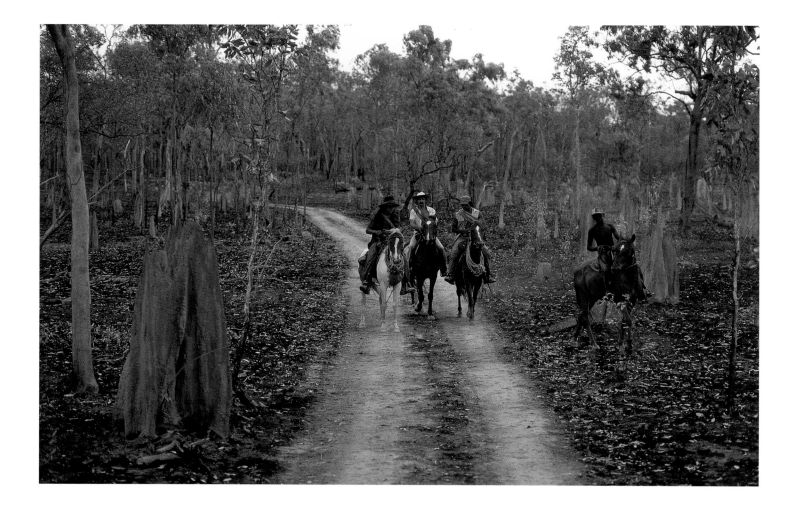

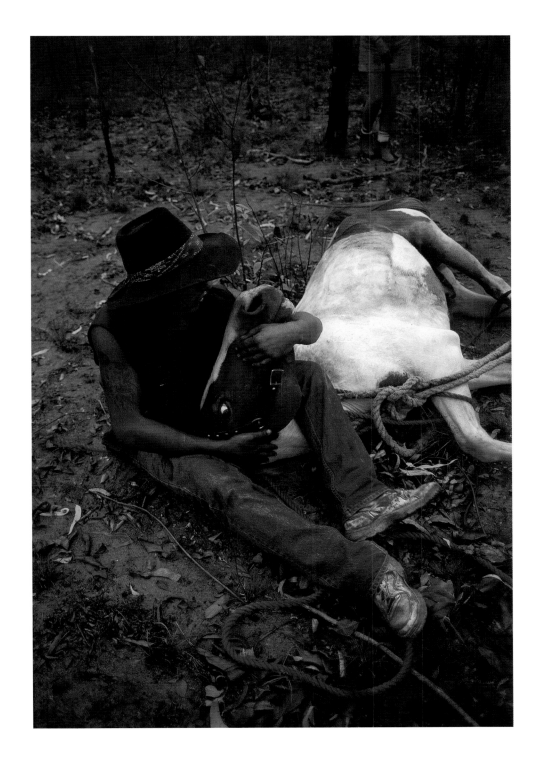

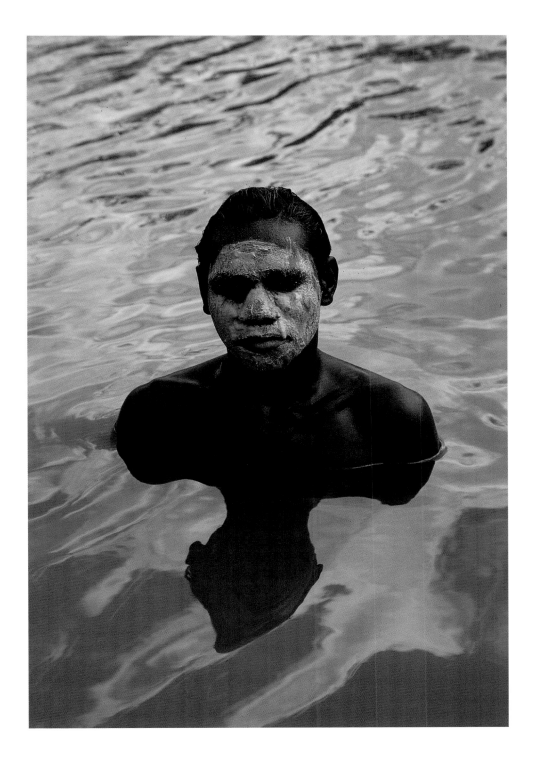

SHAKERTOWN

Shaker Village at Pleasant Hill—locally known as Shakertown—is in central Kentucky, not far from Lexington, where for six years I attended college. They were years I wished I were elsewhere and that desire blinded me to the beauty of where I was.

I went to Shakertown only once, the last day I was in Lexington. Friends took me there to say goodbye and on that spring evening in 1969 the ensemble of empty buildings surrounded us peacefully.

Twenty years passed before I returned. Shakertown was unchanged, but I was not. Two decades of travel had taught me to see and I was struck by the strength of Shaker design and by the subtlety of its setting in central Kentucky.

I spent several weeks at Pleasant Hill in different seasons but the things that usually matter to me—light, atmosphere, point of view—mattered here less. The beauty of Shakertown comes from within. It comes in the form of calm horizontal lines—in fences, wainscotting, window mullions and chair rails that knit Shakertown into an aesthetic whole. Against these lines every curve gracefully stands forth.

The Shakers themselves are gone but often it doesn't feel that way. They put their spiritual life into a physical form and it's still there. I'm not the first person to sense this. In considering the chair I photographed, the priest Thomas Merton wrote, "The peculiar grace of a Shaker chair is due to the fact that it was made by someone capable of believing an angel might come and sit on it."

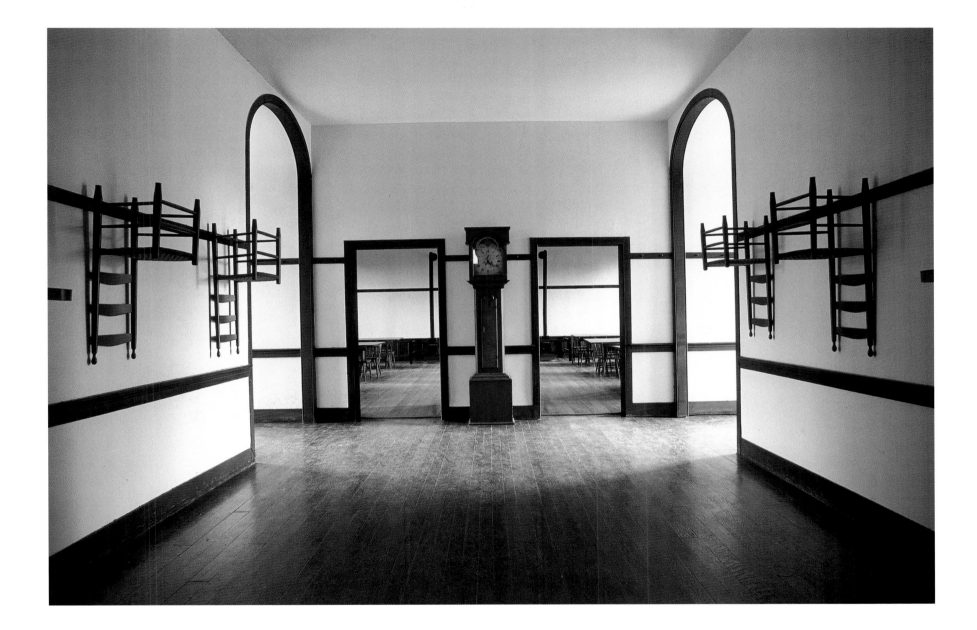

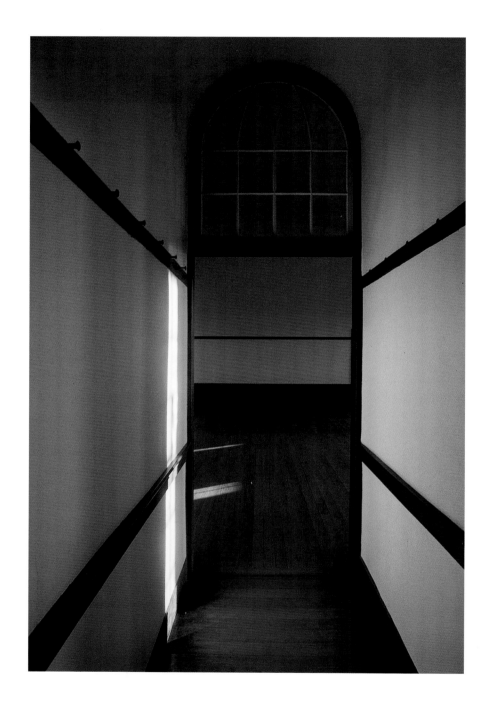

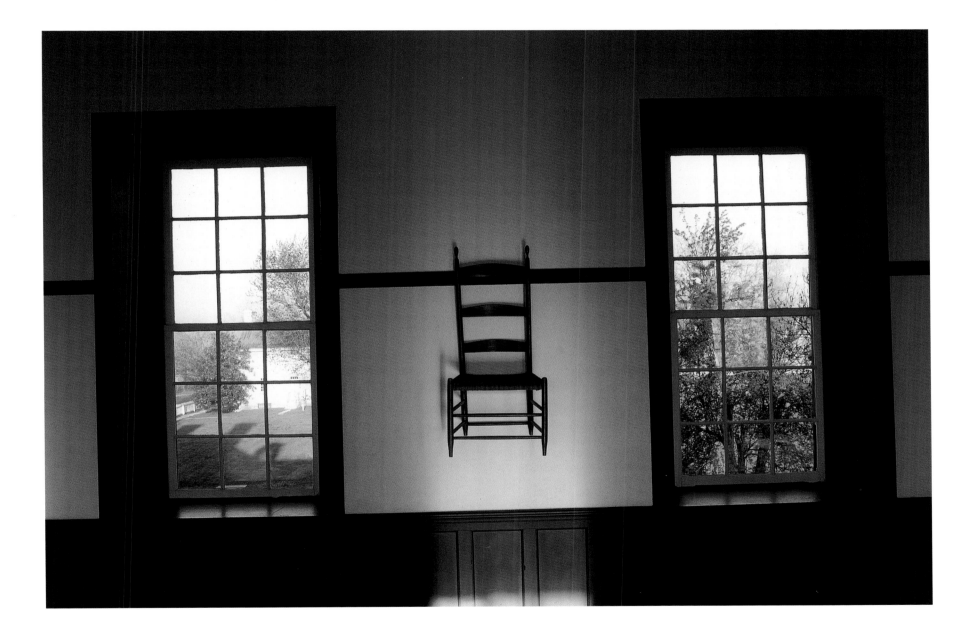

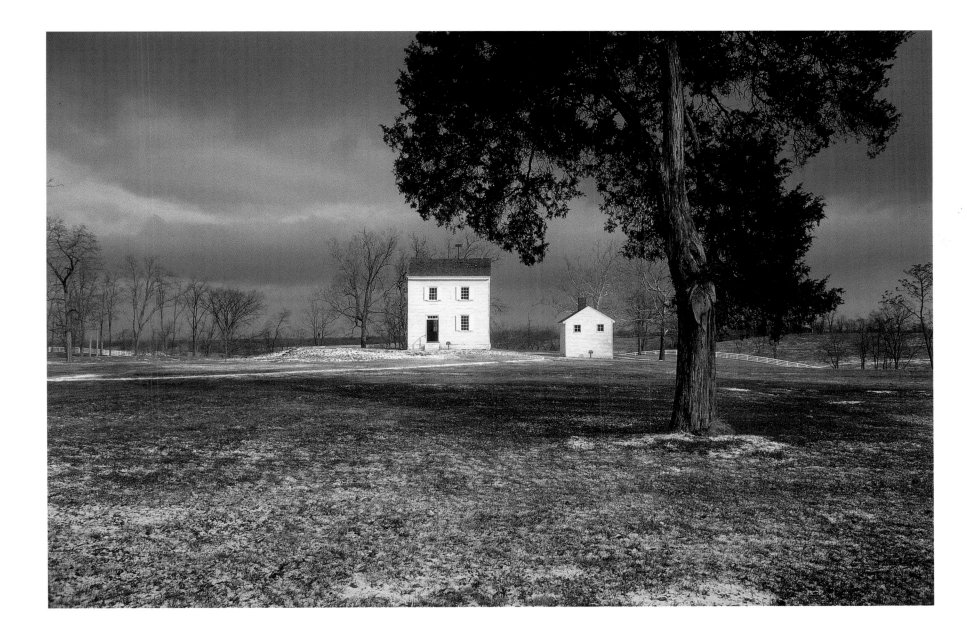

CANOEING

A canoe is a place. Often it is more of a place than the scenes it passes by. I felt that at twelve when I first slid a wooden canoe onto still water and got in. Within its secure and subtle shape I could quietly go places. It was as transforming to me as a camera, which came into my life at about the same time.

Twenty years later I spent a year canoeing with my camera. The resulting essay is a meditation on stillness which is one of the things canoeing and camera work have in common.

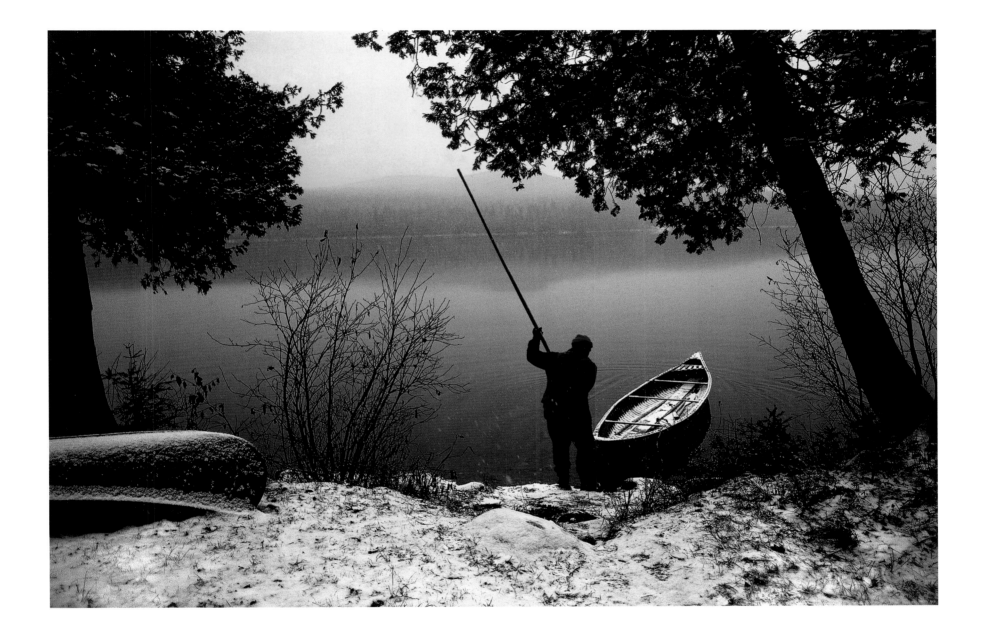

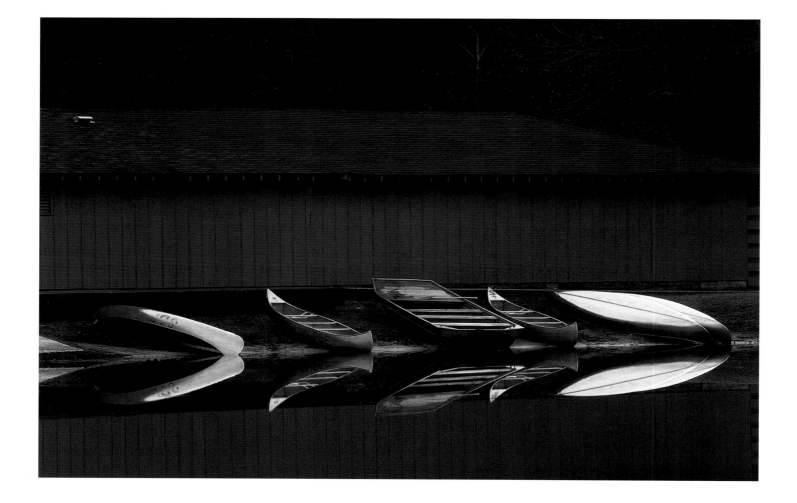

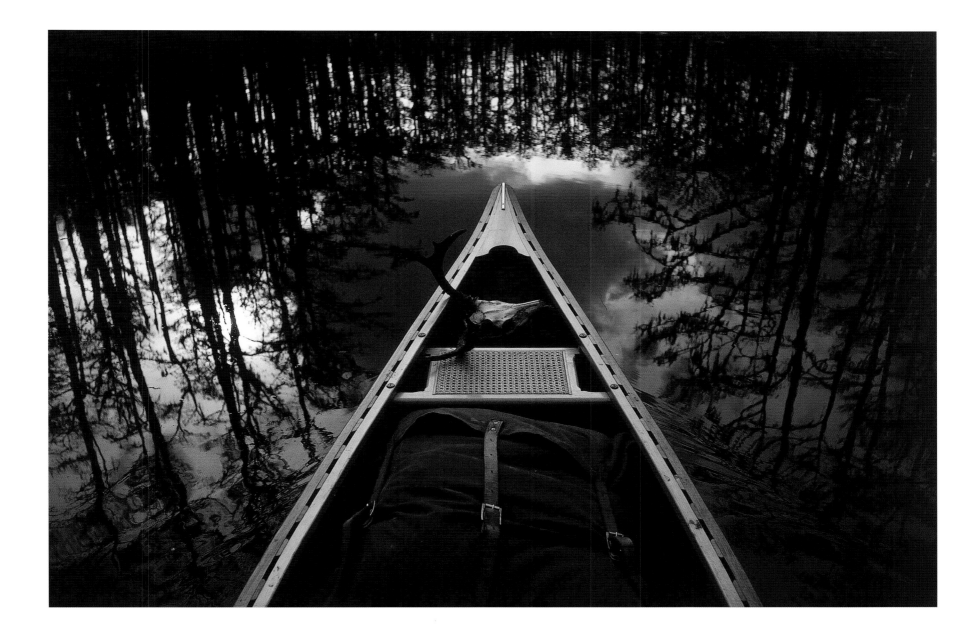

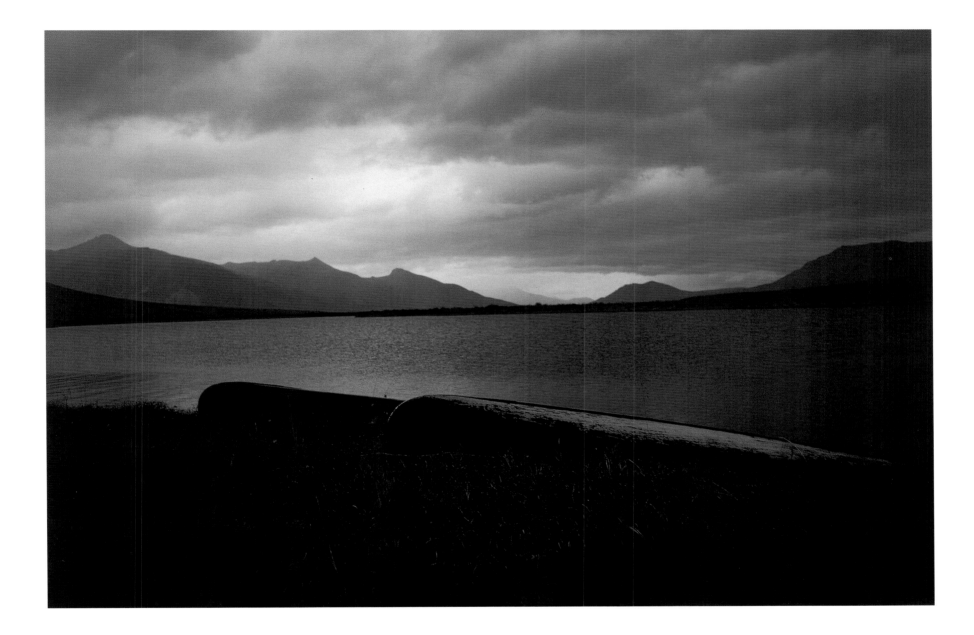

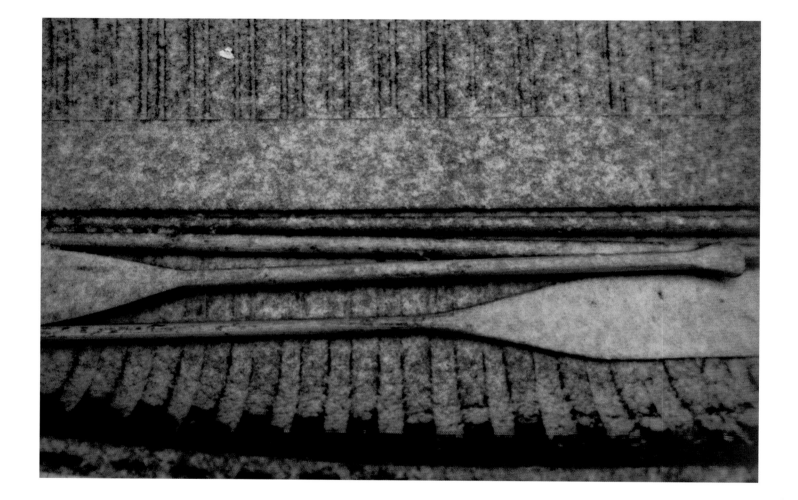

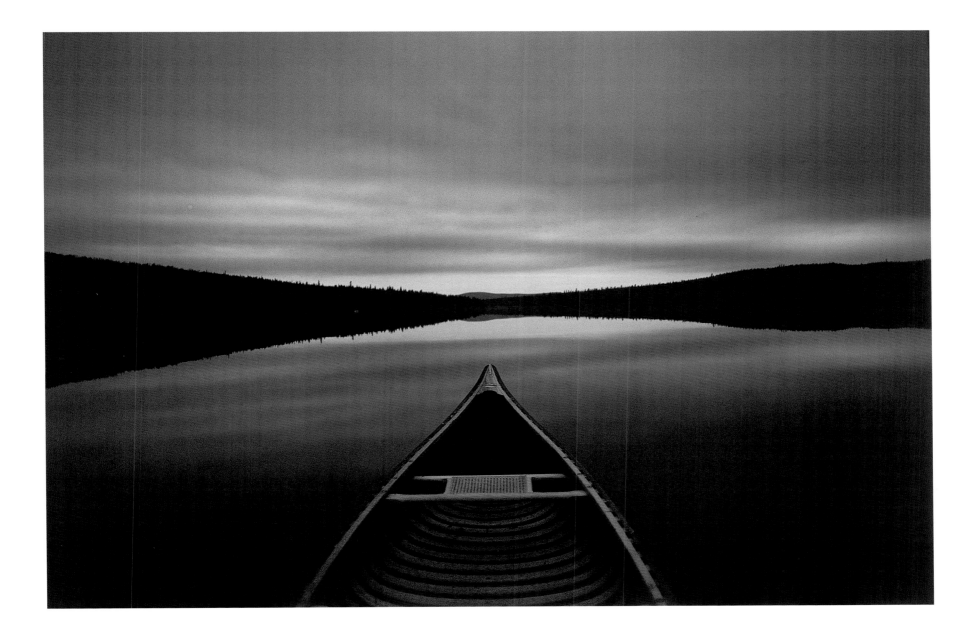

THE LIFE BEHIND THINGS

I encountered the image of Mercedes McKee in Muscatine, Iowa, in May 2001 and made several photographs of her. I studied these photographs and a month later returned to photograph her again. I was after an image of her image and through it an understanding of photography's place in our imagination; how photography both makes, and takes, memories.

Mercedes was first photographed in 1942 to promote the family's pearl button business. When that business declined the picture of her was set aside. Sixty years passed. Now she was out again, standing in the shell of a building about to become the Pearl Button Museum. She was there as the optimistic emblem of an era that had faded into history.

But her image was unfaded and I was held by that. To me her picture gives expression to photography's promise of immortality.

In reaching for immortality the images of Mercedes McKee connect with the themes of duality in my work: of color and its absence, of truth and illusion, permanence and evanescence, of things and the life behind them.

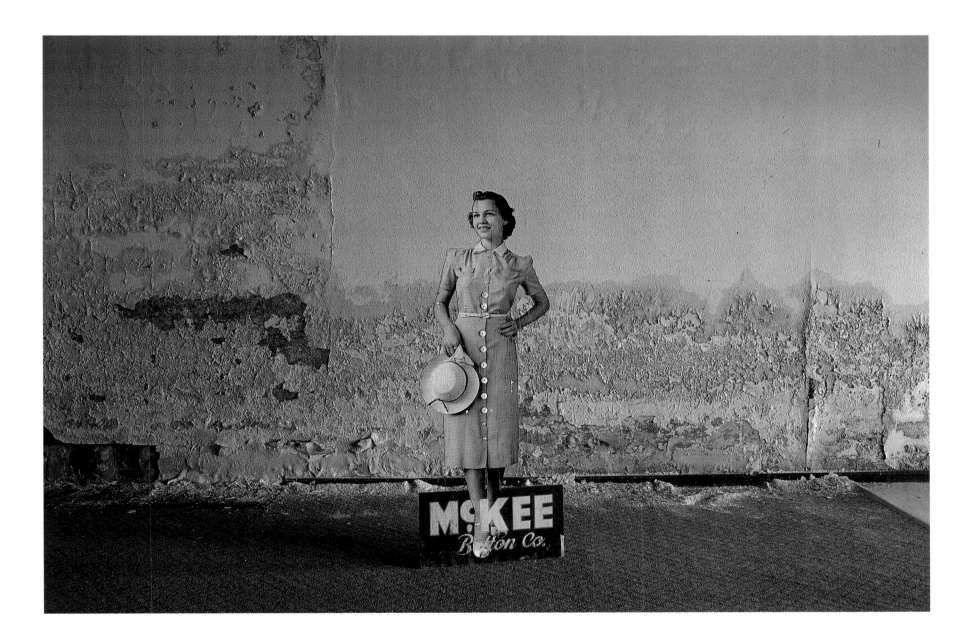

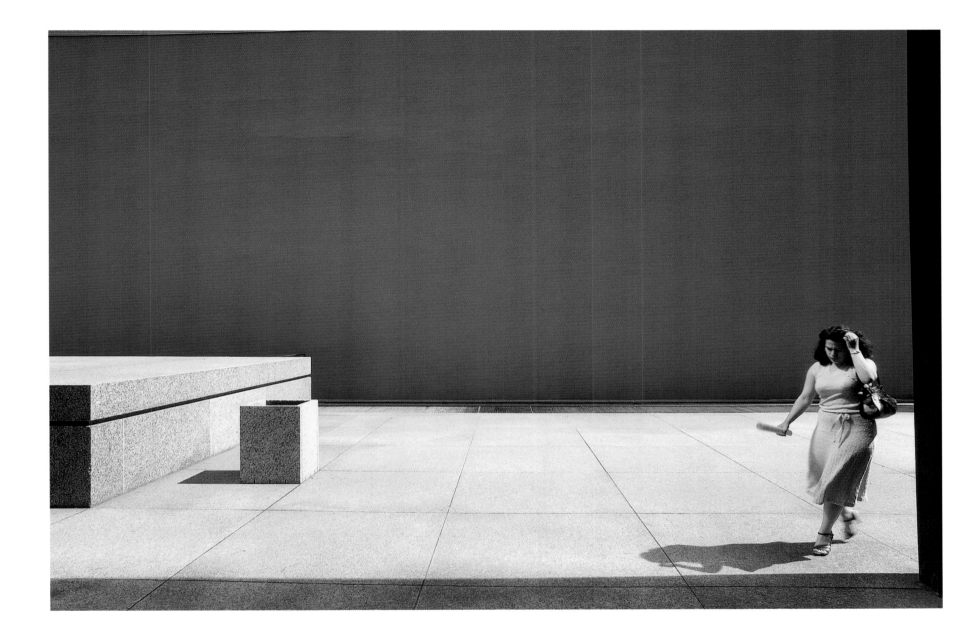

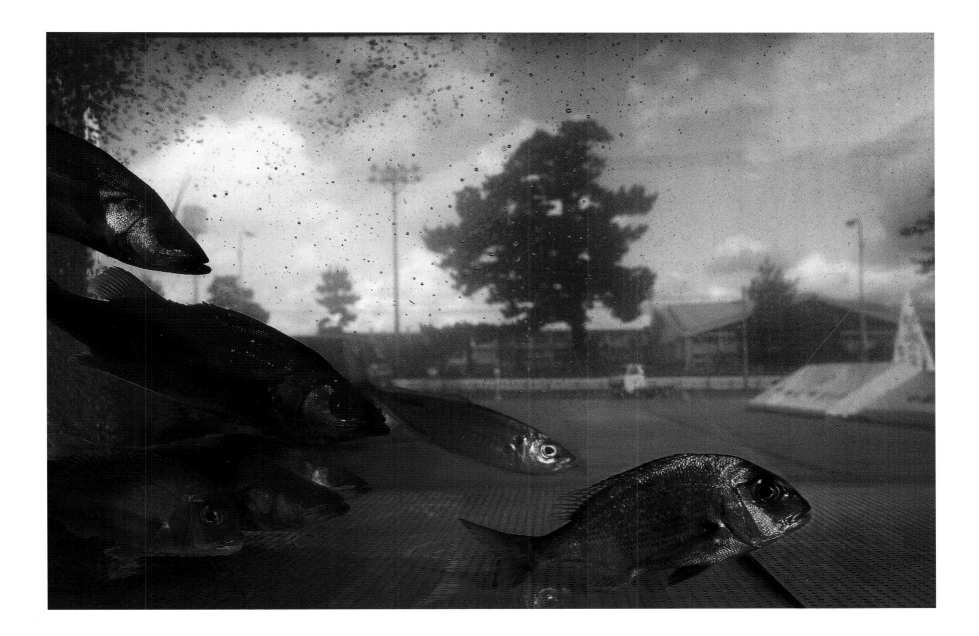

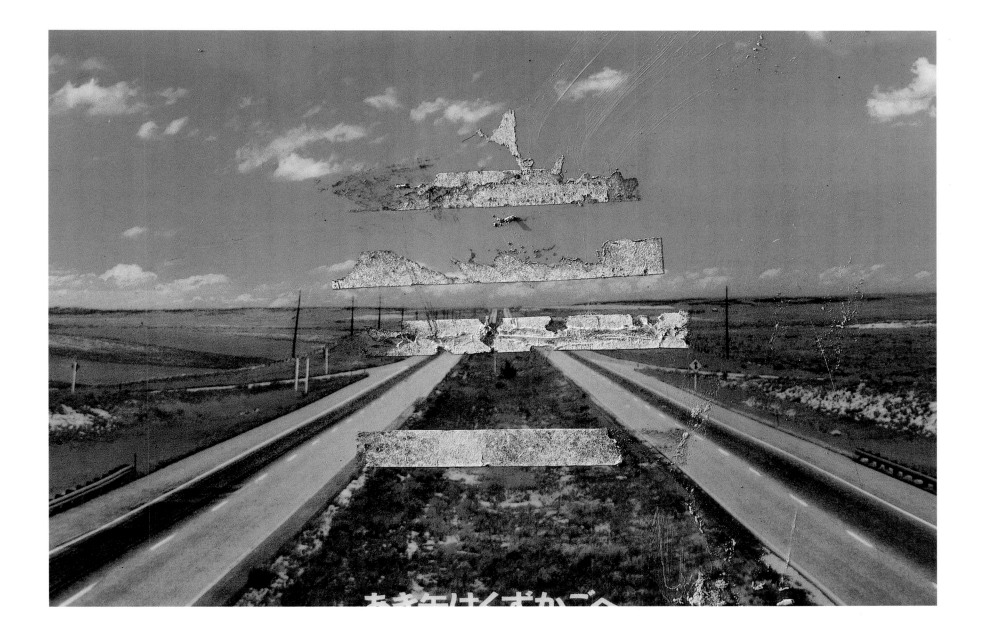

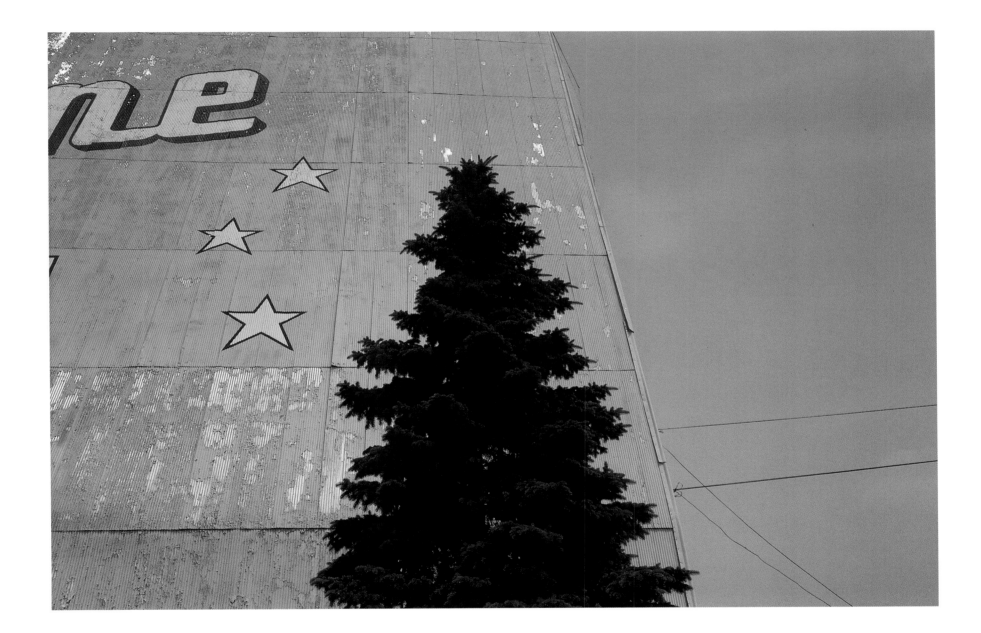

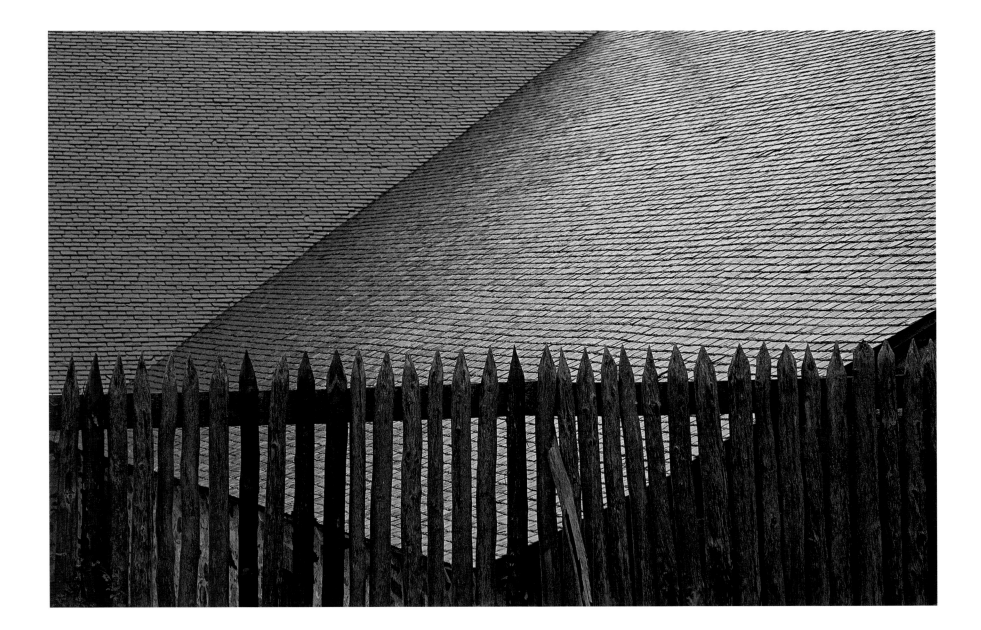

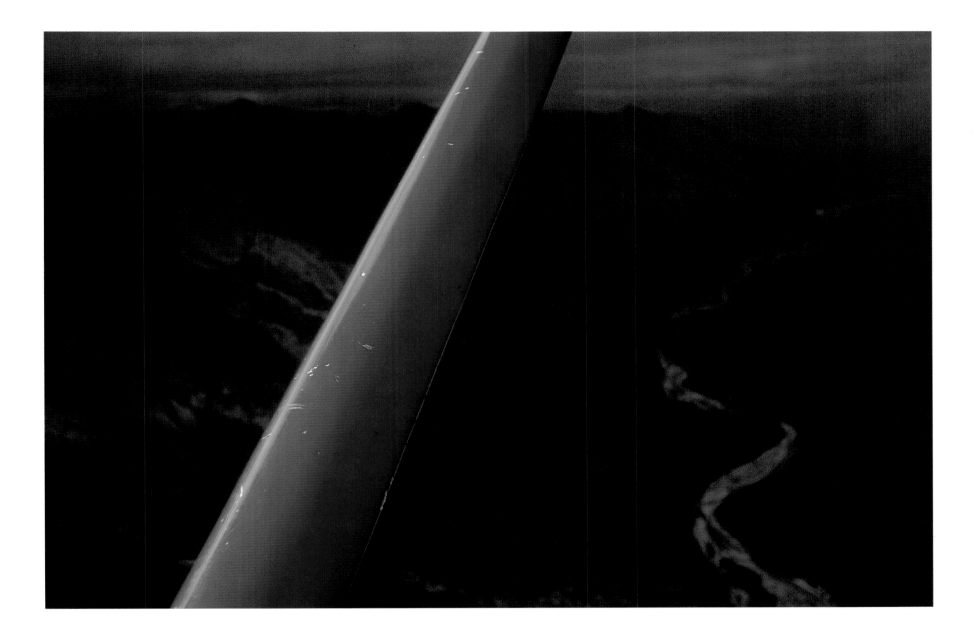

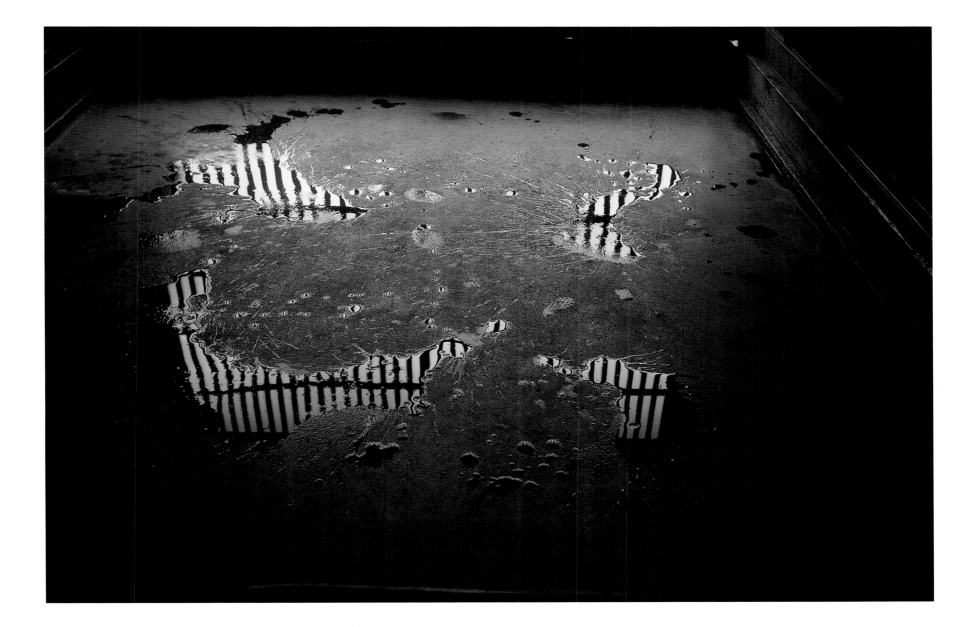

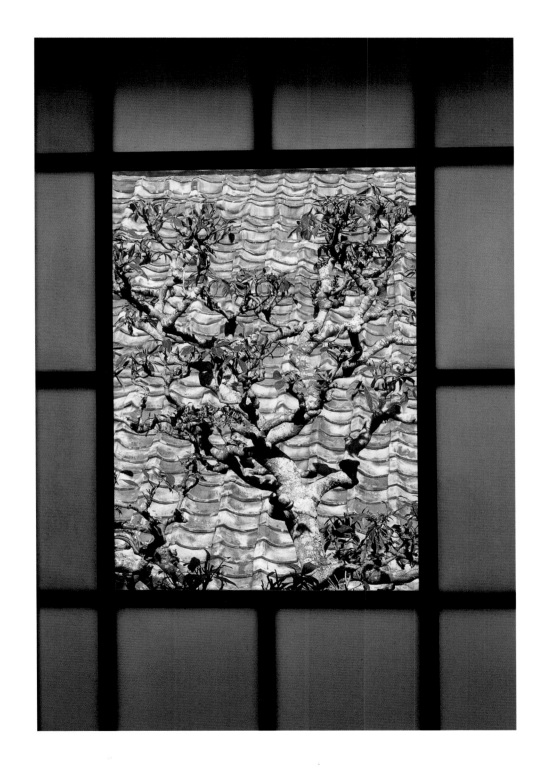

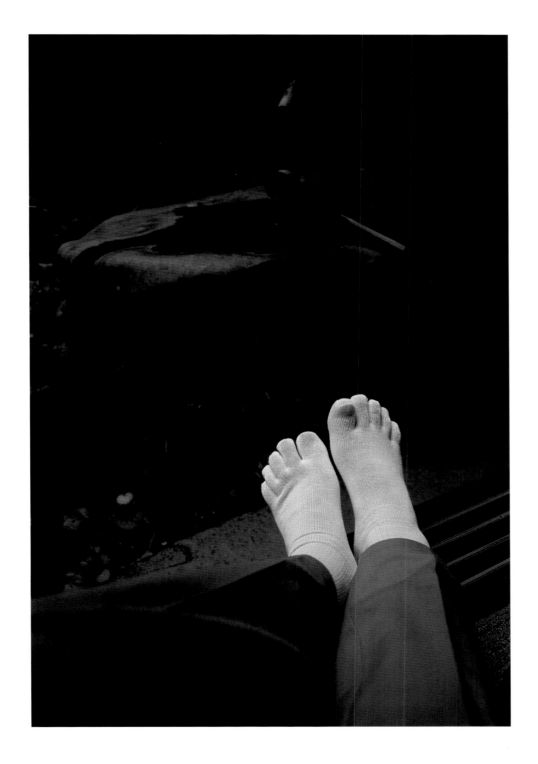

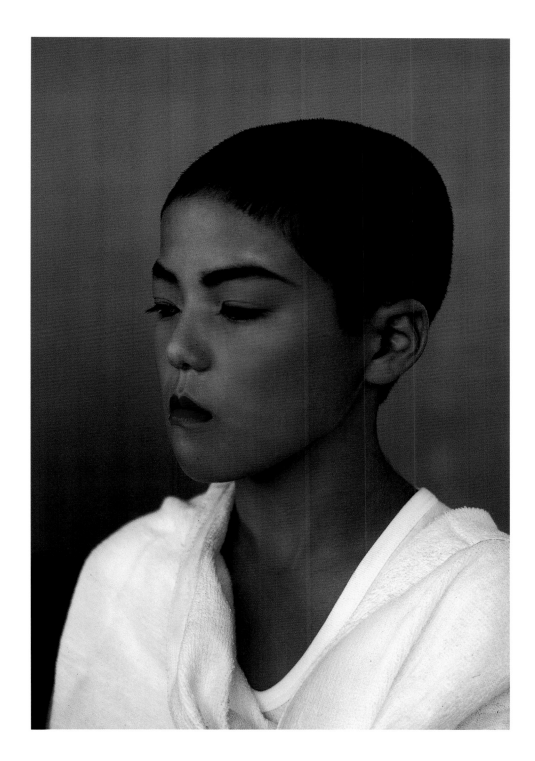

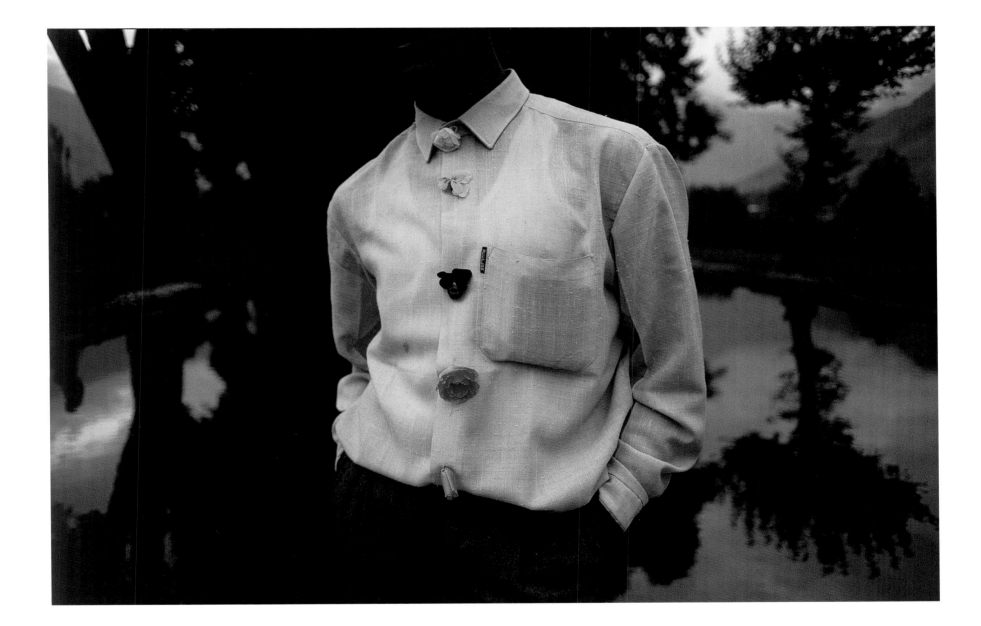

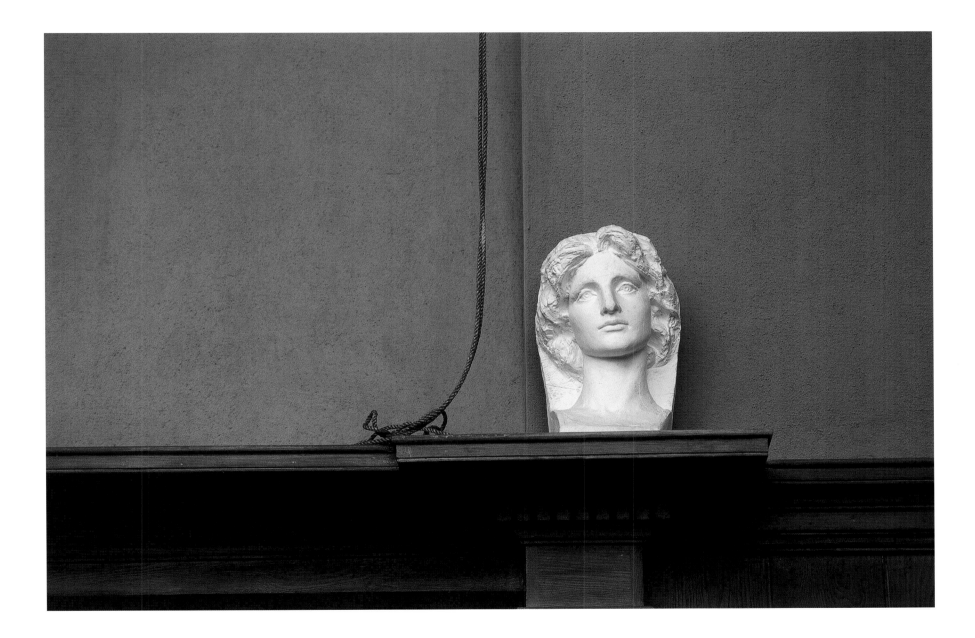

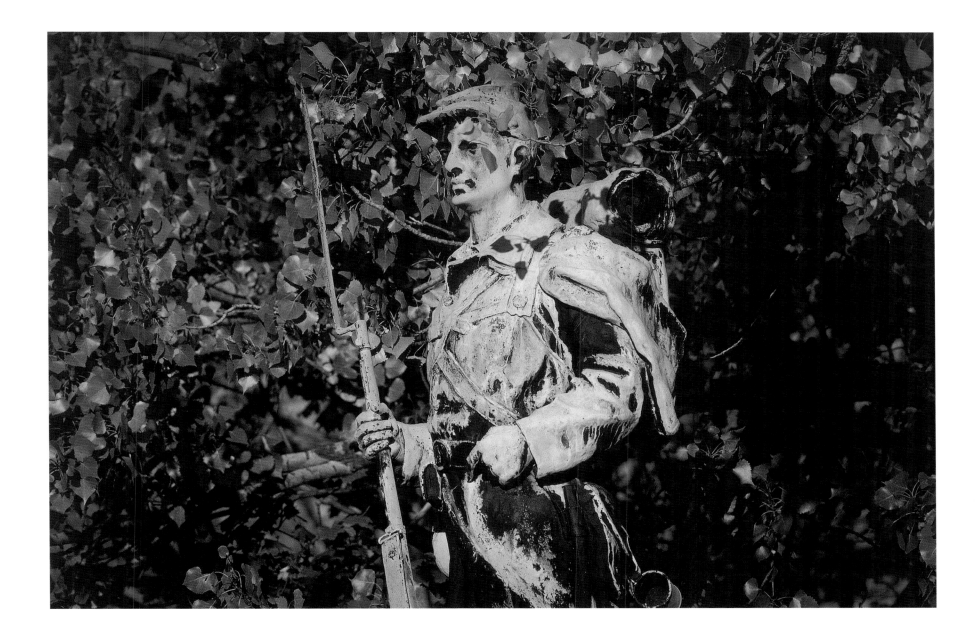

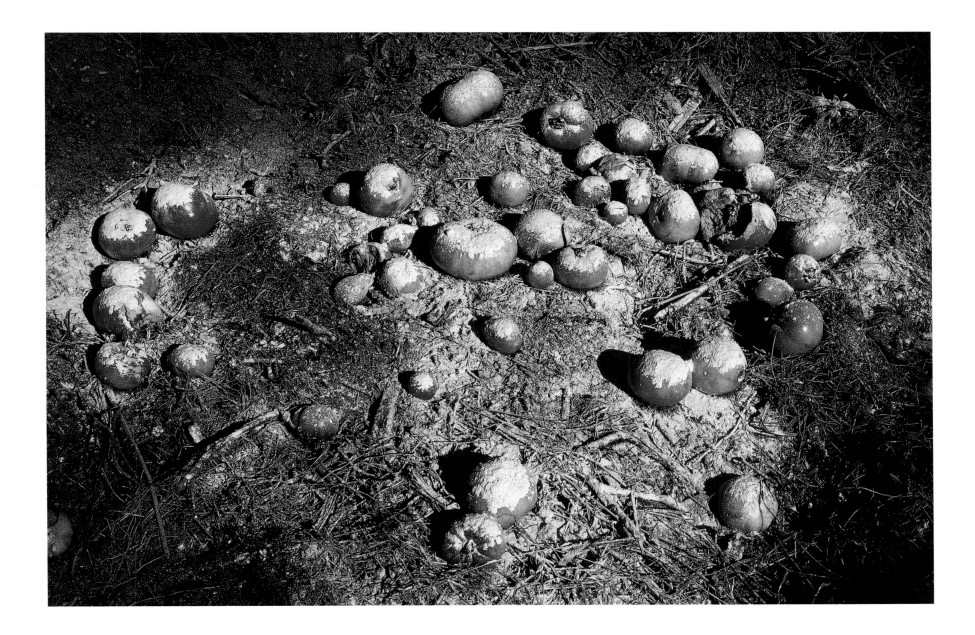

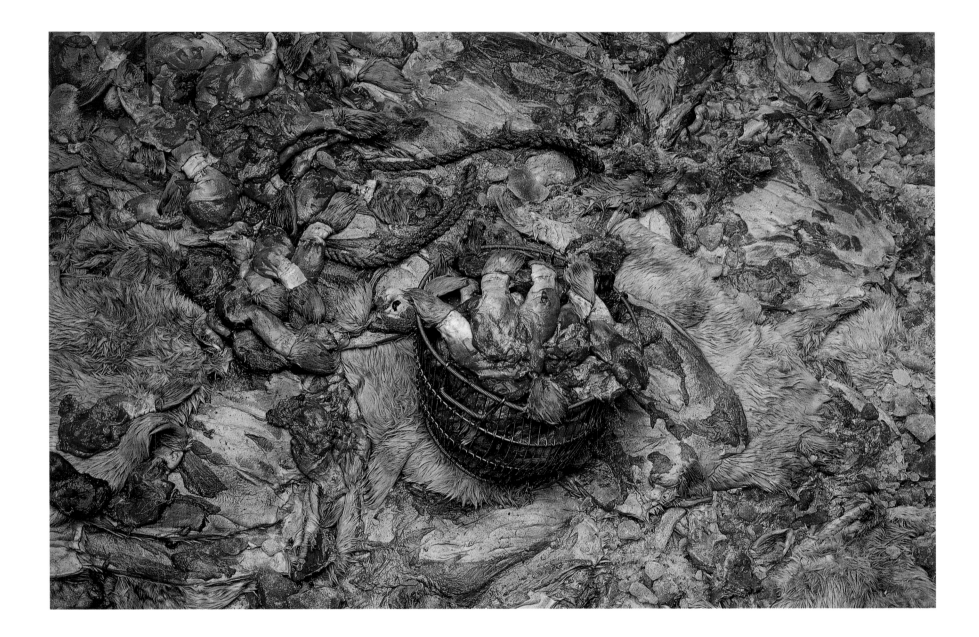

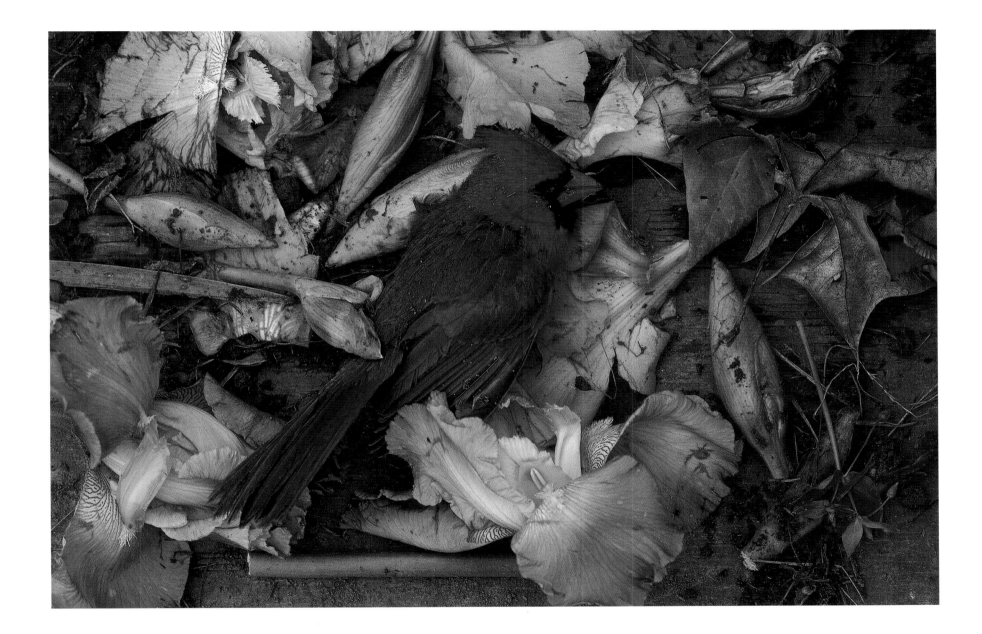

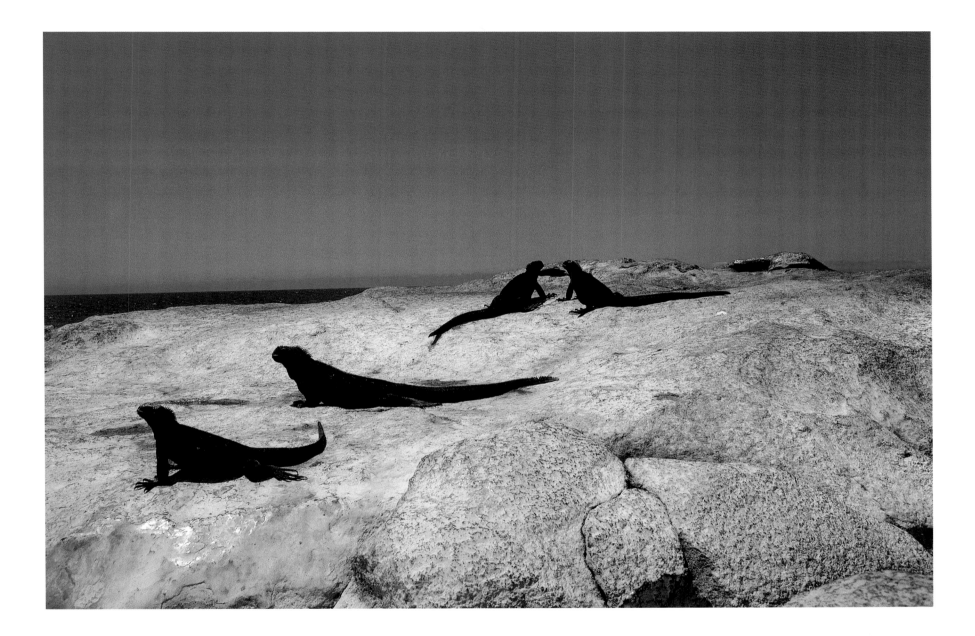

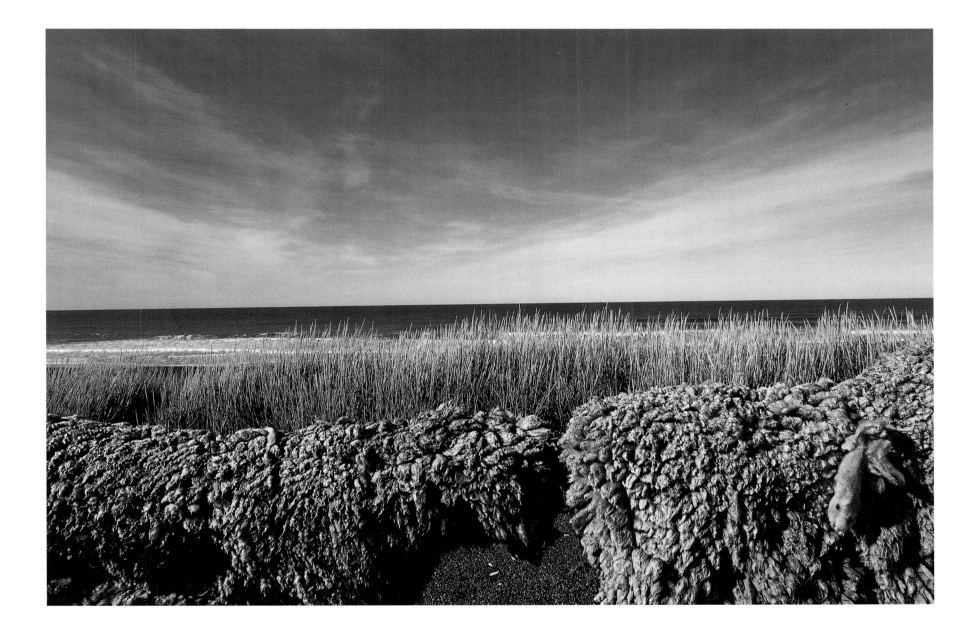

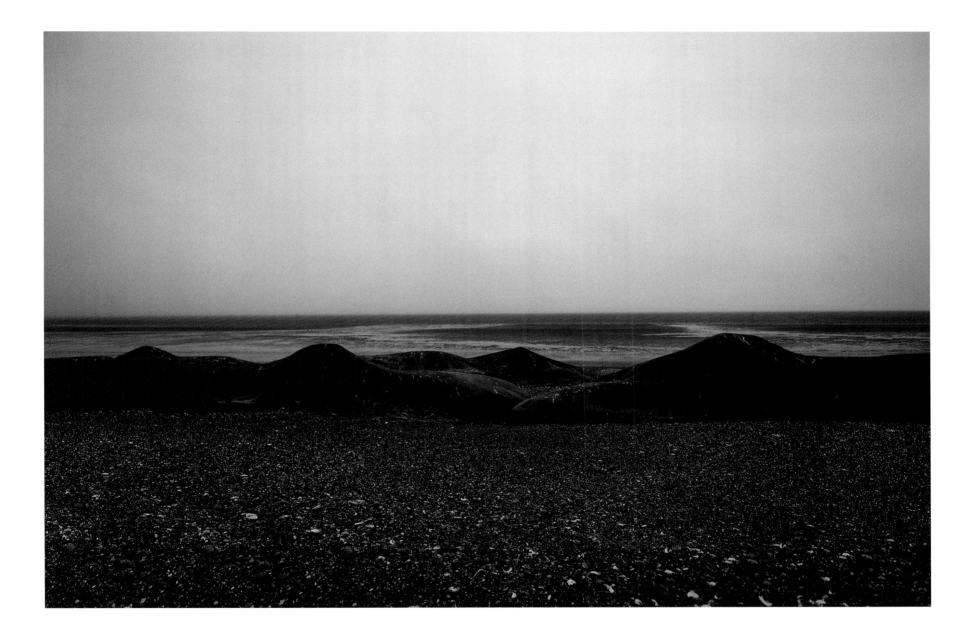

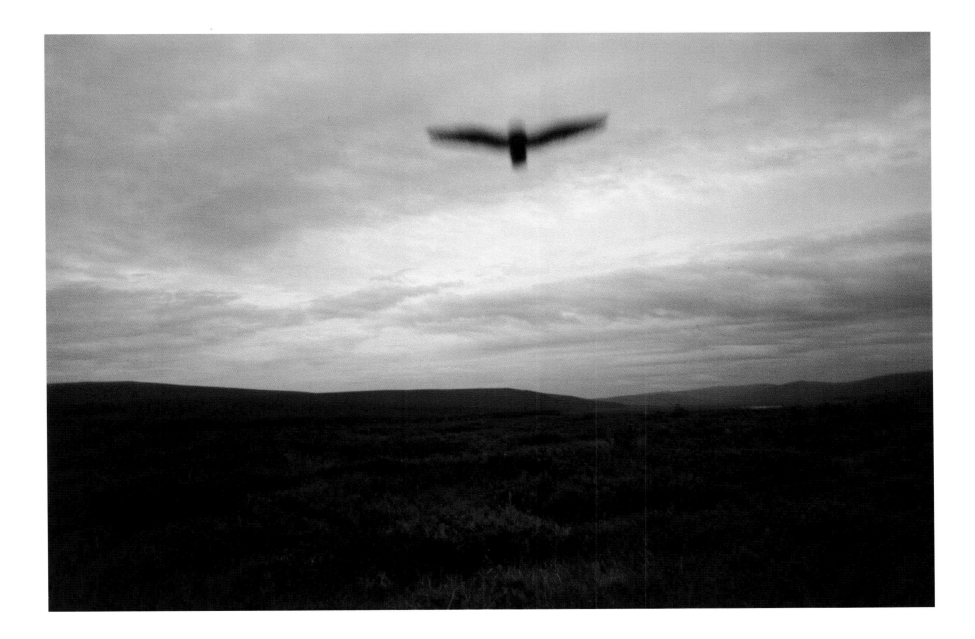

First published in the United States of America in 2002
by RIZZOLI INTERNATIONAL PUBLICATIONS, INC.
300 Park Avenue South, New York, NY 10010

ISBN: 0-8478-2496-9
LCCN: 2002092679

Printed in China
Distributed to the US trade by St. Martin's Press, New York.
2002 2003 2004 2005 2006 / 10 9 8 7 6 5 4 3 2 1

The authors would like to thank

THE OAKWOOD ARTS AND SCIENCES CHARITABLE TRUST

RENEE AND JOHN GRISHAM

for sponsorship of this book

For sponsorship of the exhibition

THE NATIONAL GEOGRAPHIC SOCIETY: GIL GROSVENOR, JOHN FAHEY, PANDORA TODD, ANNE COWIE

VIRGINIA NATIONAL BANK: C. WILSON MCNEELY III AND REID NAGLE

For support of the exhibition

STEPHEN AND MOIRA AMBROSE, CAROL ANGLE, HAL EASTMAN, DIANE AND HOWIE LONG, DOROTHY AND COLIN ROLPH

ARTSPACE COMMITTEE OF UNIVERSITY PROGRAMS COUNCIL at the UNIVERSITY OF VIRGINIA

ARTS ENHANCEMENT FUND, UNIVERSITY OF VIRGINIA

VOLUNTEER BOARD and YOUNG FRIENDS of the UNIVERSITY OF VIRGINIA ART MUSEUM

ALBEMARLE MAGAZINE, C & O RESTAURANT

SARAH AND DOUGLAS DUPONT

For support of the project

DAVID BLECH

CANON USA

The authors would like to thank the following individuals for their contributions

AT OAKWOOD ARTS AND SCIENCES CHARITABLE TRUST: FRANK AND MERRY THOMASSON

AT RIZZOLI NEW YORK: CHARLES MIERS, REBECCA CREMONESE, JOHN BRANCATI

AT THE UNIVERSITY OF VIRGINIA ART MUSEUM: JILL HARTZ, SUZANNE FOLEY, KATE PATRICK

AT SANTA FE CENTER FOR VISUAL ARTS: REID CALLANAN

AT ALBEMARLE MAGAZINE: RUTH HART

AT AMERICAN PHOTO MAGAZINE: RUSSELL HART, EXECUTIVE EDITOR

AT CANON USA: MICHAEL NEWLER

AT ALLIED COLOR INC.: MIKE GORTON, GREGORY GETMAN

COLOR EXHIBITION PRINTS: EDDIE SOLOWAY

BLACK AND WHITE EXHIBITION PRINTS: STUART DIEKMEYER

BOOK DESIGN: ROBERT W. MADDEN and MARILYN F. APPLEBY

BOOK COVER DESIGN: SARAH WATERS

SCANNING: MARTIN SENN, PHILOMONT, VIRGINIA

SAM ABELL has been a photographer for *National Geographic* since 1970. His previous books include *Stay This Moment* and *Seeing Gardens*. He is a member of the Board of Trustees of the George Eastman House, Rochester, New York, and the Santa Fe Center for the Visual Arts, where he teaches. He is represented by the Kathleen Ewing Gallery, Washington D.C.

He lives with his wife Denise in Crozet, Virginia.

LEAH BENDAVID-VAL is the author of four books on photography including *Propaganda & Dreams* and *Stories on Paper & Glass*. She has curated photography exhibitions for the Corcoran Gallery of Art, Washington D.C., and the Pushkin Museum of Art, Moscow. She has been a book editor for National Geographic since 1985 and is presently Editorial Director for inSIGHT, an ongoing series of monographs on photographers.

She and her husband Avrom have three children and live in Washington, D.C.